8/17

D1381141

HUMANS
OF NEW YORK

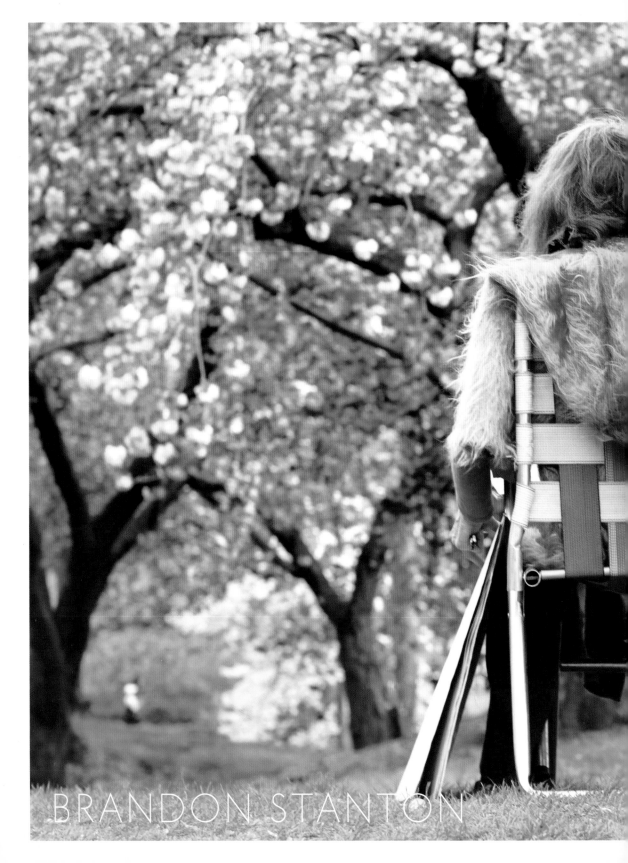

HUMANS
OF NEW YORK

ST. MARTIN'S PRESS ✠ NEW YORK

TO THE CITY OF NEW YORK.

I HAD THIS CRAZY, JUVENILE IDEA
THAT YOU WERE GOING TO MAKE ALL MY
DREAMS COME TRUE. AND YOU DID.

WWW.STMARTINS.COM

BOOK DESIGN: JONATHAN BENNETT
PRODUCTION MANAGER: ERIC GLADSTONE

LIBRARY OF CONGRESS CATALOGING-IN-PUBLICATION DATA
AVAILABLE UPON REQUEST

ISBN 978-1-250-03882-1 (HARDCOVER)
ISBN 978-1-250-03881-4 (E-BOOK)

ST. MARTIN'S PRESS BOOKS MAY BE PURCHASED FOR EDUCATIONAL,
BUSINESS, OR PROMOTIONAL USE. FOR INFORMATION ON BULK
PURCHASES, PLEASE CONTACT MACMILLAN CORPORATE AND PREMIUM
SALES DEPARTMENT AT 1-800-221-7945 EXTENSION 5442 OR WRITE
SPECIALMARKETS@MACMILLAN.COM.

FIRST EDITION: OCTOBER 2013

30 29 28 27 26

INTRODUCTION

I got my first camera in January 2010. I was working as a bond trader, so I only had time to use it on weekends, but I fell in love with it. Every Saturday and Sunday, I'd take my camera into downtown Chicago and photograph everything. If I found something especially beautiful, I'd photograph it from twenty different angles—just to be sure that I'd end up with one good shot. I'd return home each night with over one thousand new photos. Almost all of them were awful, but I didn't mind. I was hooked. Photography felt like a treasure hunt, and even though I sucked at it, I'd occasionally stumble upon a diamond. And that was enough to keep me wanting more.

I lost my trading job that July and immediately decided I wanted to be a photographer. I had enjoyed my time as a trader. The job was challenging and stimulating. And I'd obsessed over markets in the same way that I'd later obsess over photography. But the end goal of trading was always money. Two years of my life were spent obsessing over money, and in the end I had nothing to show for it. I wanted to spend the next phase of my life doing work that I valued as much as the reward. Photography seemed like an obvious choice. Like I said, it felt like a treasure hunt. And that seemed like a pretty good way to spend my time.

My parents thought I was crazy. There were several awkward phone calls during this time. My mother didn't try to hide her disappointment. She saw bond trading as a very prestigious profession. Photography, on the other hand, seemed like a thinly veiled attempt to avoid employment. After all, I had no experience or formal training. And it didn't help that I had no plan for making money. But I figured the best way to become a photographer was to start photographing. So I planned a photo tour through several major American cities.

I left Chicago in late July and started across the country. My first stop was Pittsburgh. I explored the city in the same way that I'd explored Chicago: I walked around aimlessly, got lost, and photographed everything. Each night I uploaded my photos to an album on my personal Facebook account. I titled the album "Yellow Steel Bridges," because that was my first impression of the city. Most of my photos were of buildings and bridges. But occasionally, I'd include a shot of an interesting person.

I repeated the process in Philadelphia. I spent my days combing the streets for interesting photographs, and each night I deposited the photos in a Facebook album. I named this album "Bricks and Flags." My photos remained similar to those I'd taken in Chicago and Pittsburgh, but with one notable exception. I was starting to take more and more pictures of people. I'd begun to move beyond candid shots, and was actually stopping strangers on the street. The resulting portraits seemed to be the most compelling of my photographs, so I focused more energy on seeking them out.

I arrived in New York in early August. I planned to spend a week in the city before hopping on a plane for the West Coast, but I ended up staying for the rest of the summer. I remember the moment my bus emerged from the Lincoln Tunnel and I saw the city for the first time. The sidewalks were covered with people. The buildings were impressive, but what struck me most were the people. There were tons of them. And they all seemed to be in a hurry. That night, I created a photo album for my New York photos. I called it "Humans of New York."

Back then I had no intention of starting a blog. I didn't even know what a blog was. But after spending some time in New York, I knew that I wanted to photograph people. I spent that entire summer stopping people on the streets. By the end of August, I'd collected over six hundred portraits. I began to sense that I was on to something special. I returned to Chicago long enough to pack my bags, and returned to New York on November 4, 2010.

I first envisioned HONY as a photographic census of New York City. I wanted to take ten thousand portraits and plot them on an interactive map of the city. That way you could click on any neighborhood in New York and scroll through the faces of people who live there. I worked for several months with that goal in mind. This effort resulted in thousands of photographs, but very few people were paying attention. During the first year of HONY, only a handful of people were coming to my Web site each day.

Then I discovered the power of social media. I've got to thank my friend Mike Schaefer, because he was the one who convinced me to start a Facebook page for Humans of New York. I'd been resisting the suggestion for some time, because I was already posting my photos to my personal account. Making a separate page seemed redundant. But one night he finally talked me into it, and I started a new page for Humans of New York. In just over a year, that haphazard decision would lead to the discovery of half a million fans.

It wasn't an immediate explosion of growth. Progress was slow at first. But after a few weeks of posting, I began to notice unfamiliar names interacting with my photography. With each new post, a few more strangers began to follow my work. I could now see a direct correlation between my work and my growth. HONY was growing every day. After months of spinning my wheels, this was a very liberating feeling.

My next big break came when I discovered Tumblr. No other platform puts a higher value on promoting its artists and creators. HONY took root on Tumblr very quickly, mainly because of the early support of Tumblr's editorial team. Soon hundreds of thousands of

people were following HONY on Tumblr, and I remain very thankful for Tumblr's role in my success.

The last major evolution in HONY came when I began interviewing my subjects. Whenever possible, I started pairing my photos with a story or quotation. This mix of photography and writing caused HONY to grow even faster. Hundreds of new fans started following the site every single day. Then thousands. And as the audience began to balloon, HONY evolved from a photography project into an ongoing blog. I began to shift my priorities. I no longer aimed to complete an epic photography project. Instead, I sought to provide my audience with a few good portraits, every single day. And I hope to continue doing so for a very long time.

This book is the result of nearly three years of work. I walked several thousand miles to find these portraits. I stopped over ten thousand people on the street. It was exhausting work, but I enjoyed every minute of it. The people in these pages are very dear to me. By allowing me to take their photo, each one of them helped me to realize my dream. And I am so thankful for their participation.

Last, thanks to all of you who follow my work. You've supported me so much. It's been a dream, really. Thank you for making this happen for me. Thank you, thank you, thank you.

I hope you enjoy the Humans of New York as much as I have.

'I'M JUST FIGURING OUT
WHAT I WANT TO DO,

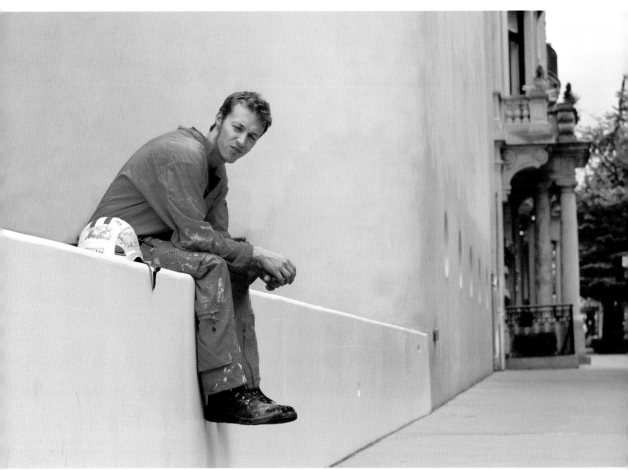

'CAUSE IT AIN'T THIS.'

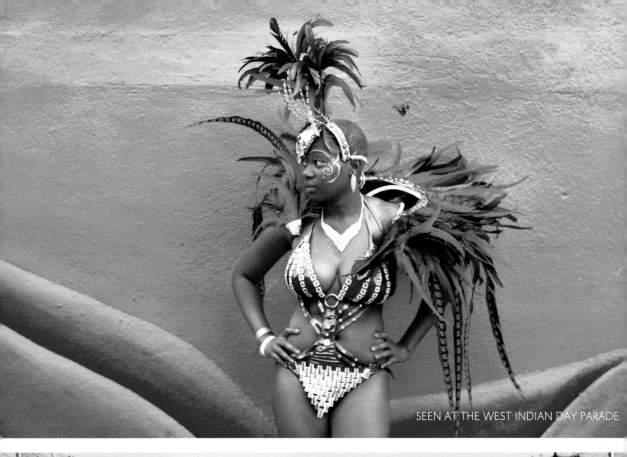

SEEN AT THE WEST INDIAN DAY PARADE

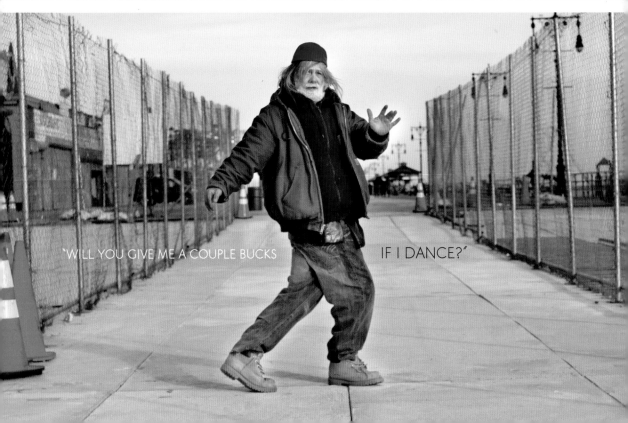

"WILL YOU GIVE ME A COUPLE BUCKS IF I DANCE?"

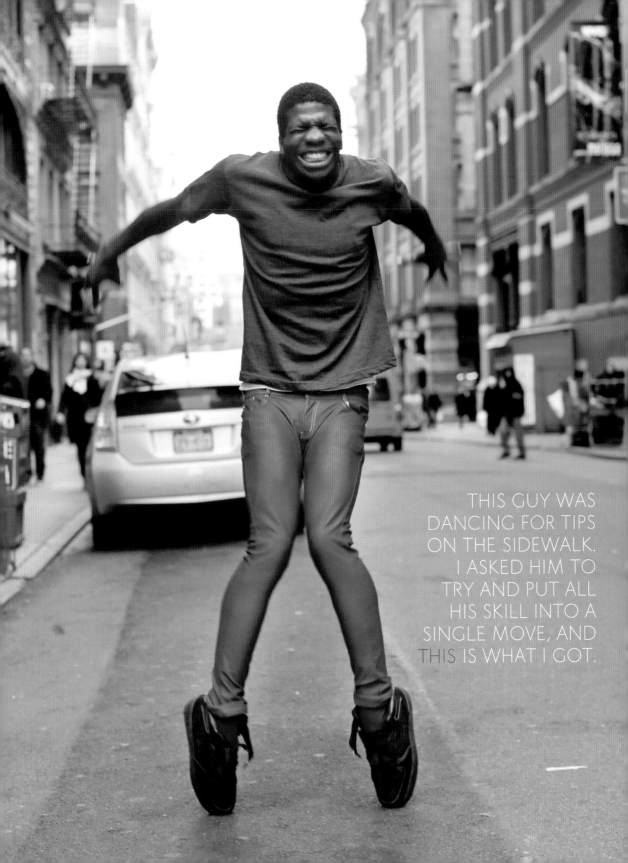

THIS GUY WAS
DANCING FOR TIPS
ON THE SIDEWALK.
I ASKED HIM TO
TRY AND PUT ALL
HIS SKILL INTO A
SINGLE MOVE, AND
THIS IS WHAT I GOT.

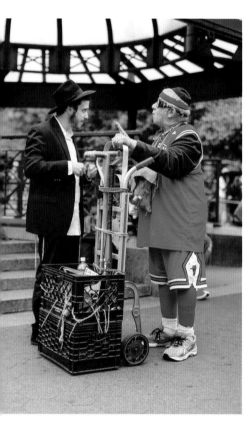

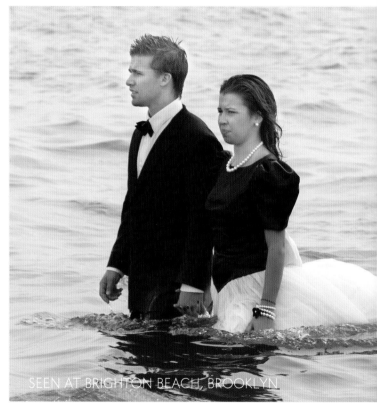

SEEN AT BRIGHTON BEACH, BROOKLYN

GOOD NEWS, EVERYONE!
ALL REMAINING
MYSTERIES OF THE
UNIVERSE WERE SOLVED
YESTERDAY AFTERNOON.

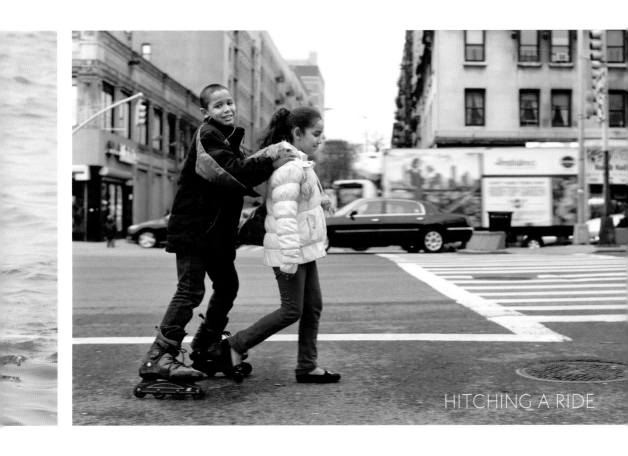

HITCHING A RIDE

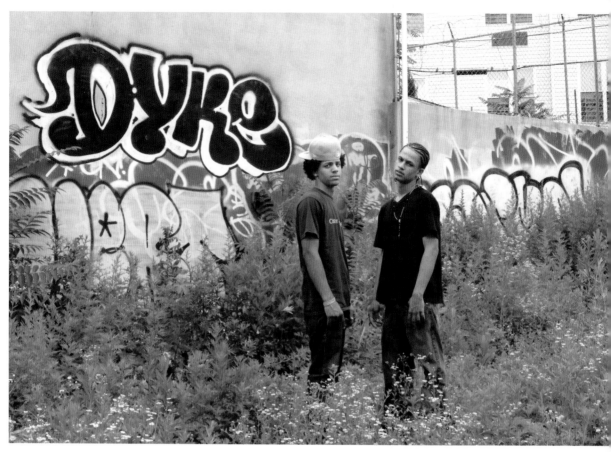

SEEN IN BEDFORD-STUYVESANT, BROOKLYN

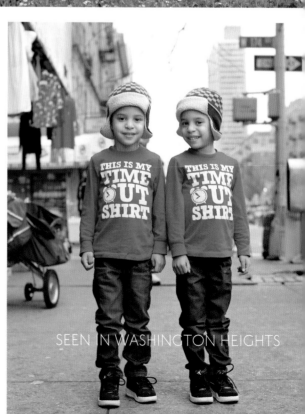

SEEN IN WASHINGTON HEIGHTS

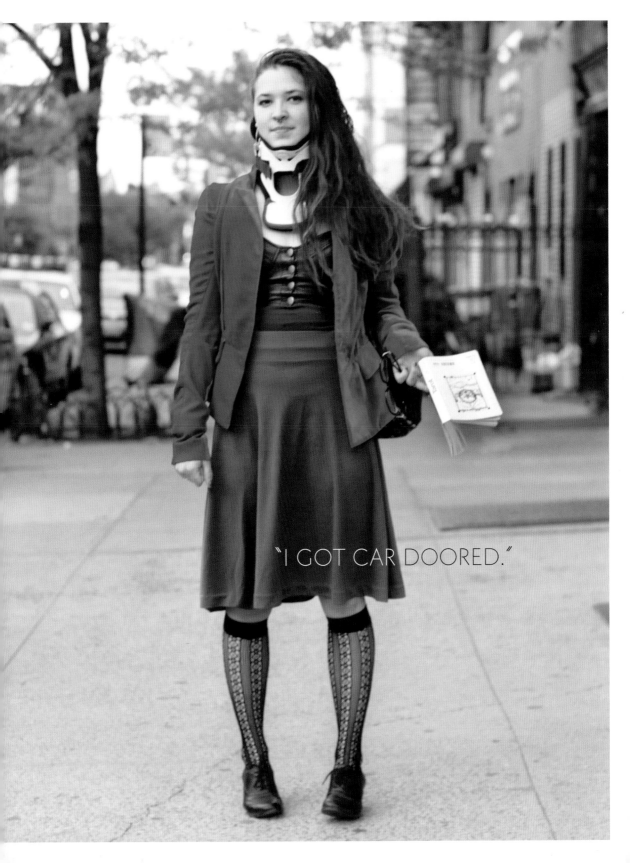

"I GOT CAR DOORED."

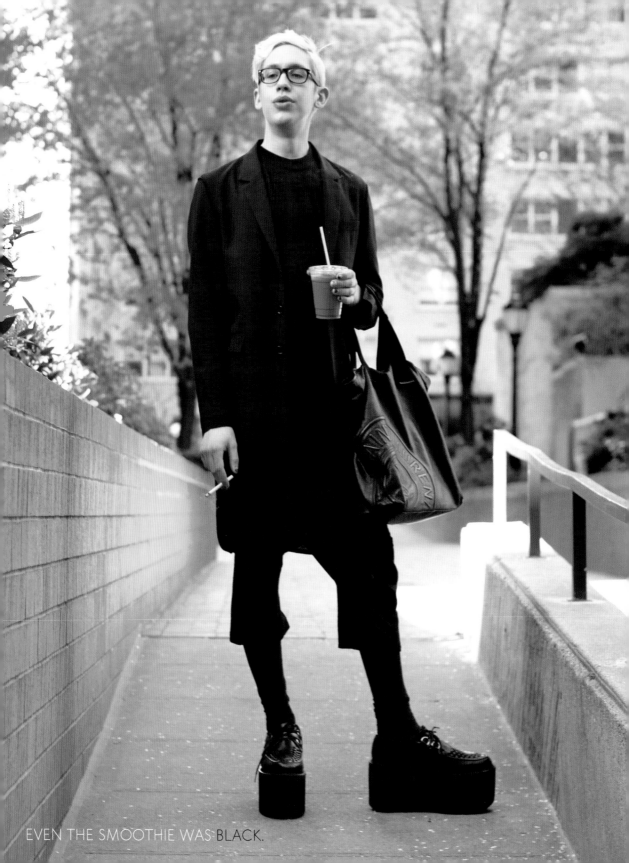

EVEN THE SMOOTHIE WAS BLACK.

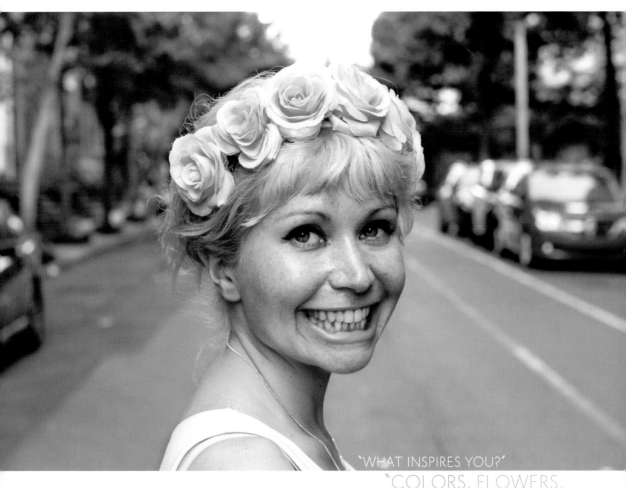

"WHAT INSPIRES YOU?"
"COLORS, FLOWERS,
AND PICNICS."

GAC FILIPAJ IS A REFUGEE FROM THE FORMER YUGOSLAVIA. FOR THE PAST TWELVE YEARS, HE HAS WORKED AS A JANITOR FOR COLUMBIA UNIVERSITY. HIS JOB TITLE IS `HEAVY CLEANER,' WHICH INCLUDES EMPTYING THE TRASH AND CLEANING THE TOILETS.

THROUGHOUT THAT TIME, HE WORKED UNTIL 11 P.M. EVERY NIGHT DURING THE WEEK. AFTER HIS SHIFT CONCLUDED, HE WOULD START STUDYING. THIS WEEKEND, AFTER TWELVE YEARS OF STUDY, GAC GRADUATED FROM COLUMBIA UNIVERSITY WITH A CLASSICS DEGREE. RARELY HAVE I MET A PERSON WHO EXHIBITED SO MANY QUALITIES I ADMIRE.

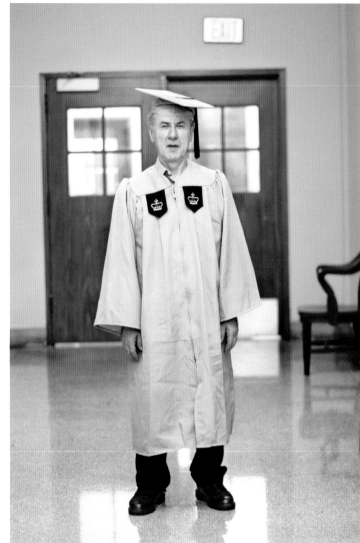

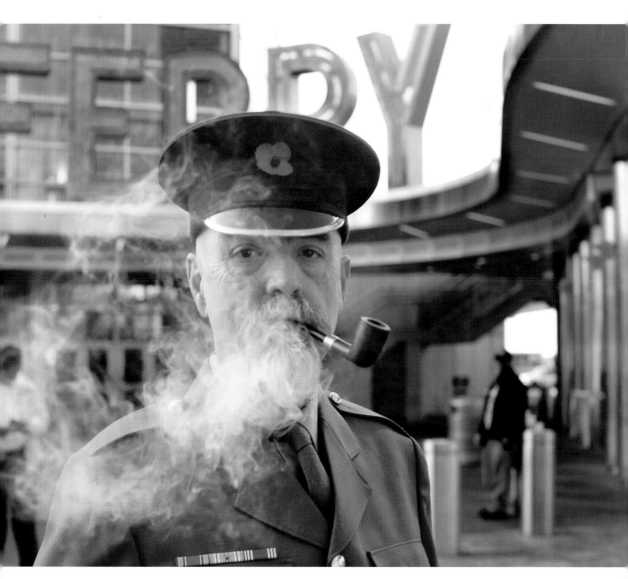

'I CAN TIE A FULL WINDSOR WHILE DRIVING DOWN THE ROAD AT SIXTY-FIVE MILES PER HOUR.'

I NOTICED A LARGE CROWD GATHERED AT WASHINGTON SQUARE PARK.
I PUSHED MY WAY TO THE CENTER, AND FOUND THIS.

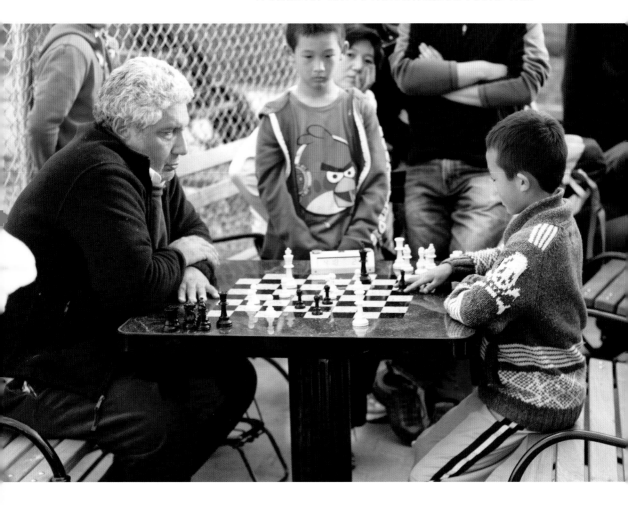

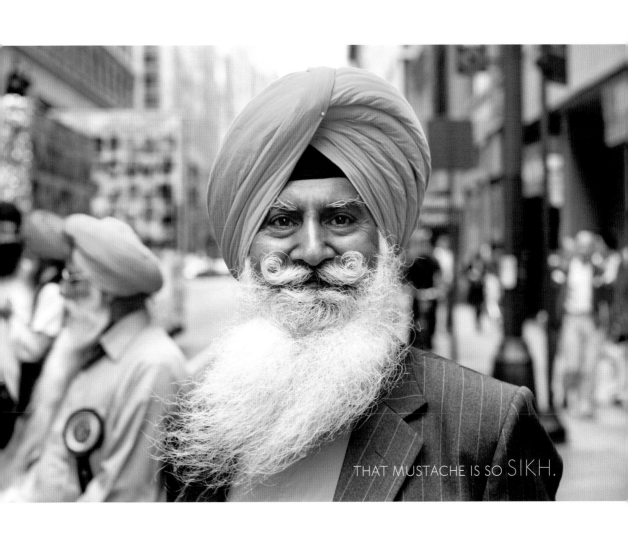

THAT MUSTACHE IS SO SIKH.

I FOUND A HUGE GEYSER OF STEAM COMING UP FROM A GRATE IN TRIBECA.
THEN I FOUND TWO BALLET STUDENTS EATING LUNCH ON A NEARBY CURB.

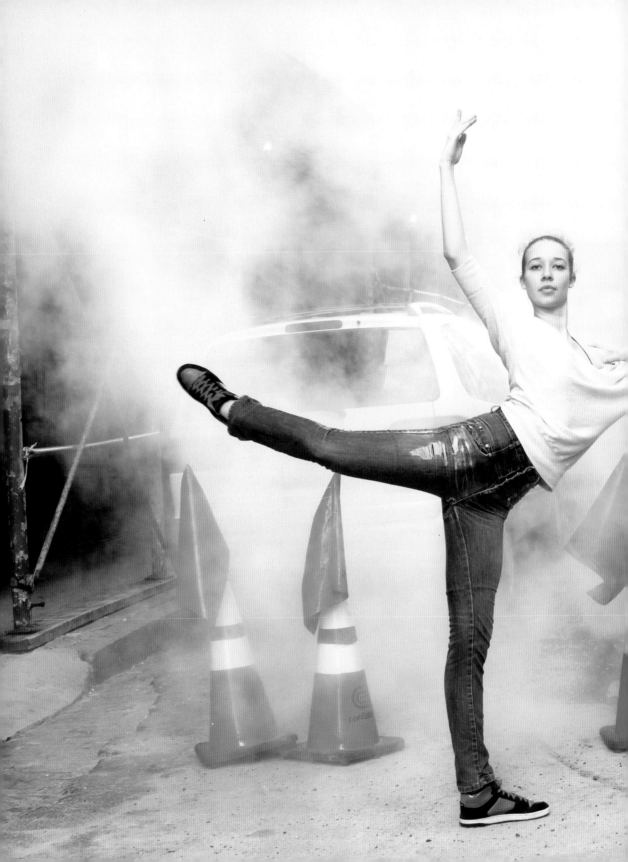

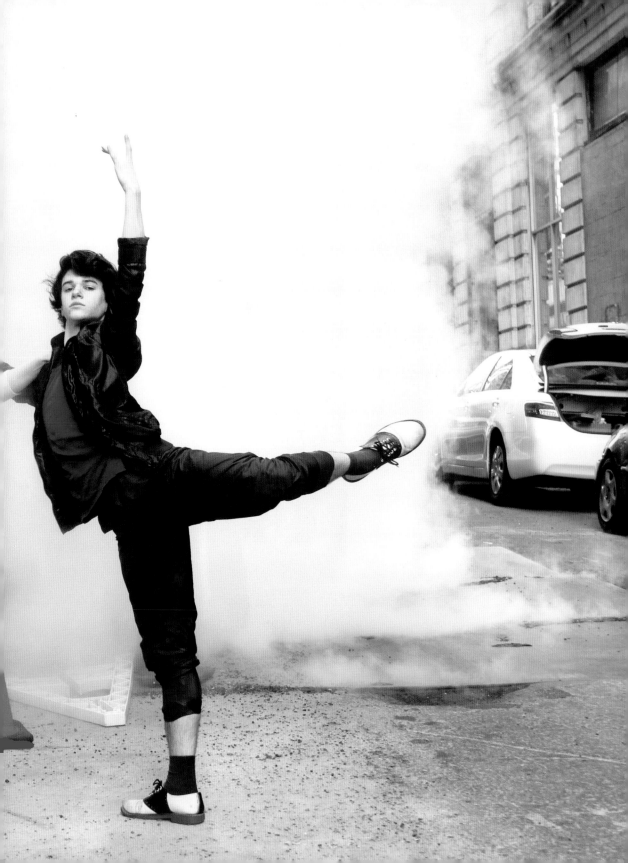

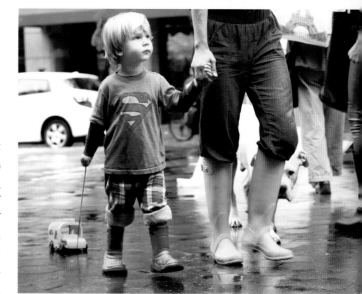

IN AN AGE OF
IPHONES AND
PLAYSTATIONS,
IT'S GREAT
TO SEE THAT
SOMEBODY'S
STILL ROCKING
THE BUS-ON-
A-STRING.

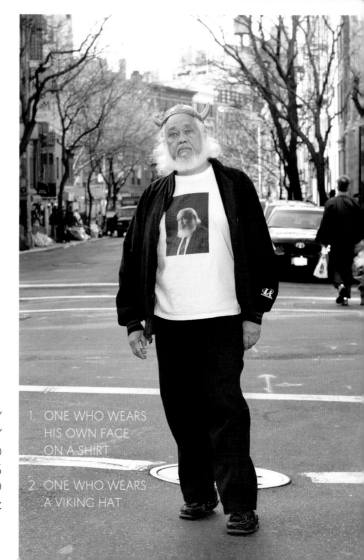

THE HONY
DICTIONARY
CONTAINS TWO
DEFINITIONS
FOR THE WORD
'CHAMPION':

1. ONE WHO WEARS
HIS OWN FACE
ON A SHIRT

2. ONE WHO WEARS
A VIKING HAT

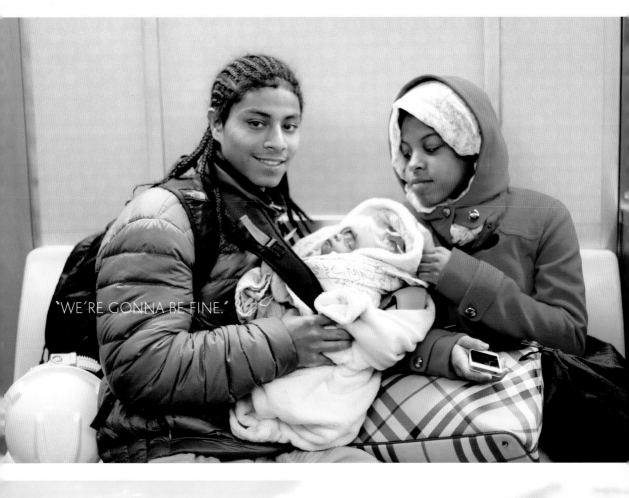

"WE'RE GONNA BE FINE."

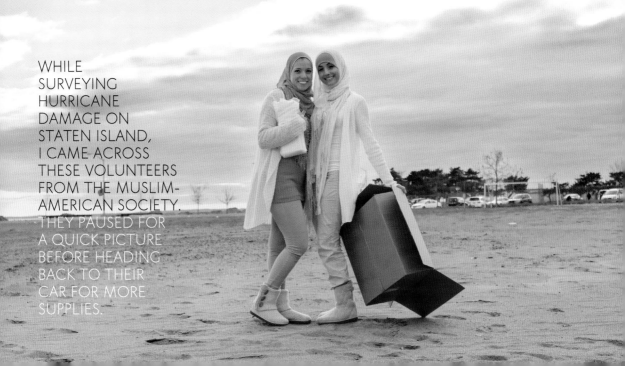

WHILE SURVEYING HURRICANE DAMAGE ON STATEN ISLAND, I CAME ACROSS THESE VOLUNTEERS FROM THE MUSLIM-AMERICAN SOCIETY. THEY PAUSED FOR A QUICK PICTURE BEFORE HEADING BACK TO THEIR CAR FOR MORE SUPPLIES.

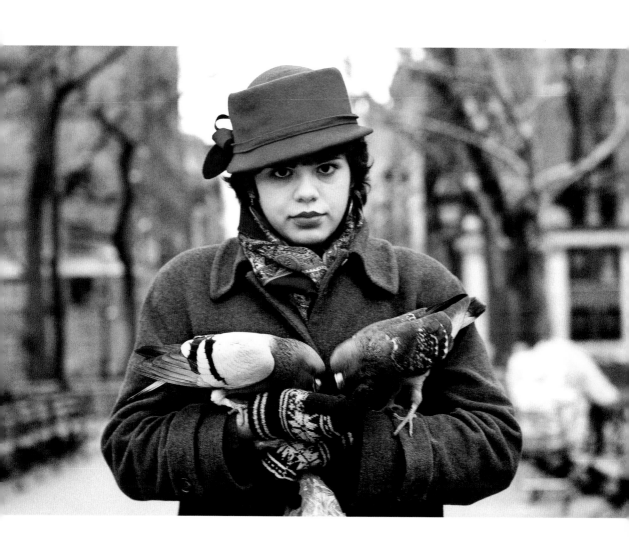

THE PIGEON WHISPERER

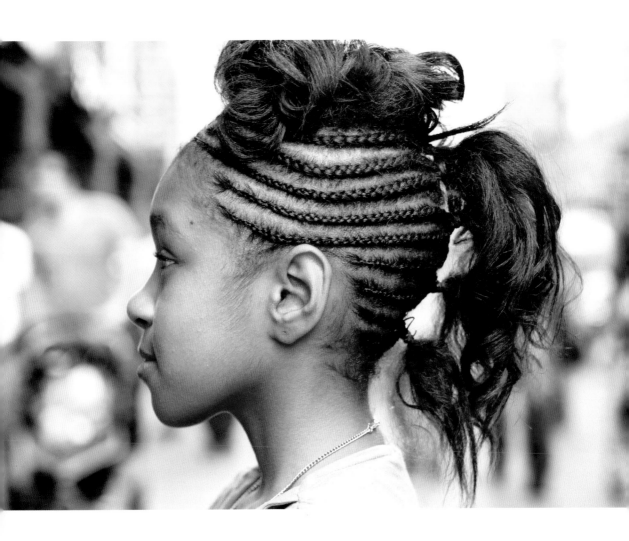

NOW THAT'S ART.

'HE WAS MY FIRST LOVE. WE DATED FOR TEN DAYS WHEN WE WERE VERY YOUNG, BUT MY MOM WOULD NOT ALLOW THE RELATIONSHIP. SHE TOLD ME: 'HE'S AN AMERICAN, AND HE'S AN ACTOR. HE'LL NEVER MAKE ANYTHING OF HIMSELF.' THEN SHE SAID: 'THERE ARE MILLIONS OF MEN, BUT I'M YOUR ONLY MOTHER.' SHE TOLD ME TO NEVER CONTACT HIM AGAIN AND I LISTENED TO HER. SHE TOOK ME TO KOREA FOR A FEW YEARS. I NEVER TRIED TO CONTACT HIM, EVEN WHEN I CAME BACK. I NEVER EVEN GAVE HIM AN EXPLANATION. THAT WAS OVER TWENTY YEARS AGO.

RECENTLY, I GOOGLED HIM AND SAW THAT HE WAS RUNNING A THEATER COMPANY. I WROTE HIM A LONG LETTER OUT OF THE BLUE, EXPLAINING EVERYTHING. WE'D BOTH BEEN MARRIED. WE BOTH HAD KIDS. BUT HERE WE ARE—FINALLY TOGETHER.'

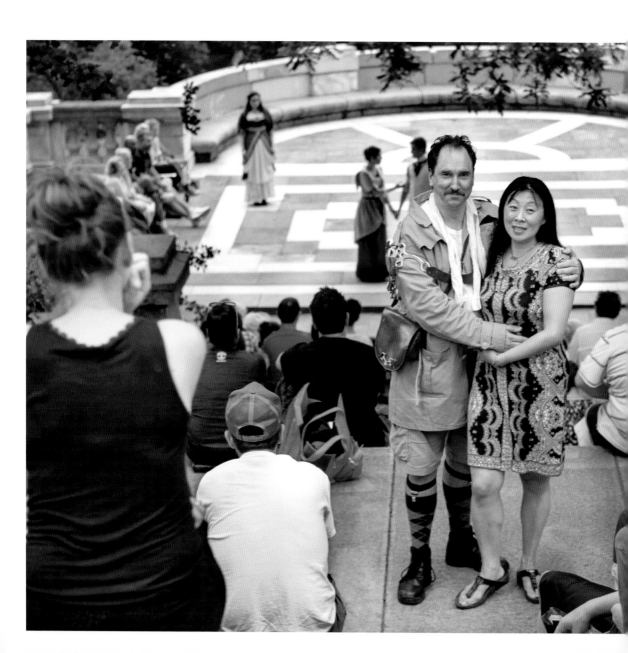

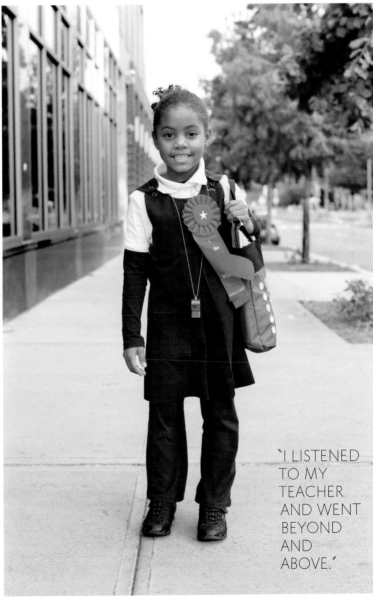

"I LISTENED TO MY TEACHER AND WENT BEYOND AND ABOVE."

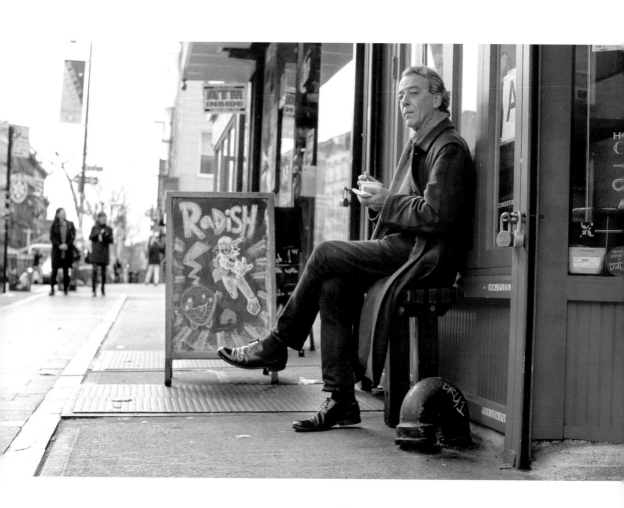

"EVERY AMERICAN SHOULD LIVE IN THE MEDITERRANEAN FOR AT LEAST A YEAR. WE HAVE A CALVINIST WORK ETHIC TRANSPORTED FROM NORTHERN EUROPE. WHEN YOU LIVE IN THE MOST BEAUTIFUL PLACE ON EARTH, THAT SEEMS LESS AND LESS IMPORTANT."

"YOU BETTER NOT MAKE IT SEEM LIKE WE WERE SITTING AROUND. . . .

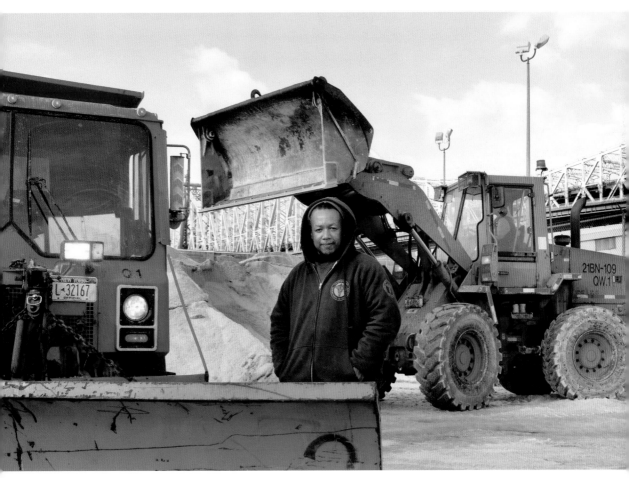

DON'T TAKE THE PICTURE UNTIL THE BULLDOZER STARTS MOVING."

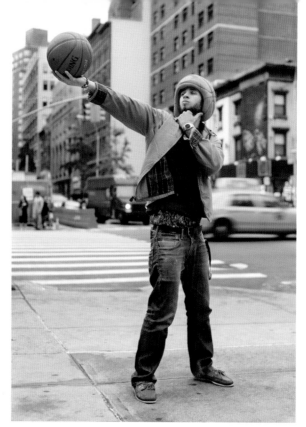

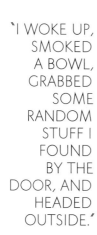

"I WOKE UP, SMOKED A BOWL, GRABBED SOME RANDOM STUFF I FOUND BY THE DOOR, AND HEADED OUTSIDE."

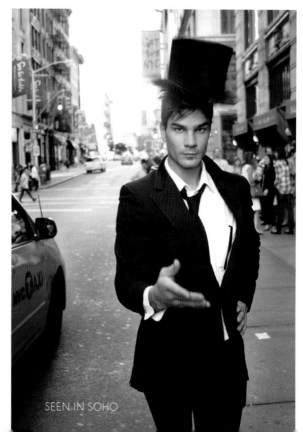

SEEN IN SOHO

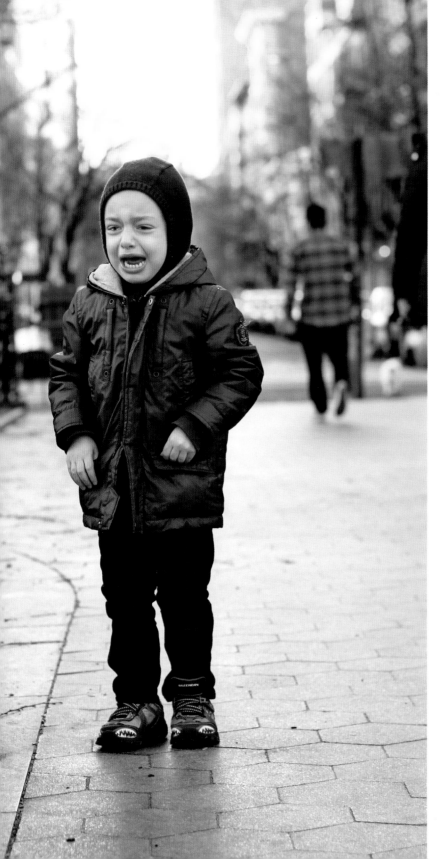

THIS LITTLE GUY WAS BOUNCING A TINY BASKETBALL WHEN IT GOT AWAY FROM HIM AND LANDED IN A BED OF PINE STRAW. TWO SQUIRRELS APPROACHED THE BALL TO INVESTIGATE. THE BOY CONCLUDED THAT THE SQUIRRELS WERE PLANNING TO STEAL HIS BALL, AND WAS OVERCOME BY DESPAIR.

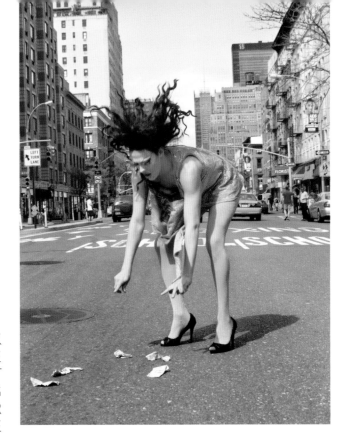

I THINK
IT'D BE
DIFFICULT
TO BRING
TOGETHER
MORE
ELEMENTS
OF NEW
YORK
CITY IN
A SINGLE
SCENE.

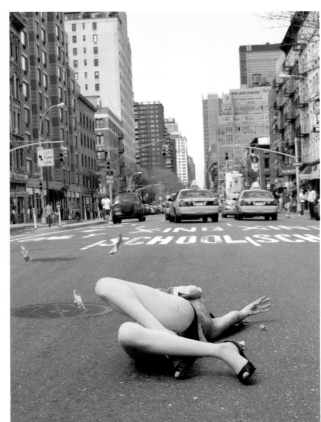

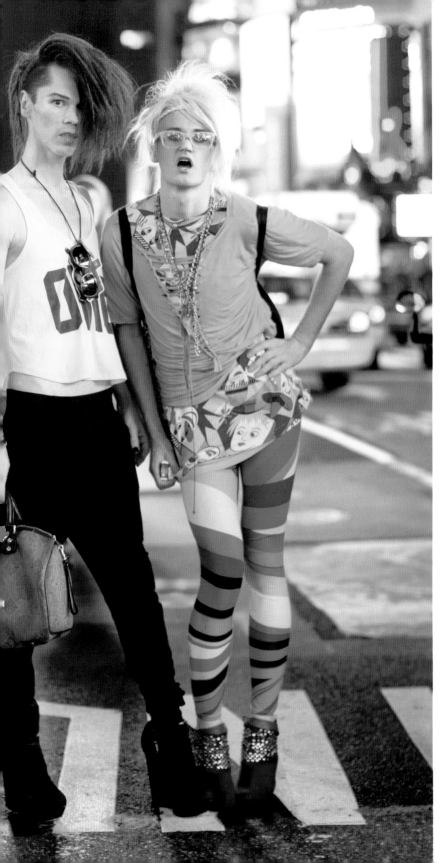

THE MAN ON
THE RIGHT SPENT
SEVERAL MINUTES
EXPLAINING
HIS PLAN TO
BECOME A
GENDER-BENDING
ROCK STAR. IT
ALL SOUNDED
VERY IMPRESSIVE.
THE MAN ON THE
LEFT WAITED
PATIENTLY WHILE
HIS FRIEND HELD
THE SPOTLIGHT.
THEN, IN A QUIET
VOICE, HE SAID:
'I'M A CARD-
CARRYING NATIVE
AMERICAN AND
THE TWILIGHT
SERIES WAS BASED
ON THE LEGENDS
OF MY FAMILY.'

BOOM.

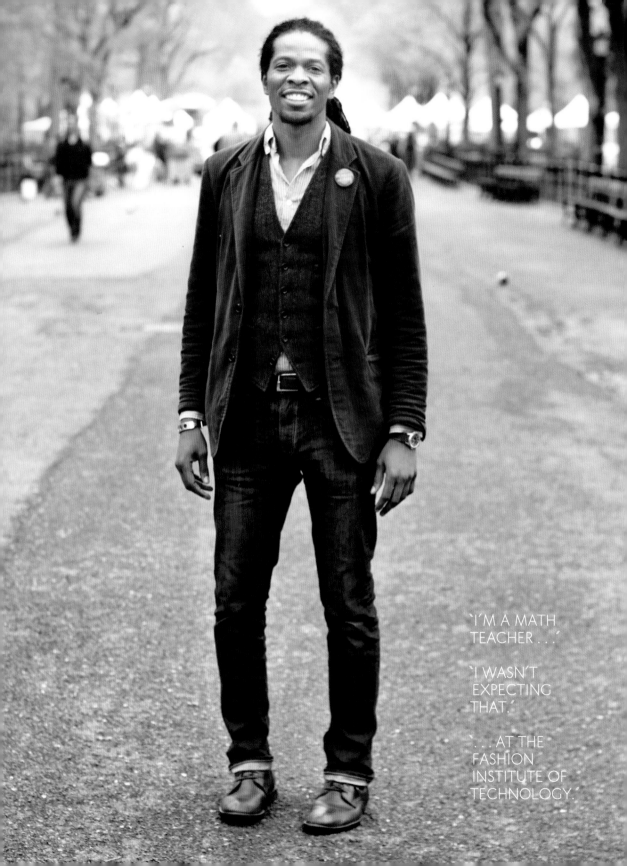

'I'M A MATH
TEACHER...'

'I WASN'T
EXPECTING
THAT.'

'...AT THE
FASHION
INSTITUTE OF
TECHNOLOGY.'

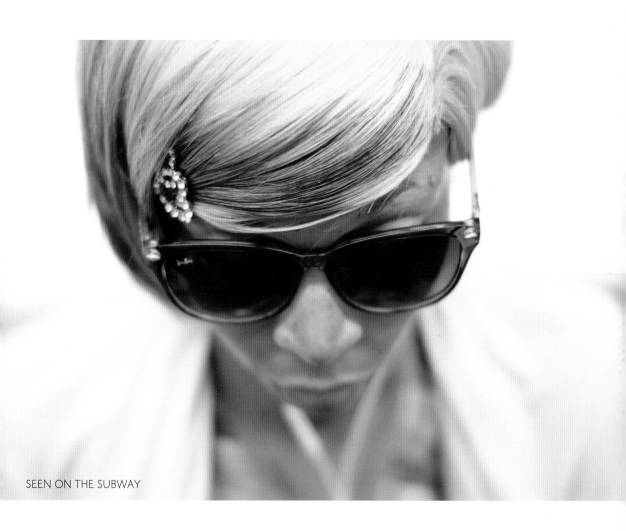

SEEN ON THE SUBWAY

A TERRIBLE CRIME HAS BEEN COMMITTED. ⟶

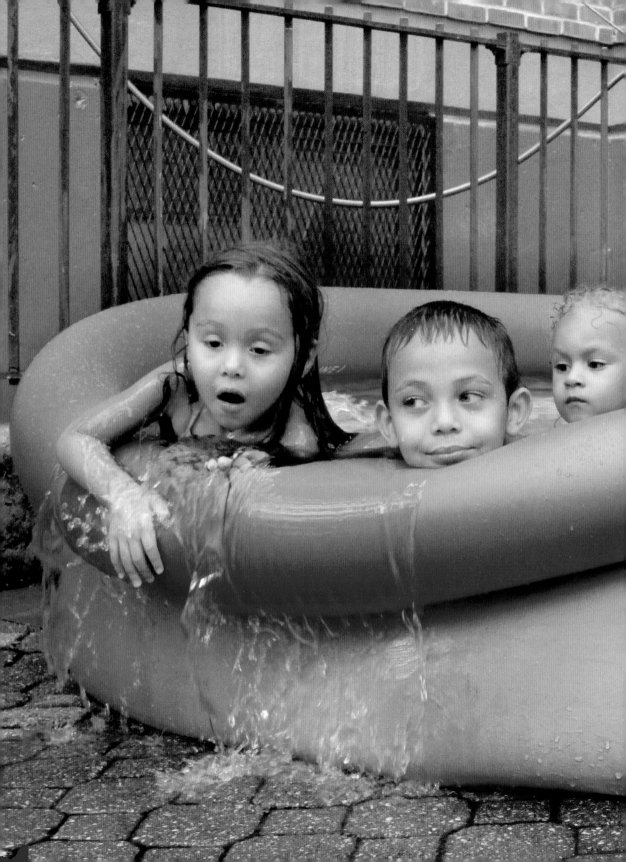

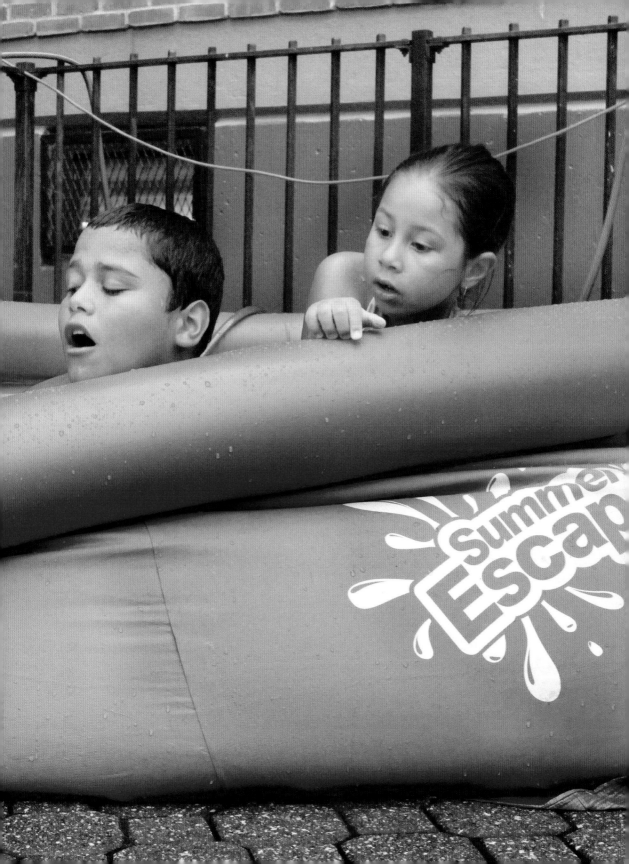

'I'VE BEEN A
WIDOW FOR
FIVE YEARS NOW.
AND I GUESS I'M
WORRIED THAT
MEN LOOK AT
HOW I DRESS
AND JUST DON'T
'GET IT.' MY
LATE HUSBAND
'GOT IT,' OF
COURSE. I'D
LOVE TO MEET
SOMEONE, BUT
I'M NOT GOING
TO CHANGE
ANYTHING
ABOUT MYSELF
TO DO IT.'

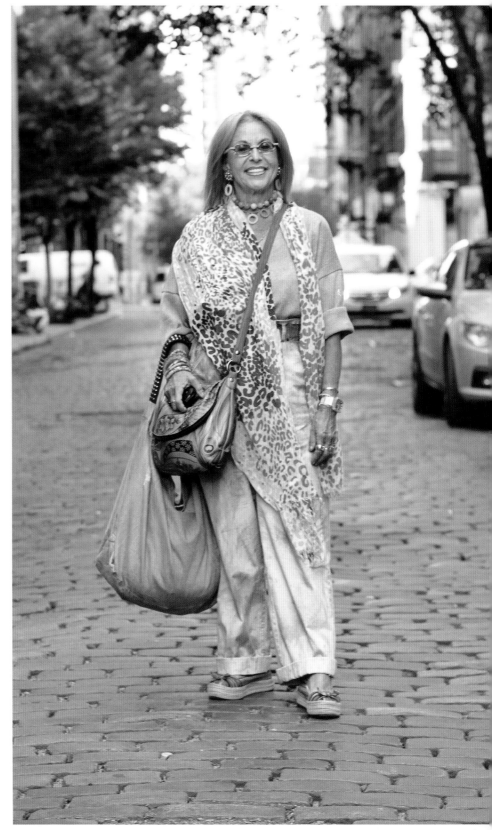

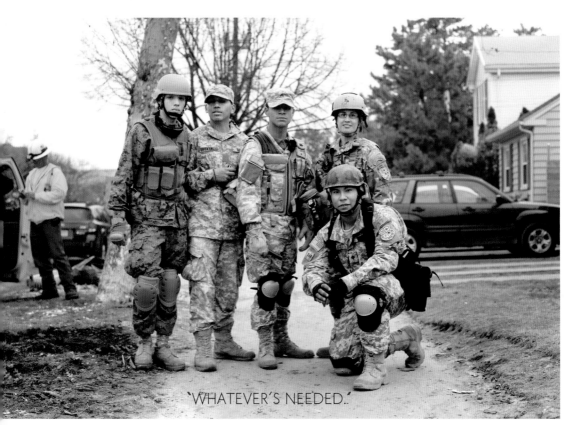

`WHATEVER'S NEEDED.`

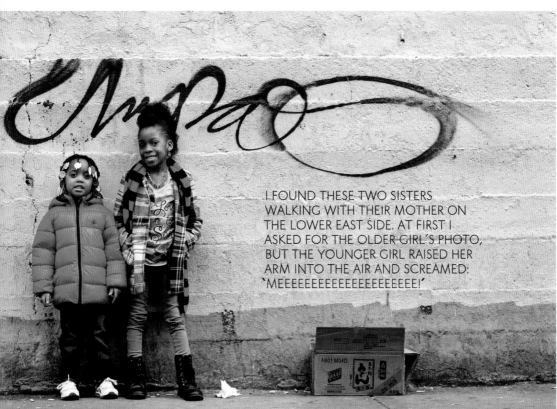

I FOUND THESE TWO SISTERS WALKING WITH THEIR MOTHER ON THE LOWER EAST SIDE. AT FIRST I ASKED FOR THE OLDER GIRL'S PHOTO, BUT THE YOUNGER GIRL RAISED HER ARM INTO THE AIR AND SCREAMED: `MEEEEEEEEEEEEEEEEEEEEE!`

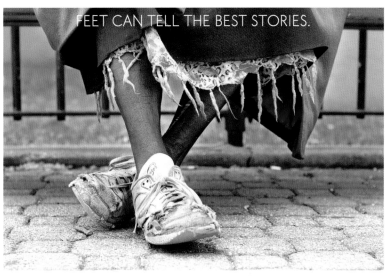

FEET CAN TELL THE BEST STORIES.

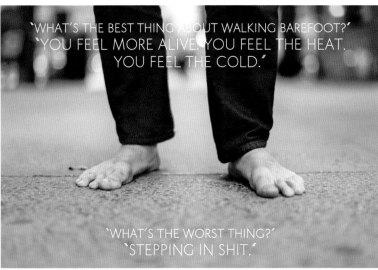

"WHAT'S THE BEST THING ABOUT WALKING BAREFOOT?"
"YOU FEEL MORE ALIVE. YOU FEEL THE HEAT.
YOU FEEL THE COLD."

"WHAT'S THE WORST THING?"
"STEPPING IN SHIT."

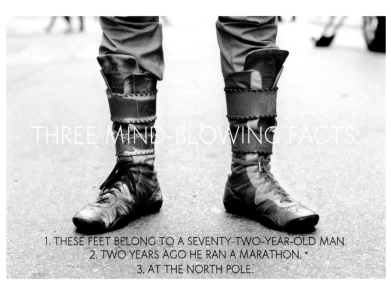

THREE MIND-BLOWING FACTS:

1. THESE FEET BELONG TO A SEVENTY-TWO-YEAR-OLD MAN.
2. TWO YEARS AGO HE RAN A MARATHON.
3. AT THE NORTH POLE.

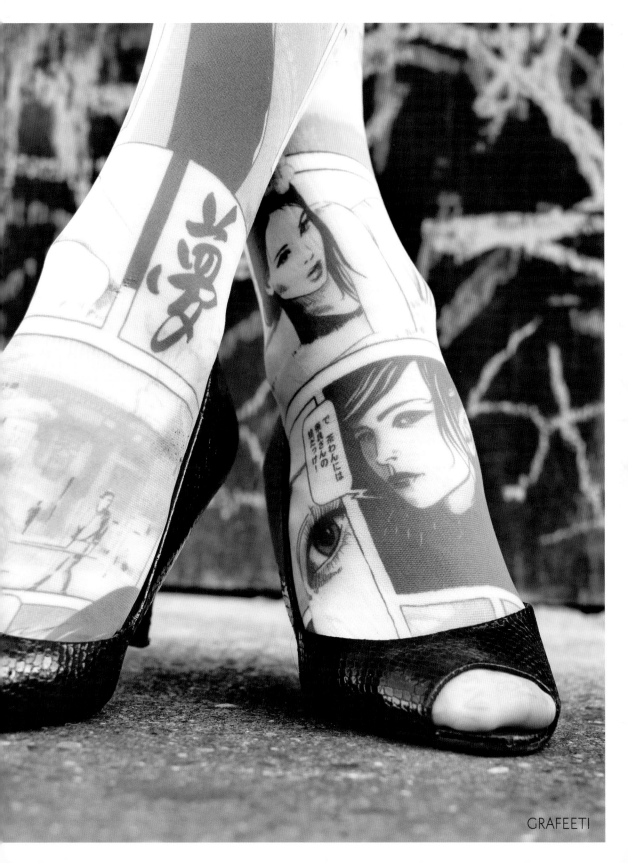

GRAFEETI

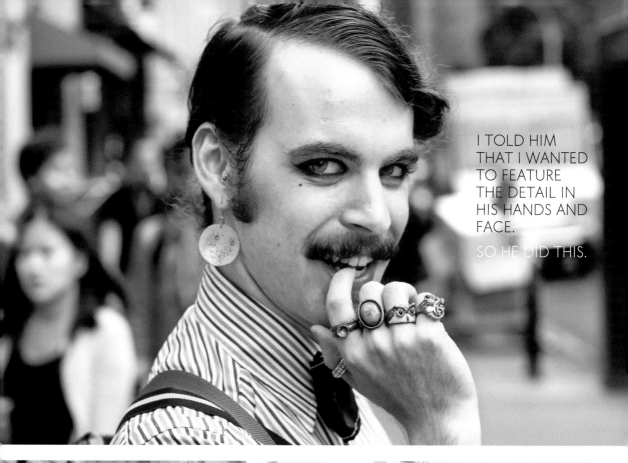

I TOLD HIM
THAT I WANTED
TO FEATURE
THE DETAIL IN
HIS HANDS AND
FACE.

SO HE DID THIS.

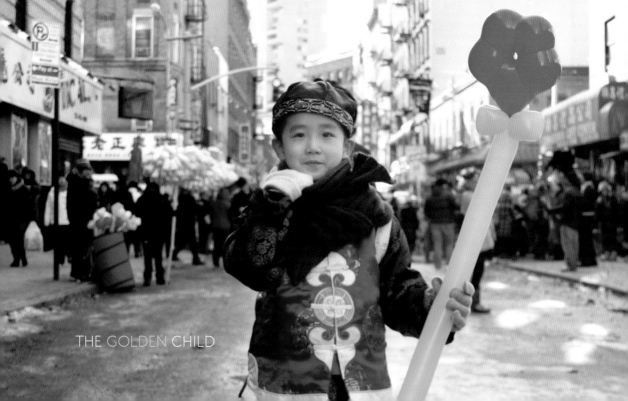

THE GOLDEN CHILD

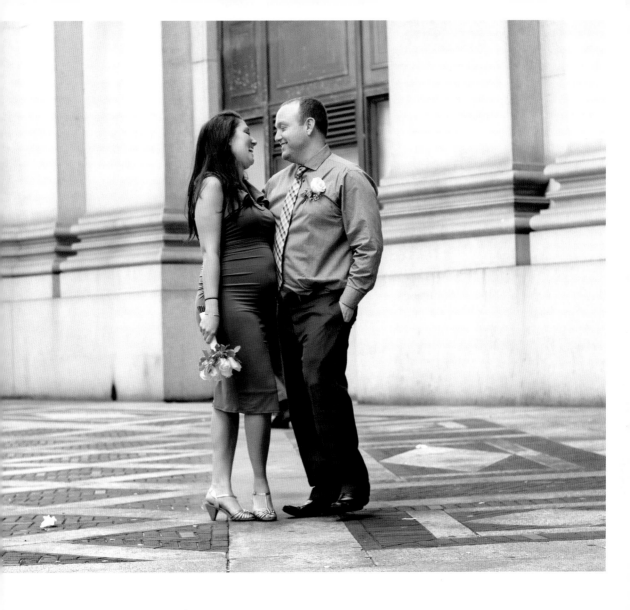

'MY FIANCÉE AND I ARE GETTING MARRIED TOMORROW AT CITY HALL. SHE IS FIVE MONTHS PREGNANT AND BEAUTIFUL.'

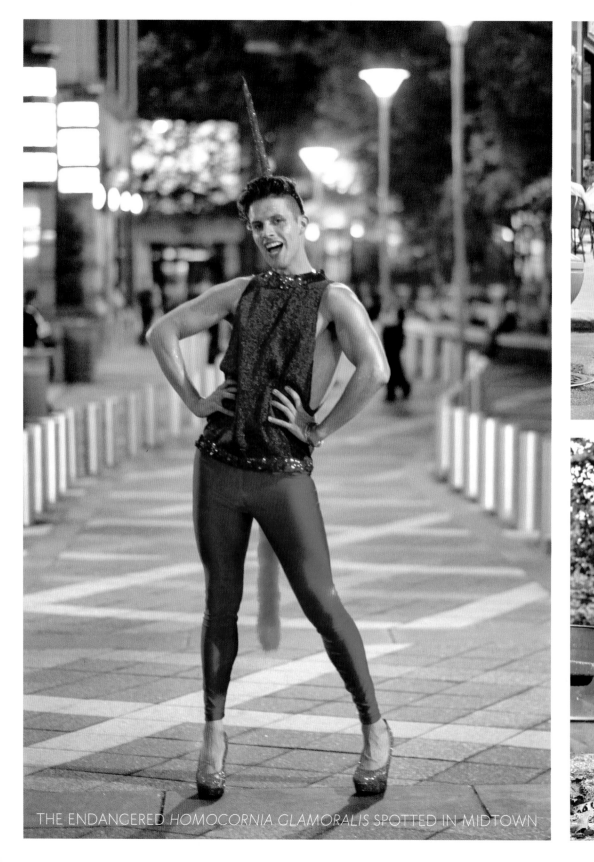

THE ENDANGERED *HOMOCORNIA GLAMORALIS* SPOTTED IN MIDTOWN

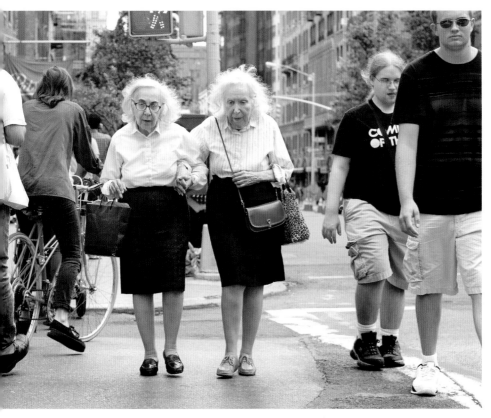

BET IT'D
BE HARD
TO HAVE
A BAD DAY
IF YOU WERE
HOLDING
HANDS WITH
THESE TWO.

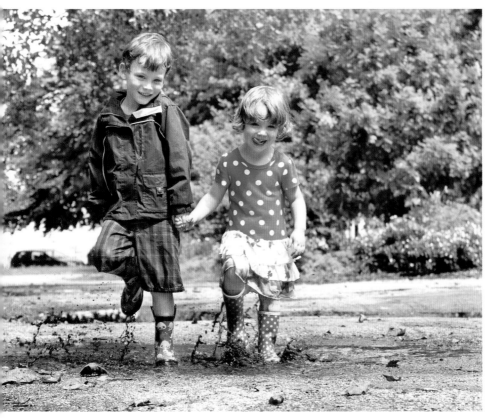

ALL YOU
NEED IS
A HAND
TO HOLD
AND A
PUDDLE
TO STOMP.

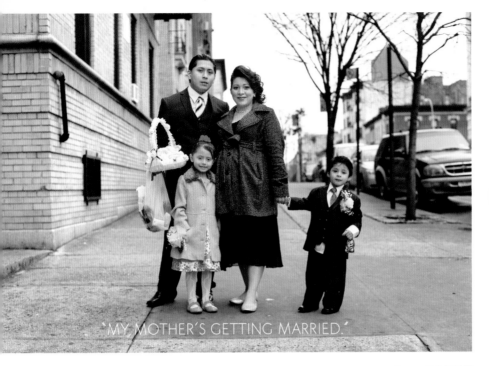

"MY MOTHER'S GETTING MARRIED."

HER PARENTS WERE VERY SKEPTICAL OF THE MAN WITH THE CAMERA. LUCKILY SHE WAS FEELING BRAVE.

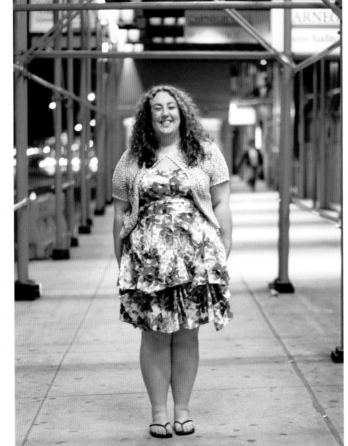

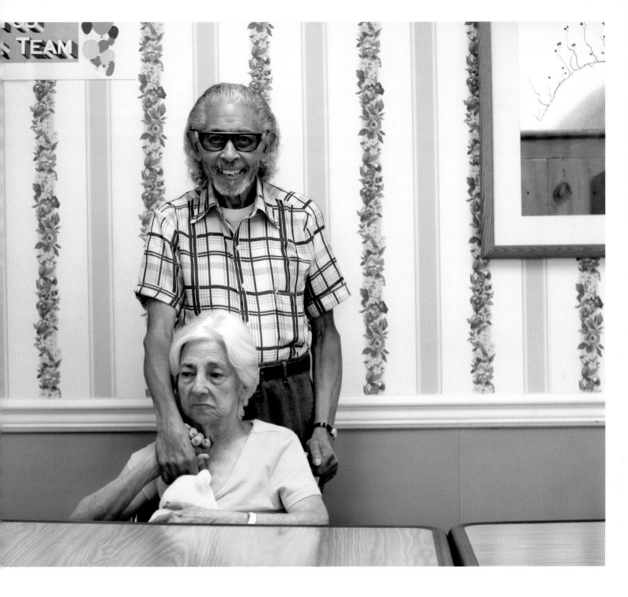

I STEPPED INSIDE AN UPPER WEST SIDE NURSING HOME, AND MET THIS MAN IN THE LOBBY. HE WAS ON HIS WAY TO DELIVER A YELLOW TEDDY BEAR TO HIS WIFE. `I VISIT HER EVERY DAY,' HE SAID. `EVEN WHEN THE MIND IS GONE, THE HEART SHOWS THROUGH.'

THE PAINTER HEARD ME LAUGHING, AND WITHOUT LOOKING DOWN, SAID:
`BOOGIE'S LOOKING AT YOU SIDEWAYS, ISN'T HE?' ⎯⎯⎯⎯

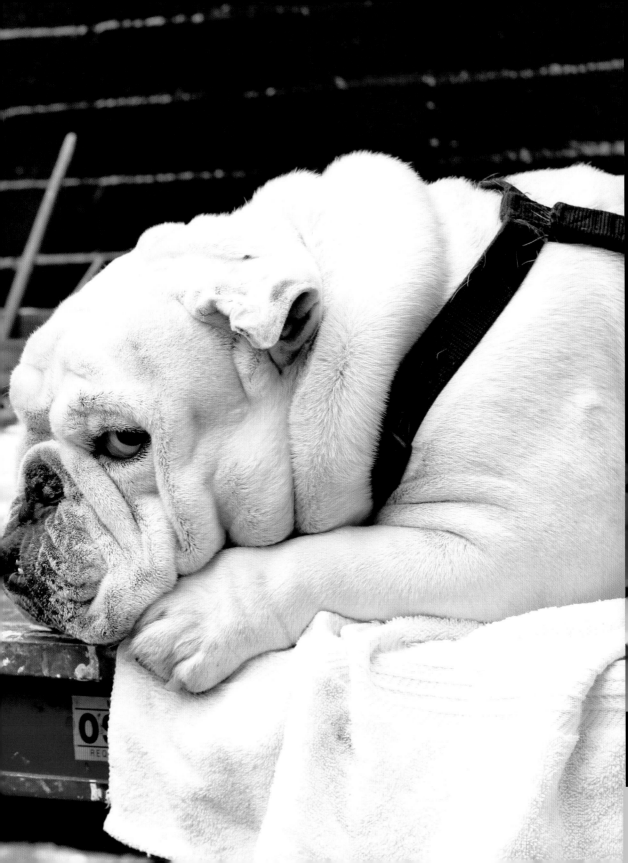

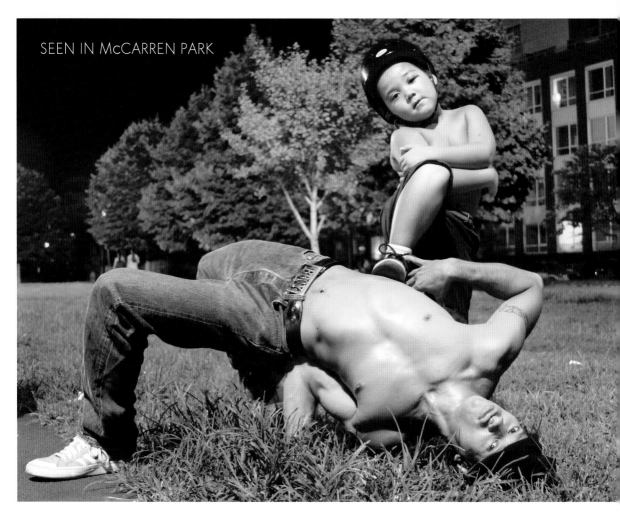

SEEN IN McCARREN PARK

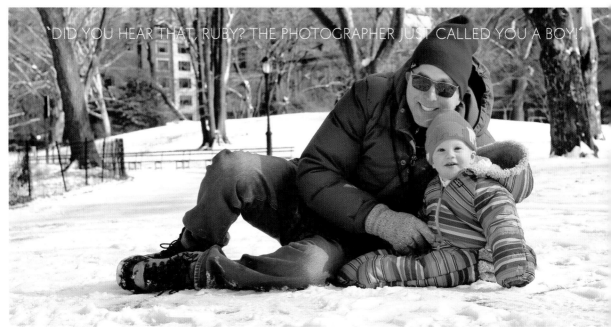

"DID YOU HEAR THAT, RUBY? THE PHOTOGRAPHER JUST CALLED YOU A BOY!"

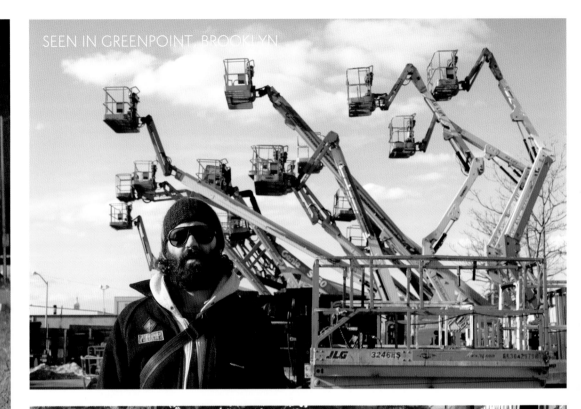

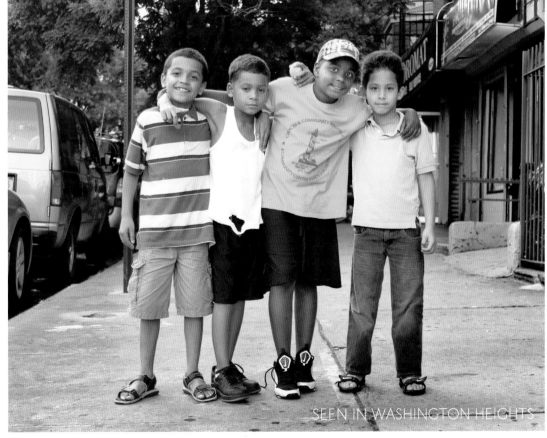

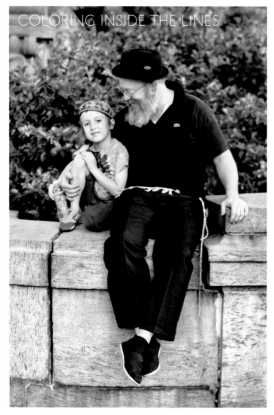

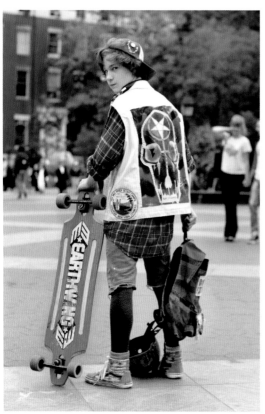

THIS KID WAS IN
THE MIDDLE OF A
SCAVENGER HUNT,
AND HAD JUST
EARNED FIVE POINTS
FOR 'POSING WITH
A WOMAN OVER
SIX FEET TALL.'

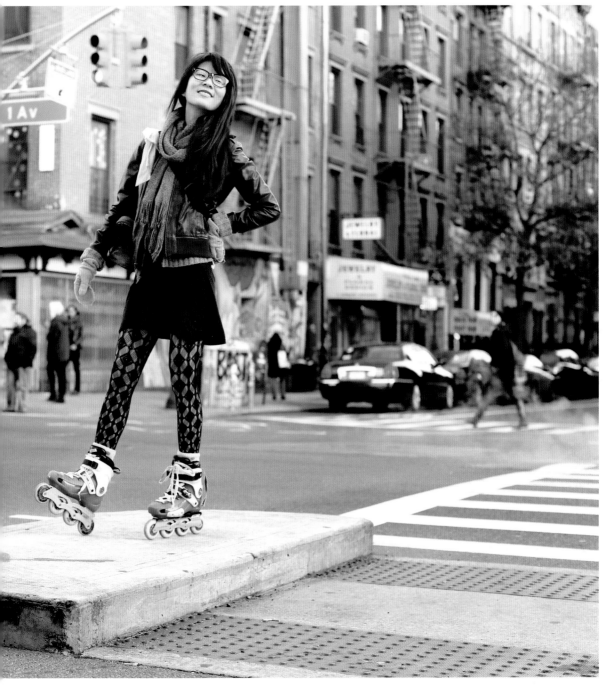

`US ROLLERBLADERS GET NO RESPECT.´

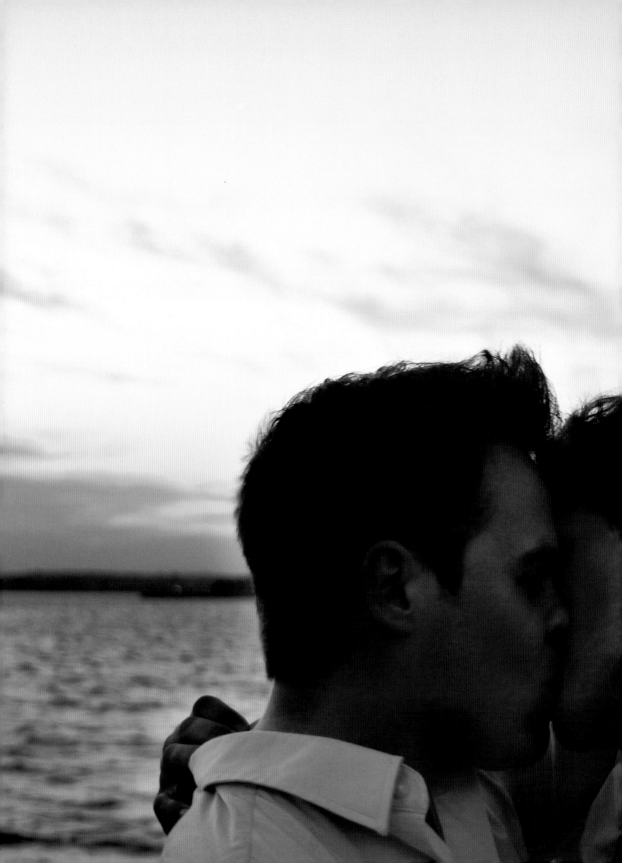

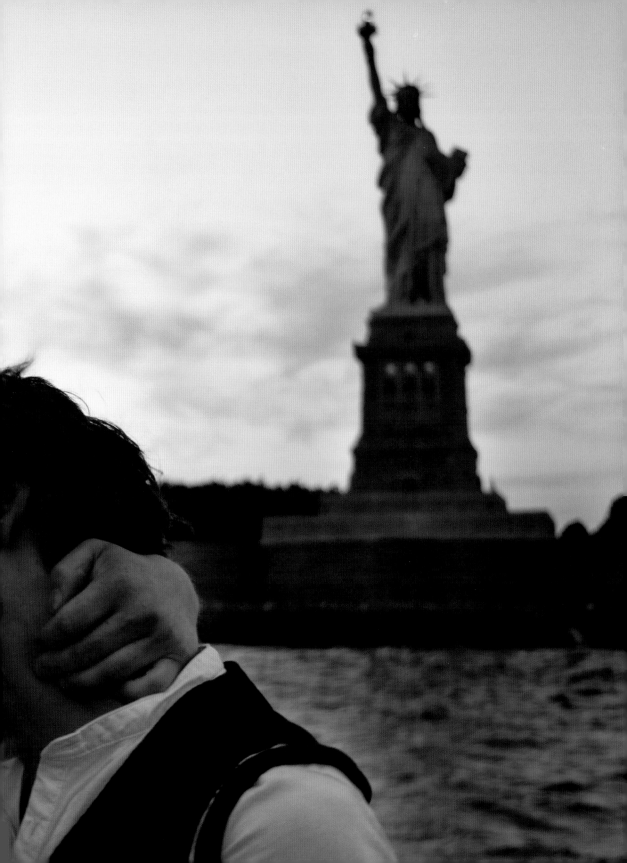

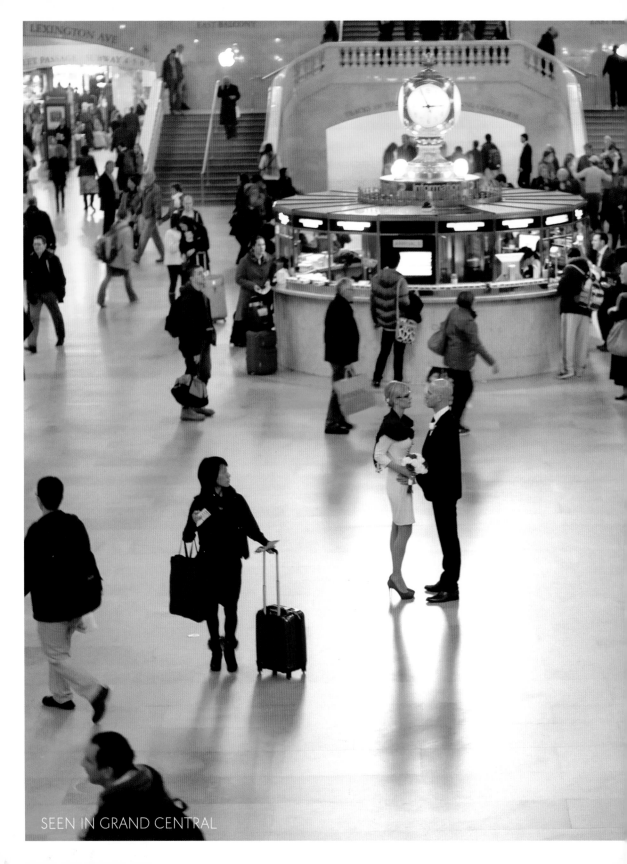

SEEN IN GRAND CENTRAL

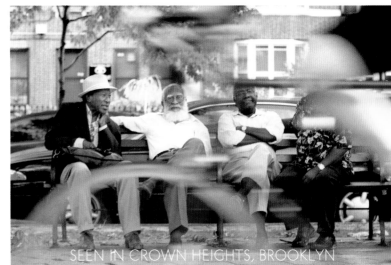

SEEN IN CROWN HEIGHTS, BROOKLYN

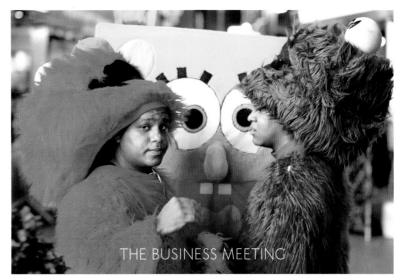

THE BUSINESS MEETING

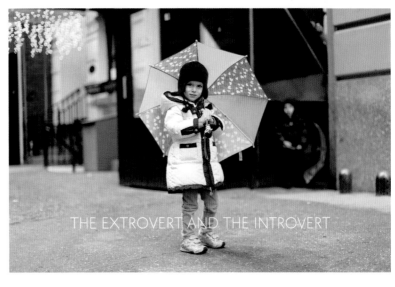

THE EXTROVERT AND THE INTROVERT

IT READS:
"WHEN BIRDS
LOOK INTO
HOUSES,
WHAT
IMPOSSIBLE
WORLDS
THEY SEE."

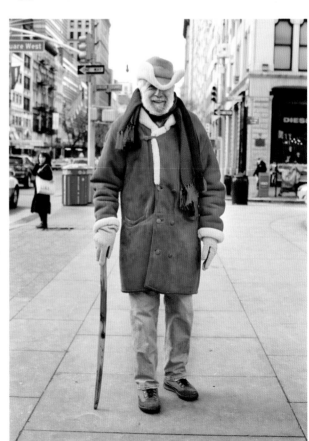

"I WAS
BORN IN
TRANSYLVANIA
AND I WRITE
BOOKS ABOUT
DRACULA."

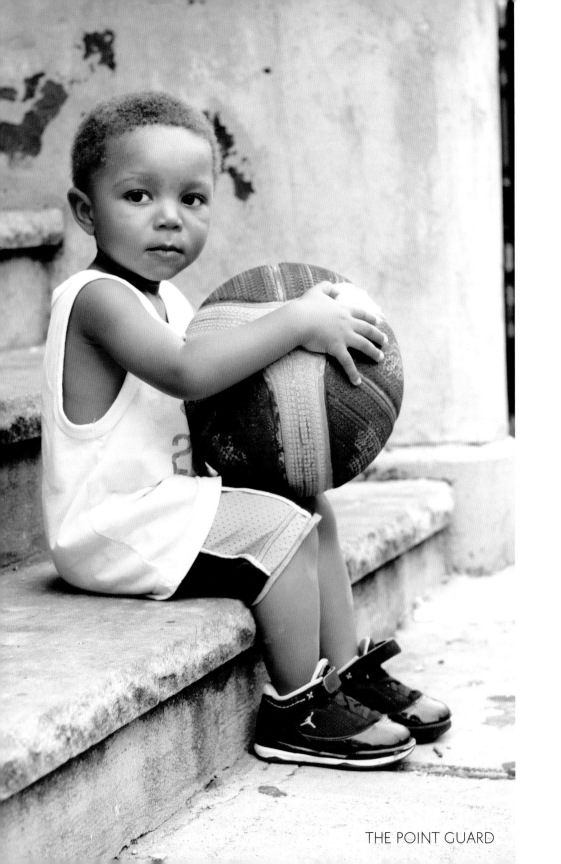

THE POINT GUARD

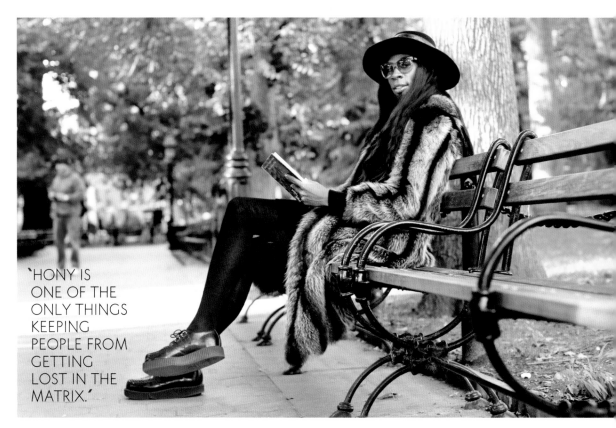

'HONY IS
ONE OF THE
ONLY THINGS
KEEPING
PEOPLE FROM
GETTING
LOST IN THE
MATRIX.'

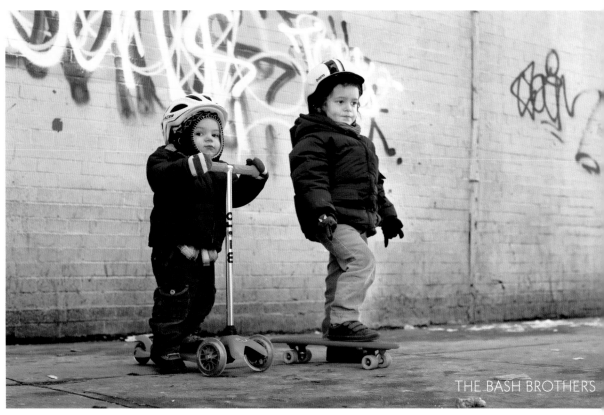

THE BASH BROTHERS

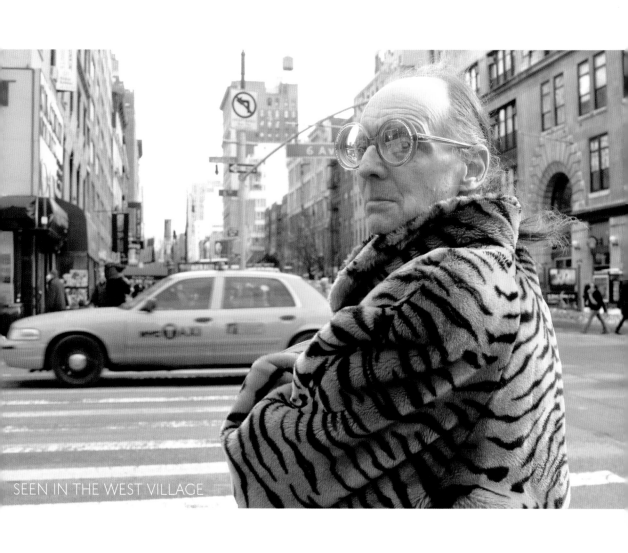

SEEN IN THE WEST VILLAGE

`I LOOK LIKE
GOD. DON'T I?`

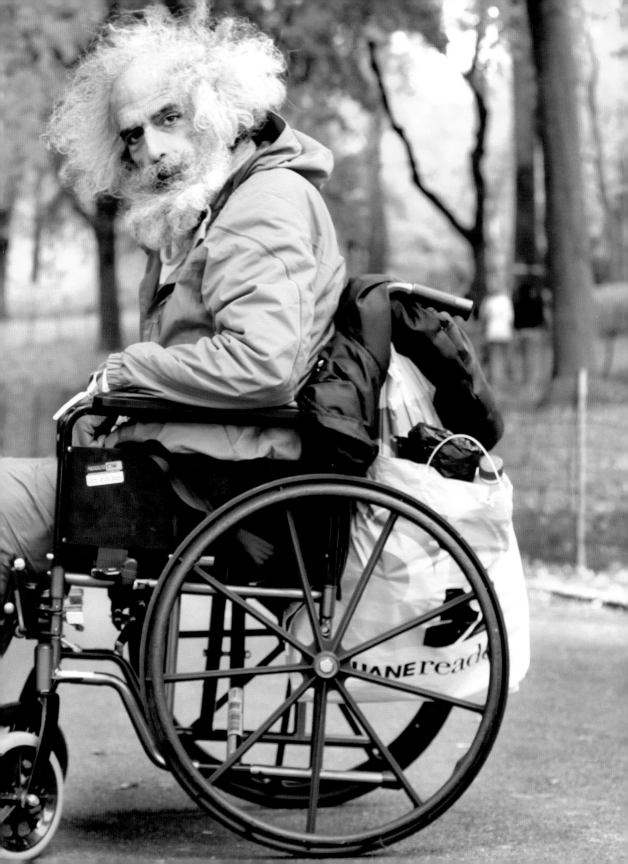

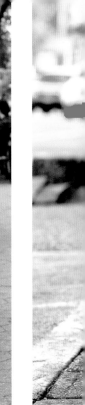
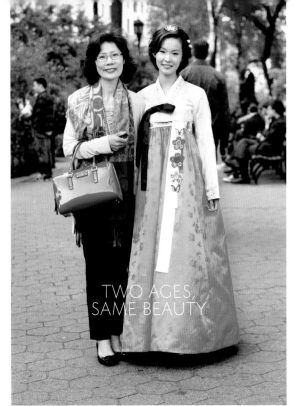

TWO AGES,
SAME BEAUTY

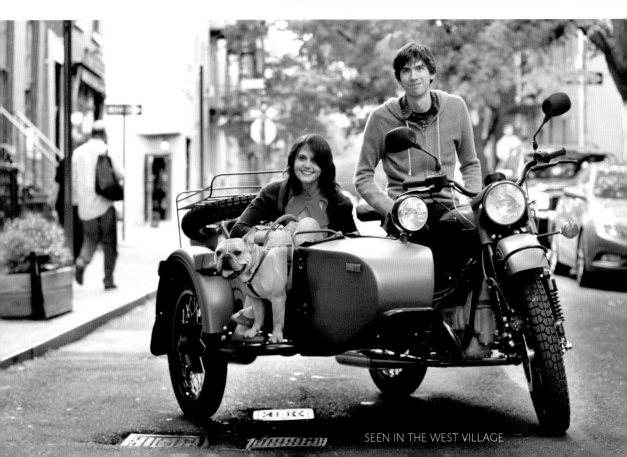

SEEN IN THE WEST VILLAGE

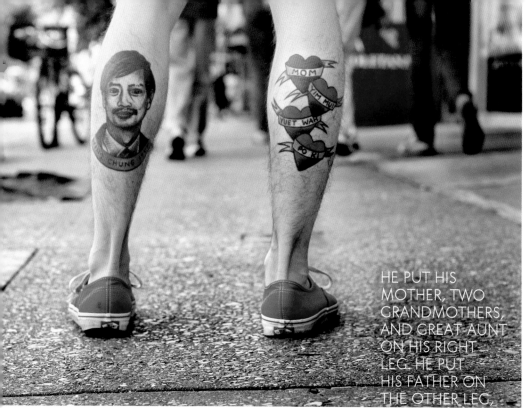

HE PUT HIS
MOTHER, TWO
GRANDMOTHERS,
AND GREAT-AUNT
ON HIS RIGHT
LEG. HE PUT
HIS FATHER ON
THE OTHER LEG,
PROBABLY SO HE
COULD HAVE A
LITTLE PEACE.

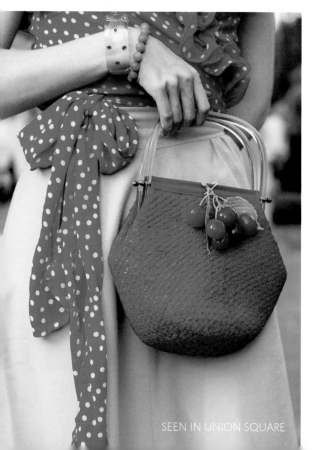

SEEN IN UNION SQUARE

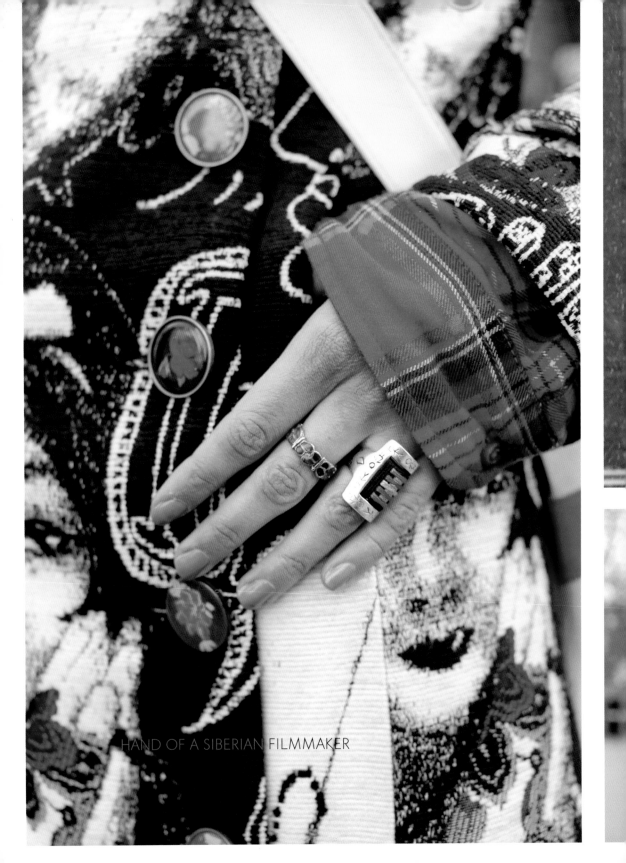

HAND OF A SIBERIAN FILMMAKER

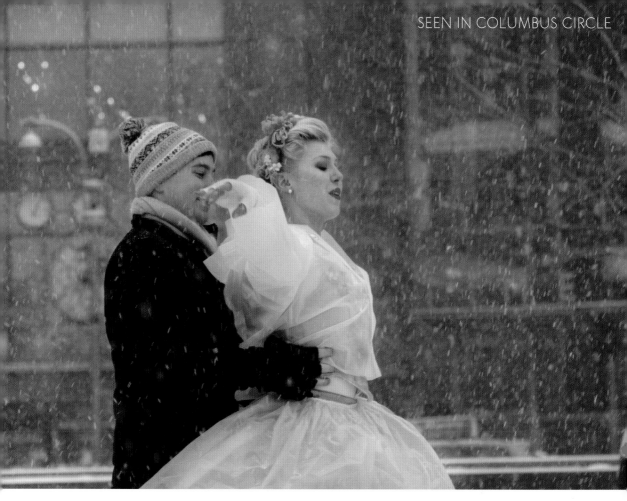

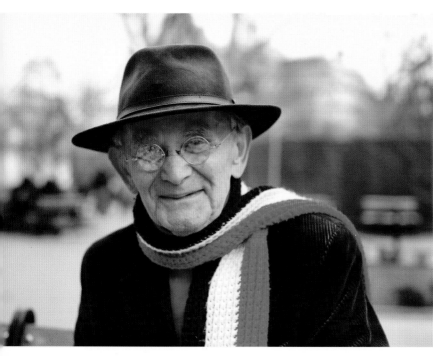

"I'M A TIME TRAVELER."

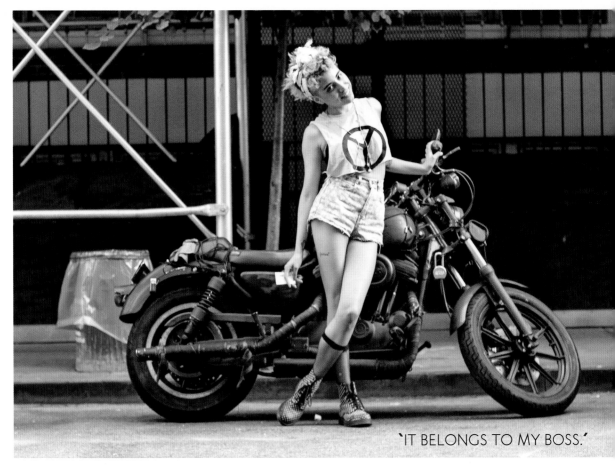

`IT BELONGS TO MY BOSS.`

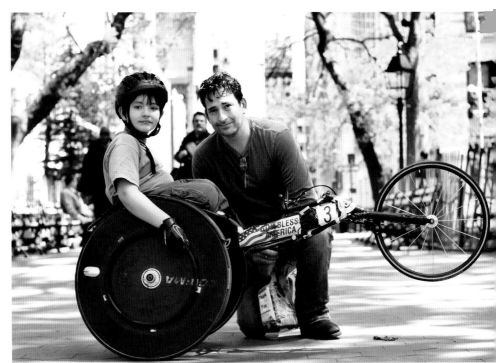

THESE TWO WERE RAISING MONEY FOR THE BOY'S ATHLETIC LEAGUE. `IT'S A GREAT PROGRAM,` EXPLAINED THE FATHER. `I FOUND IT WHILE SEARCHING FOR THINGS HE COULD DO.`

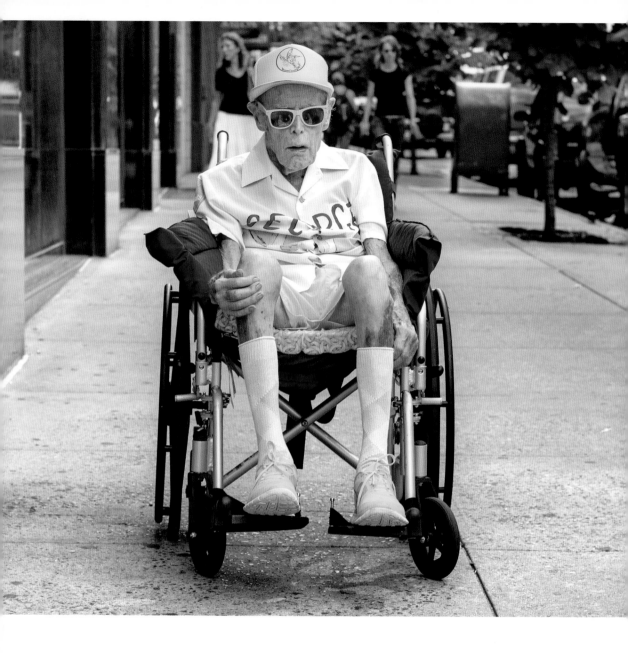

'THIS IS BANANA GEORGE,' EXPLAINED HIS CARETAKER. 'HE'S THE WORLD'S OLDEST BAREFOOT WATER-SKIER. HE'S NINETY-SEVEN NOW. WHEN HE WAS NINETY-TWO, HE SET THE WORLD RECORD FOR THE OLDEST PERSON TO WATER-SKI BAREFOOT.'

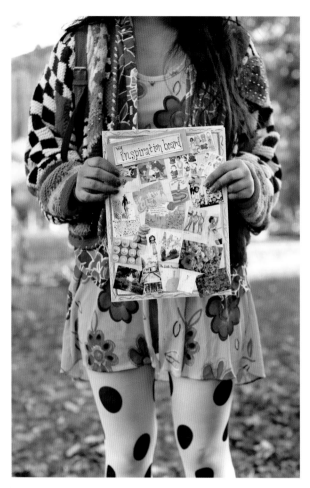

YOU KNOW
SOMEBODY IS
TRUE TO HERSELF
WHEN HER
"INSPIRATION
BOARD" IS
CAMOUFLAGED
AGAINST HER
CLOTHING.

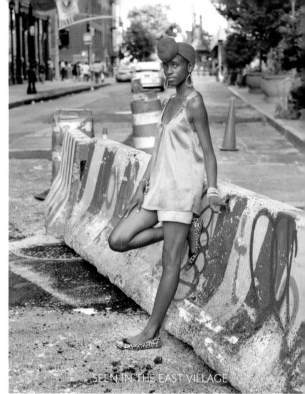

SEEN IN THE EAST VILLAGE

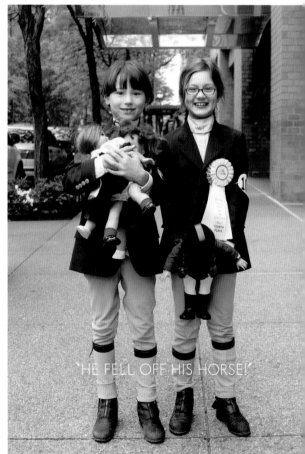

"HE FELL OFF HIS HORSE!"

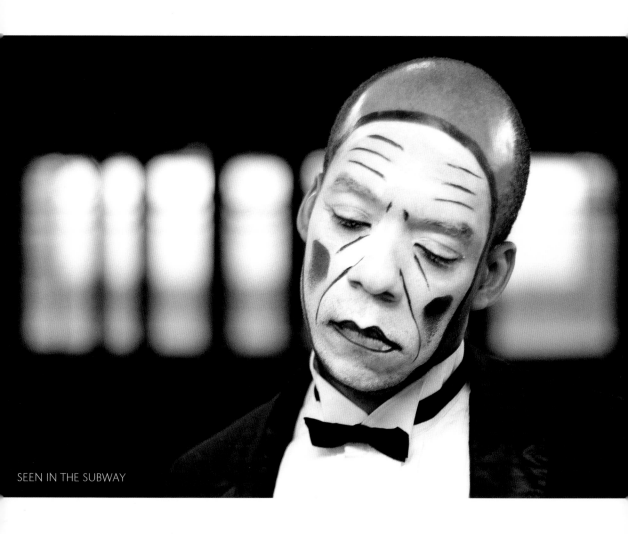

SEEN IN THE SUBWAY

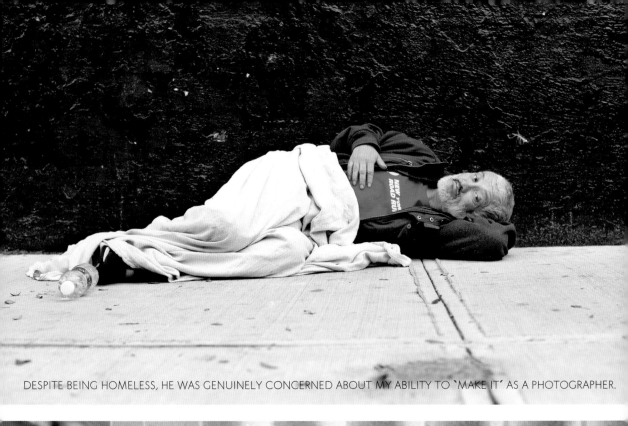

DESPITE BEING HOMELESS, HE WAS GENUINELY CONCERNED ABOUT MY ABILITY TO 'MAKE IT' AS A PHOTOGRAPHER.

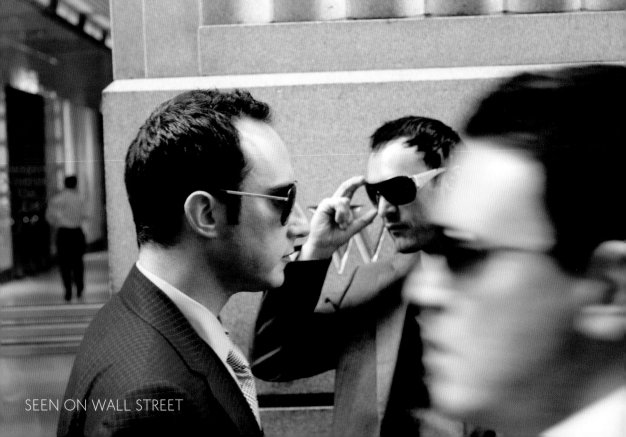

SEEN ON WALL STREET

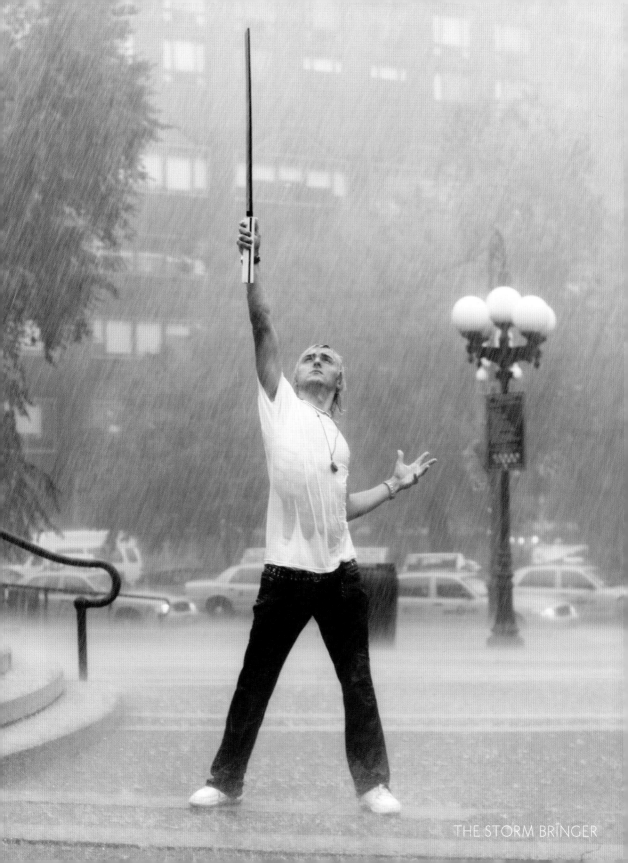

THE STORM BRINGER

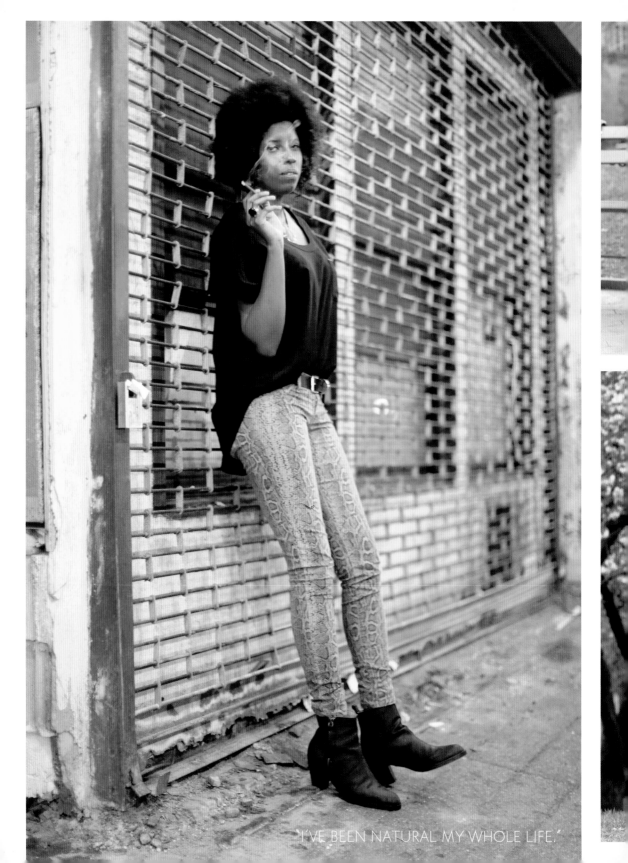

I'VE BEEN NATURAL MY WHOLE LIFE.

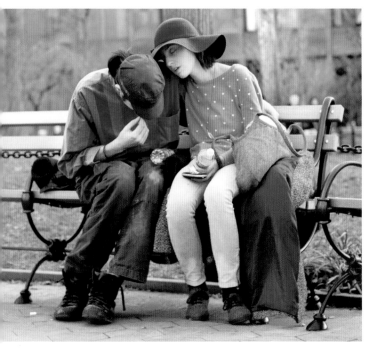

I KNEW NOTHING ABOUT THESE TWO WHEN I TOOK THEIR PHOTO IN WASHINGTON SQUARE PARK. THEY LATER BECAME A HEADLINE WHEN A CACHE OF EXPLOSIVES WAS REPORTEDLY DISCOVERED IN THEIR WEST VILLAGE APARTMENT.

INSPIRED BY NATURE

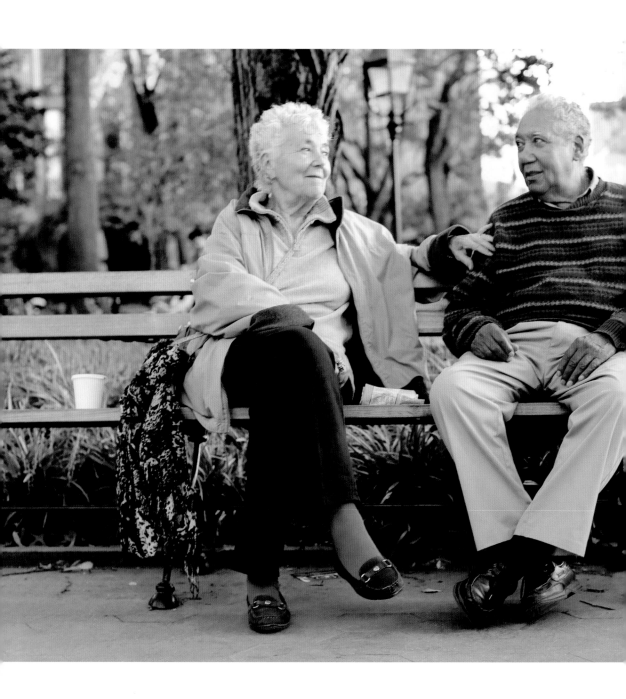

'WE WERE BOTH INVOLVED IN THE CIVIL RIGHTS MOVEMENT.
WE MET FORTY-SEVEN YEARS AGO ON A PICKET LINE.'

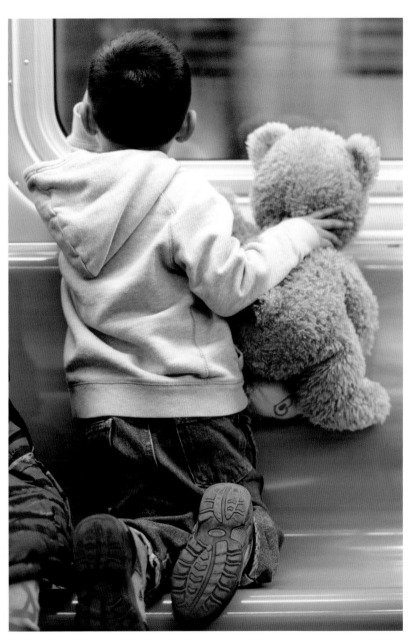

TRAVELING BUDDIES

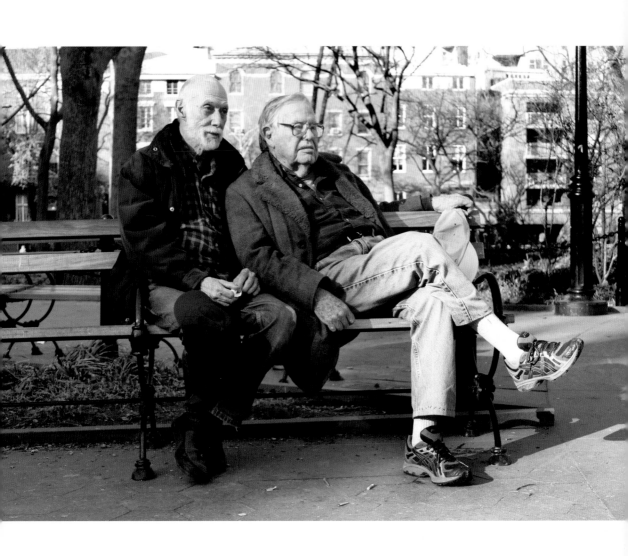

IT TAKES A LOT OF DISQUIET TO ACHIEVE THIS SORT OF QUIET COMFORT.

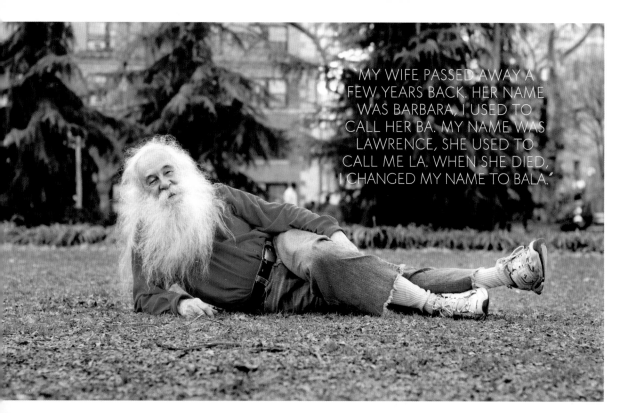

"MY WIFE PASSED AWAY A FEW YEARS BACK. HER NAME WAS BARBARA, I USED TO CALL HER BA. MY NAME WAS LAWRENCE, SHE USED TO CALL ME LA. WHEN SHE DIED, I CHANGED MY NAME TO BALA."

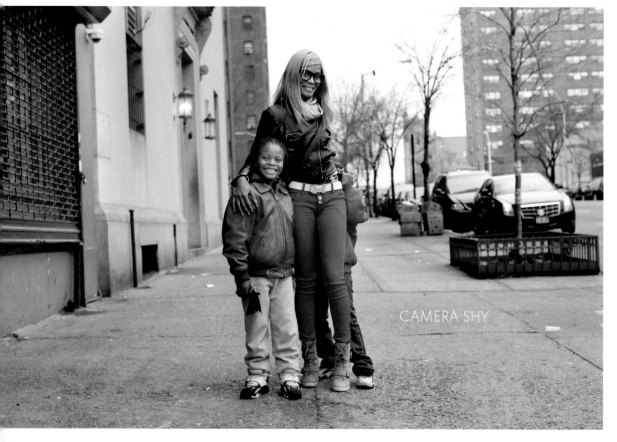

CAMERA SHY

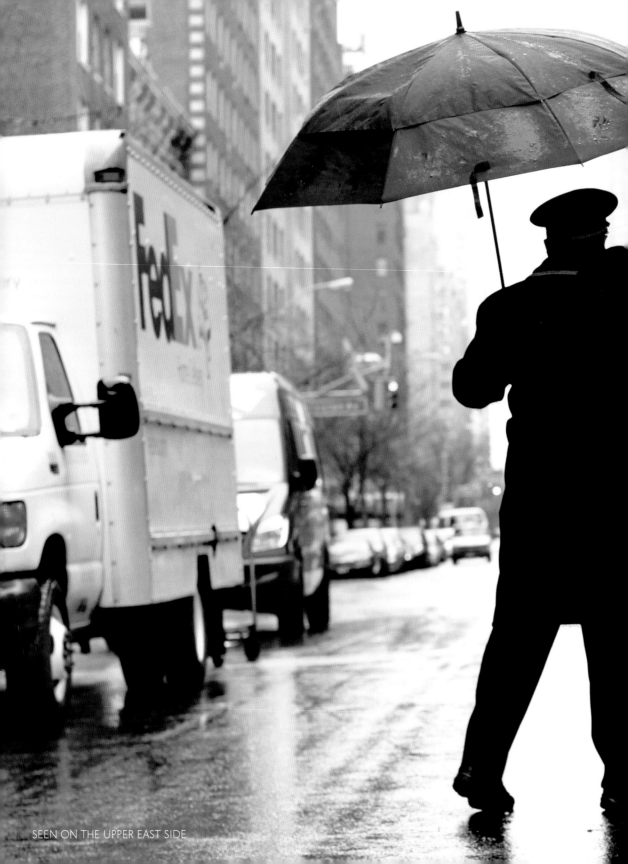

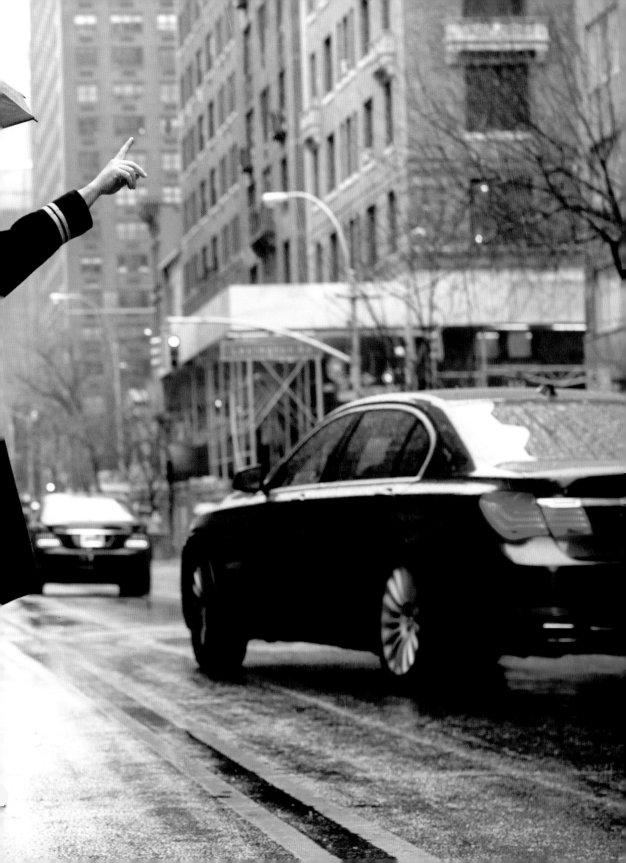

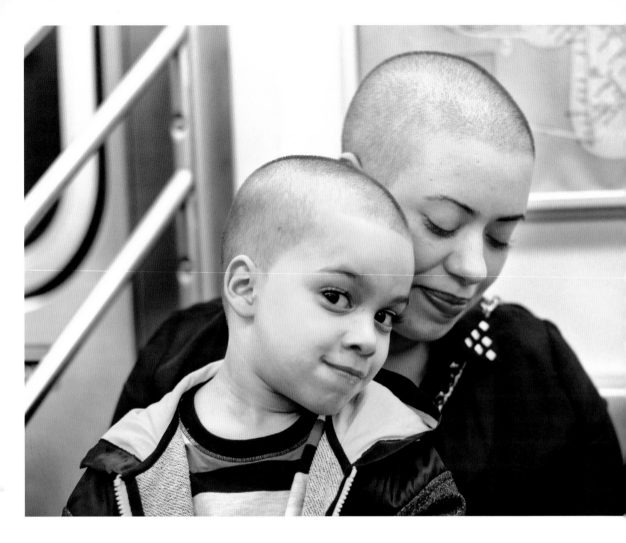

I REMEMBER TAKING AN ANTHROPOLOGY CLASS IN COLLEGE AND THE PROFESSOR WAS EXPLAINING THAT THERE IS LITTLE 'SEXUAL DIMORPHISM' IN HUMANS. HE MEANT THAT THERE ARE FEW OUTWARD, OBSERVABLE DIFFERENCES BETWEEN MALES AND FEMALES. AT THE TIME I WAS CONFUSED, SO I RAISED MY HAND. 'I FEEL LIKE IT'S VERY EASY TO TELL MEN AND WOMEN APART,' I SAID.

'THAT'S DUE TO CULTURE,' HE ANSWERED.

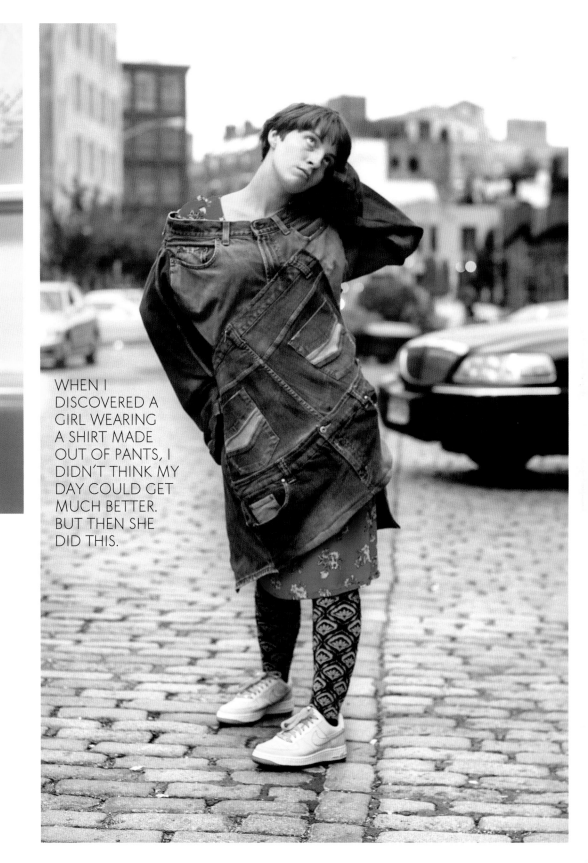

WHEN I
DISCOVERED A
GIRL WEARING
A SHIRT MADE
OUT OF PANTS, I
DIDN'T THINK MY
DAY COULD GET
MUCH BETTER.
BUT THEN SHE
DID THIS.

ARTEMIS

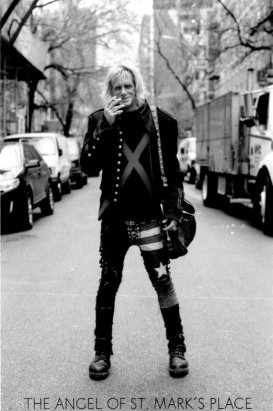

THE ANGEL OF ST. MARK'S PLACE

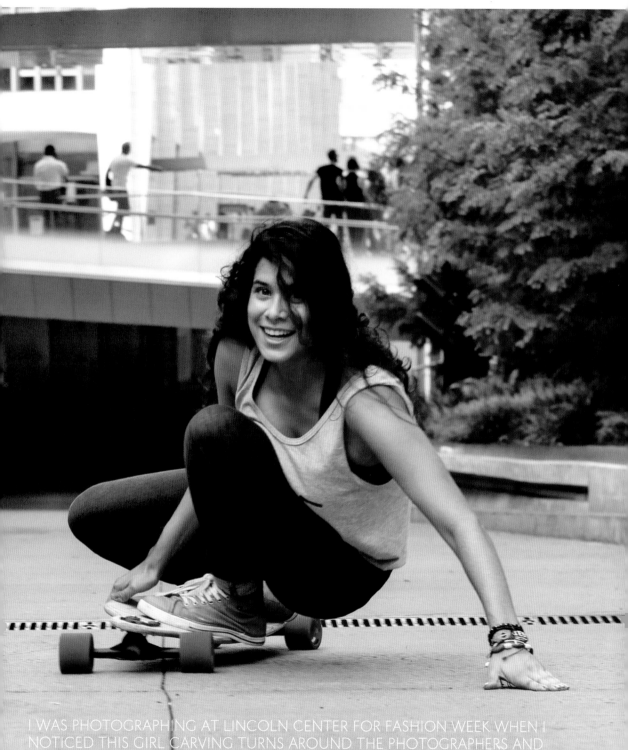

I WAS PHOTOGRAPHING AT LINCOLN CENTER FOR FASHION WEEK WHEN I NOTICED THIS GIRL CARVING TURNS AROUND THE PHOTOGRAPHERS AND MODELS. "ONE DAY," SHE TOLD ME, "I'M HOPING TO MAP OUT THE PLACES WHERE HOMELESS PEOPLE STAY. THEN I'LL GET A WHOLE GROUP OF SKATERS TO DELIVER BAGS WITH FOOD AND NECESSITIES."

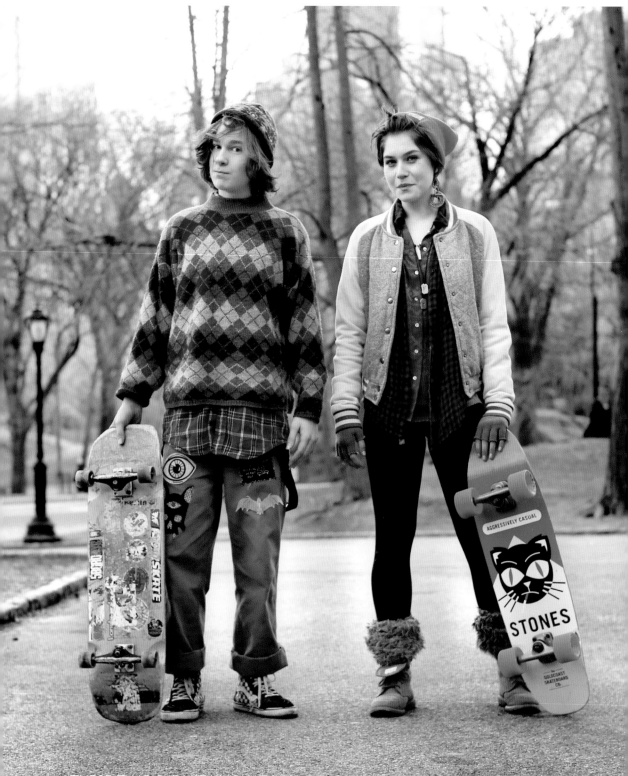

THESE TWO DIDN'T KNOW EACH OTHER, BUT I THOUGHT THEY SHOULD

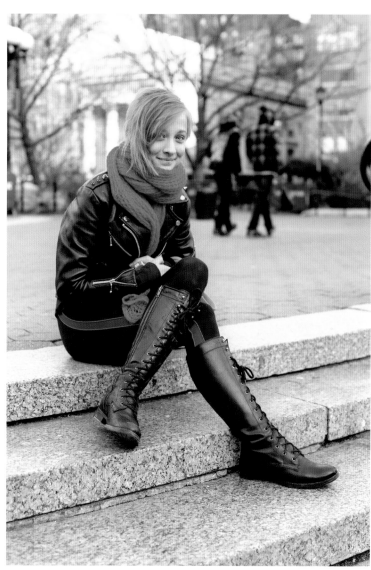

'I WAS STUDYING TO BE A BALLET DANCER, BUT NOW I'M LEARNING TO BE A TRAPEZE ARTIST.'

'WERE YOUR PARENTS UPSET ABOUT THE SWITCH?'

'NO, THEY WERE HAPPY. I FINALLY STOPPED CALLING HOME EVERY NIGHT IN TEARS.'

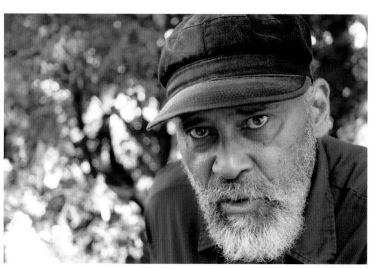

'NEW YORK HAS THE HIGHEST WASHOUT RATE OF ANY CITY IN THE COUNTRY. YOU CAN MAKE IT, BUT DON'T COME UNLESS YOU HAVE A REASON TO BE HERE.'

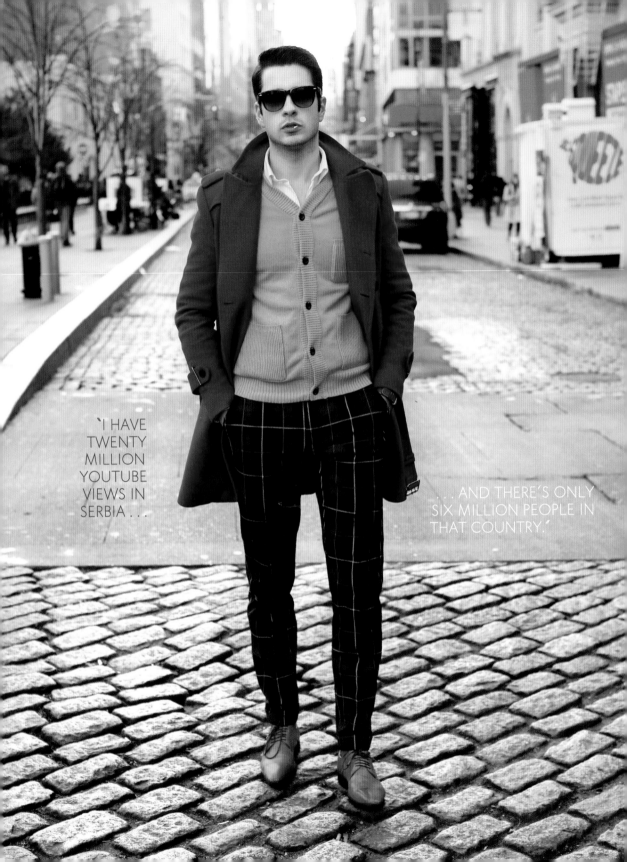

'I HAVE
TWENTY
MILLION
YOUTUBE
VIEWS IN
SERBIA . . .

. . . AND THERE'S ONLY
SIX MILLION PEOPLE IN
THAT COUNTRY.'

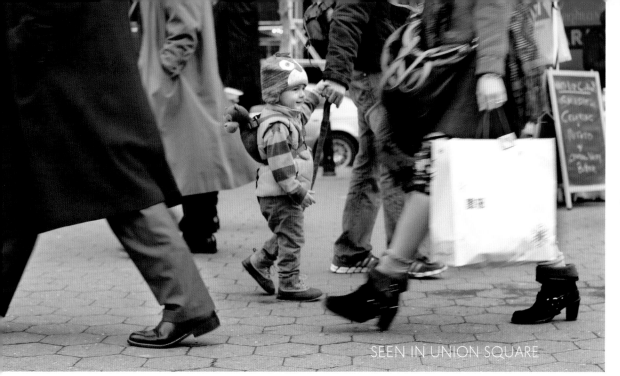

SEEN IN UNION SQUARE

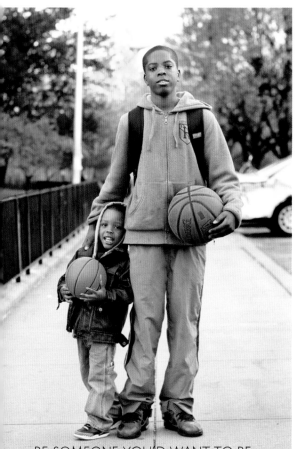

BE SOMEONE YOU'D WANT TO BE.

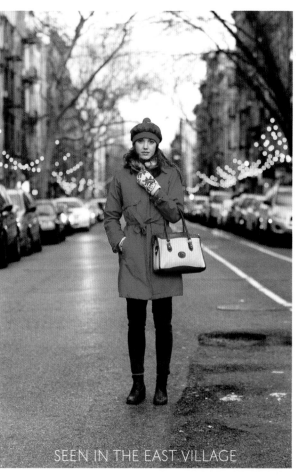

SEEN IN THE EAST VILLAGE

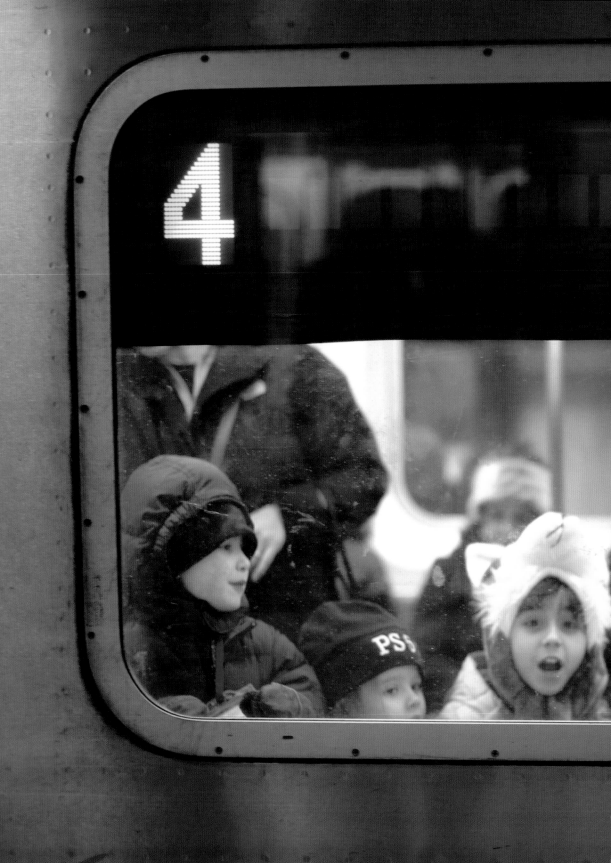

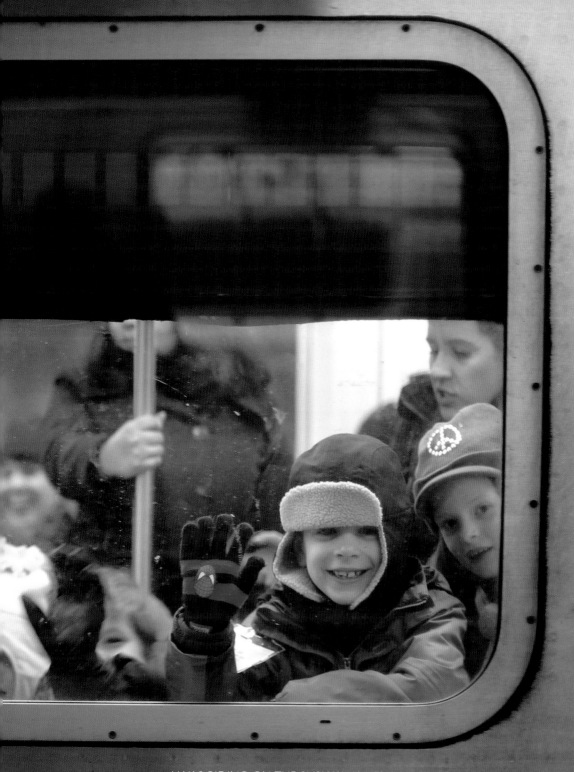

I WAS RIDING ON THE SUBWAY WHEN I NOTICED EVERYONE IN THE SEAT ACROSS FROM ME WAS TURNED AROUND, LOOKING OUT THE WINDOW. SENSING A PHOTO OPPORTUNITY, I HOPPED OUT AT THE NEXT STOP.

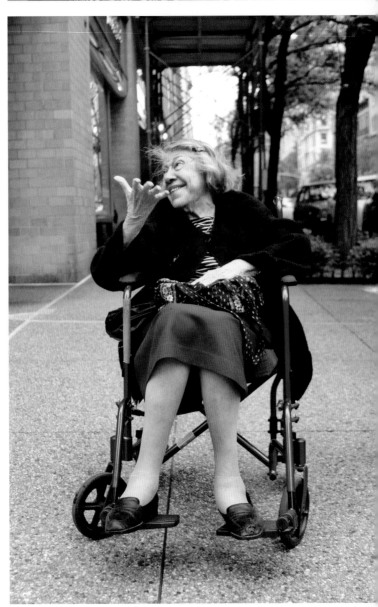

"EVERY TIME
I FORCE
MYSELF TO
GO OUTSIDE,
SOMETHING
WONDERFUL
HAPPENS!"

"EXCUSE ME, IS
THERE ANY WAY I
CAN TAKE YOUR
PHOTO? I RUN
A BLOG CALLED
HUMANS OF
NEW YORK, AND
I'M TRYING TO
DOCUMENT
ALL THE
NEIGHBORHOODS
OF NEW YORK BY
PHOTOGRAPHING
THE PEOPLE WHO
LIVE THERE."

"I DIDN'T HEAR
A WORD YOU
JUST SAID."

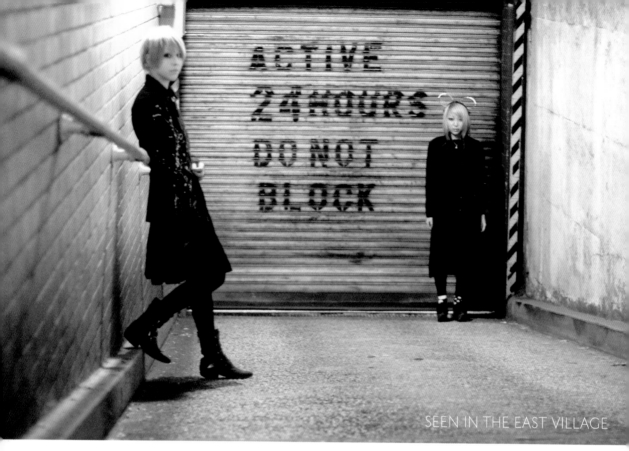

SEEN IN THE EAST VILLAGE

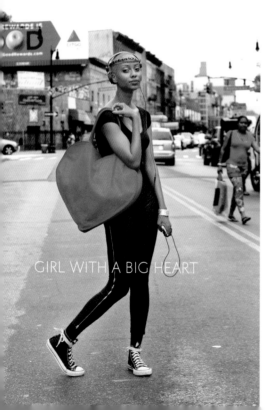

GIRL WITH A BIG HEART

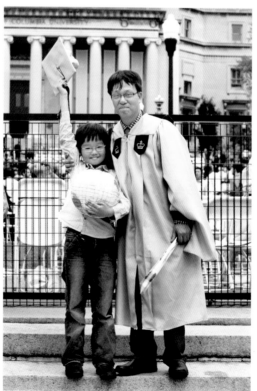

TO THE WORLD YOU MAY BE ONE PERSON, BUT TO ONE PERSON YOU MAY BE THE WORLD.

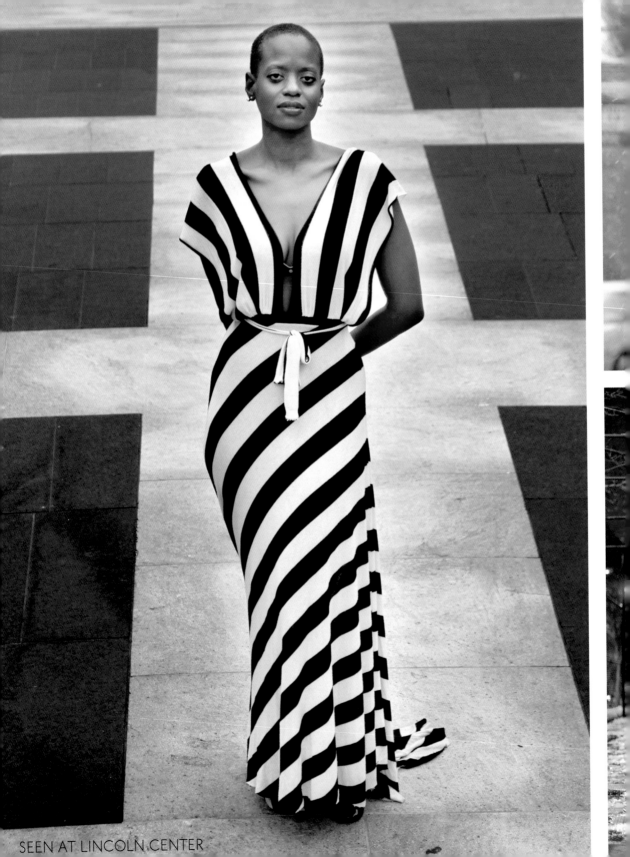

SEEN AT LINCOLN CENTER

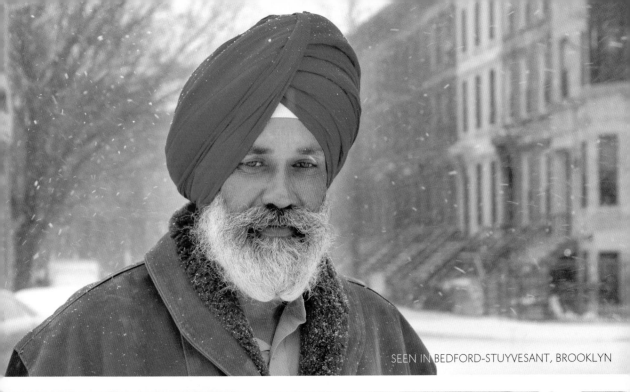

SEEN IN BEDFORD-STUYVESANT, BROOKLYN

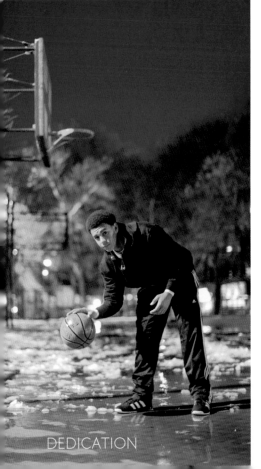

DEDICATION

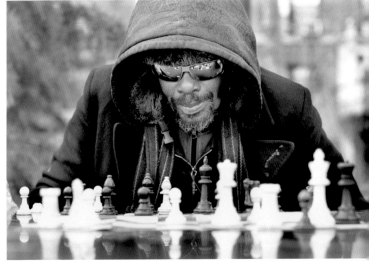

"YOU CAN PHOTOGRAPH ME COUNTING
MY MONEY, IF YOU'D LIKE."

I SAW THEM WALKING ON TWO OPPOSITE ENDS OF THE PLAZA,
AND STARTED PRAYING THAT THEY'D END UP IN THE SAME PLACE.

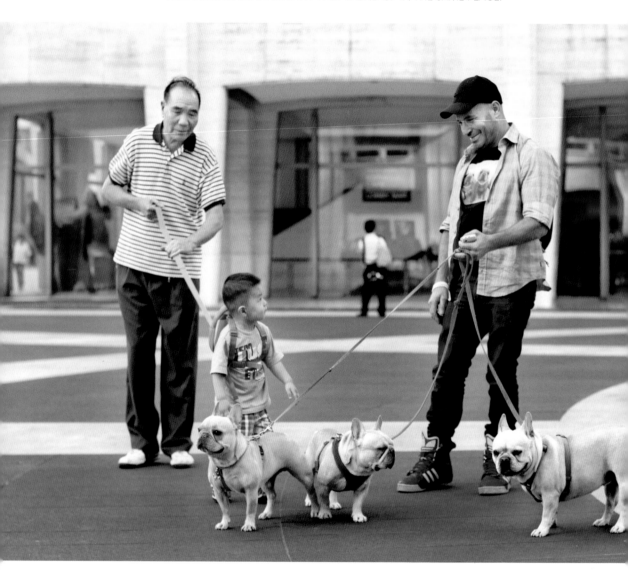

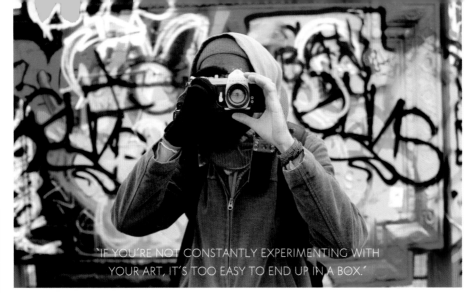

"IF YOU'RE NOT CONSTANTLY EXPERIMENTING WITH YOUR ART, IT'S TOO EASY TO END UP IN A BOX."

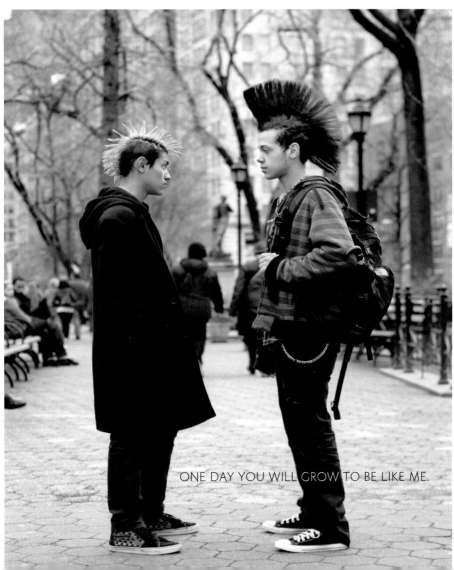

ONE DAY YOU WILL GROW TO BE LIKE ME.

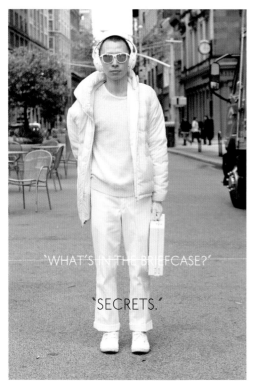

"WHAT'S IN THE BRIEFCASE?"

"SECRETS."

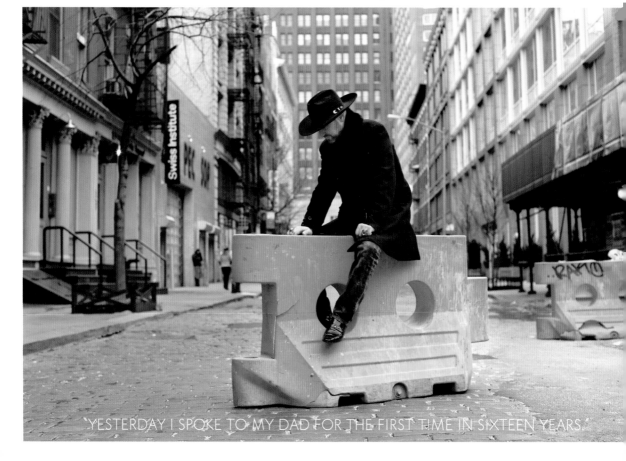

"YESTERDAY I SPOKE TO MY DAD FOR THE FIRST TIME IN SIXTEEN YEARS."

'MY MOTHER'S ASHES
ARE IN THERE.'

'TELL ME SOMETHING
ABOUT HER.'

'SHE WAS AN AMAZING
POET. SHE WOULDN'T LET
ANYONE READ HER POEMS,
THOUGH. WE KNEW SHE
WAS WRITING THEM, BUT
SHE WOULDN'T LET US
READ THEM. I FOUND
THEM ON HER COMPUTER
AFTER SHE DIED. THEY
WERE SO BEAUTIFUL—I
COULDN'T BELIEVE SHE
WROTE THEM.'

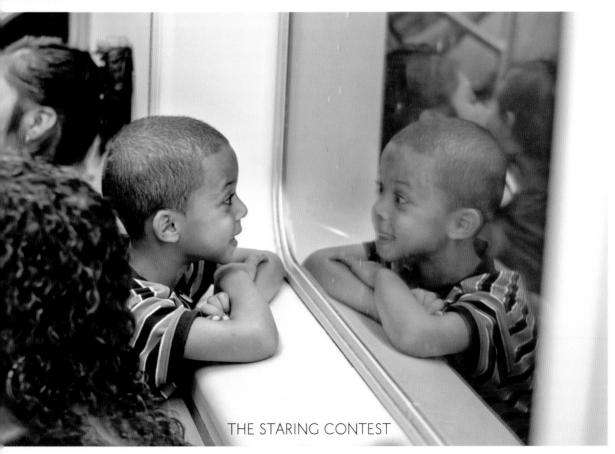

THE STARING CONTEST

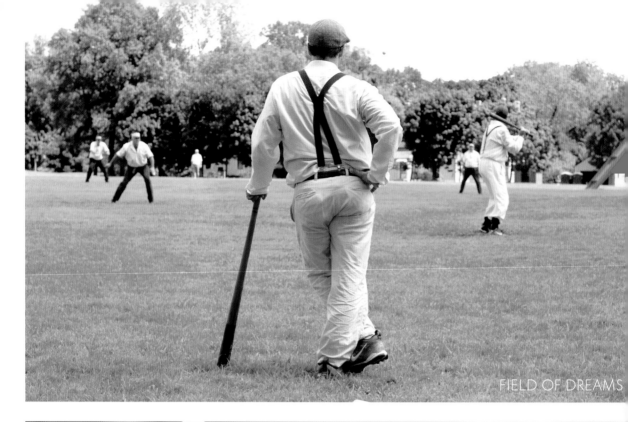

FIELD OF DREAMS

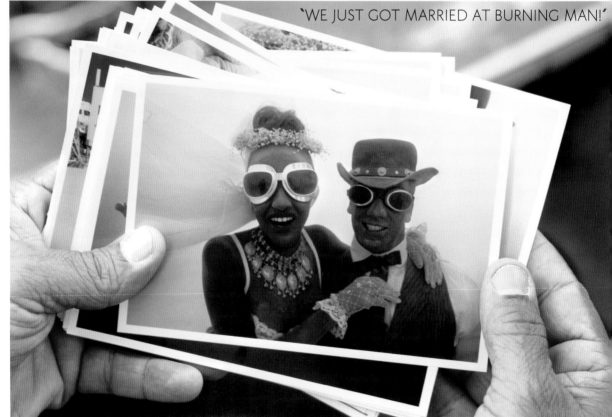

"WE JUST GOT MARRIED AT BURNING MAN!"

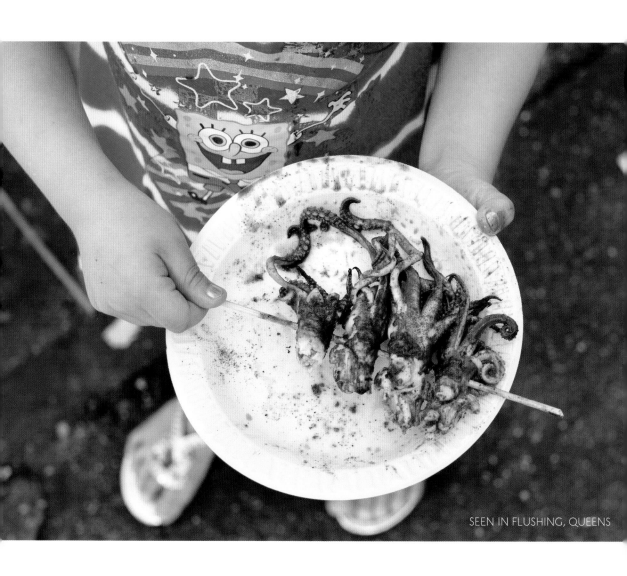

SEEN IN FLUSHING, QUEENS

I'M PRETTY SURE THAT BAG HAS A FACE. _____

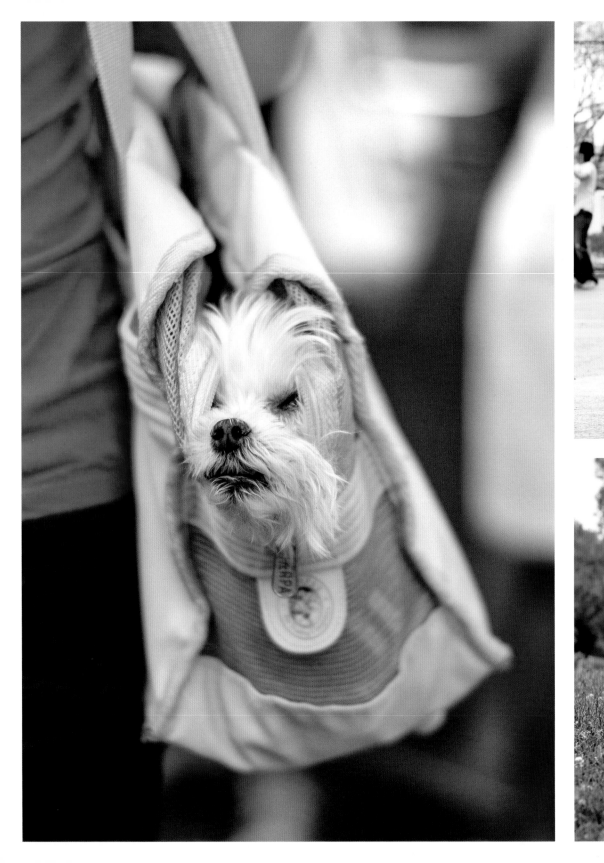

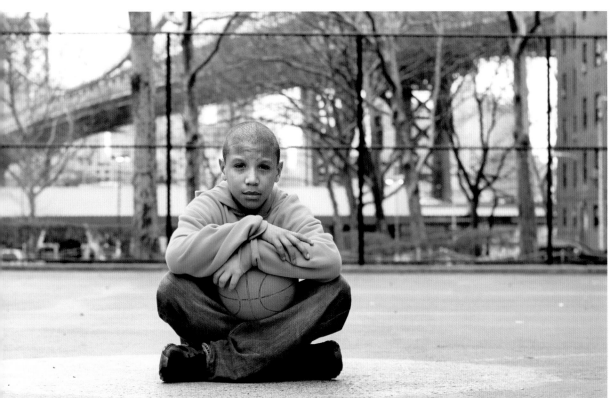

IN SOME NEIGHBORHOODS, FACES MATURE FASTER THAN BODIES.

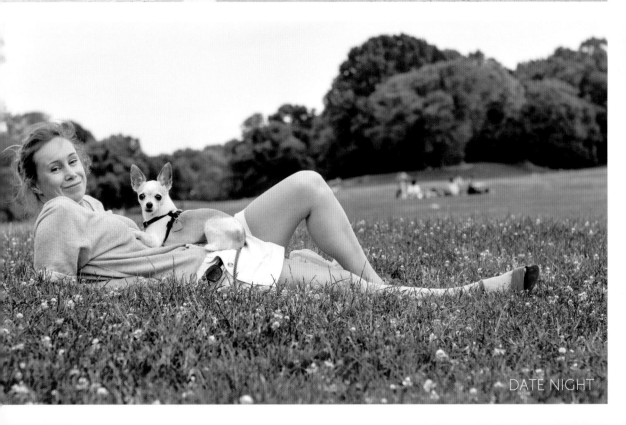

DATE NIGHT

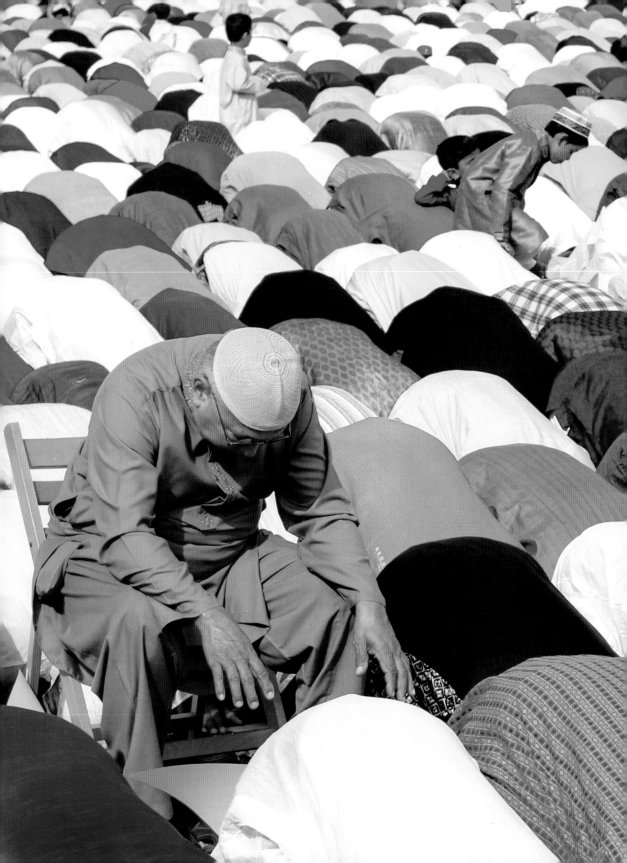

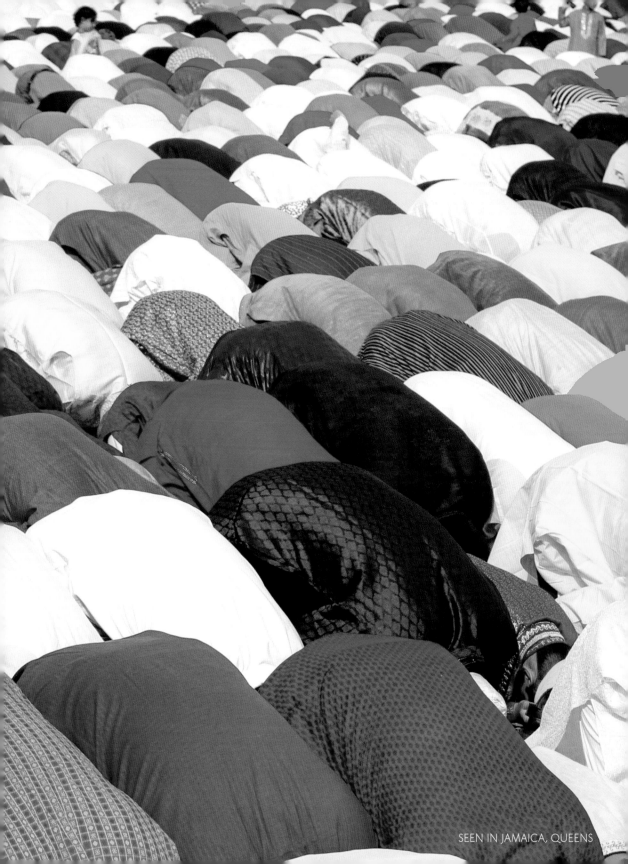

SEEN IN JAMAICA, QUEENS

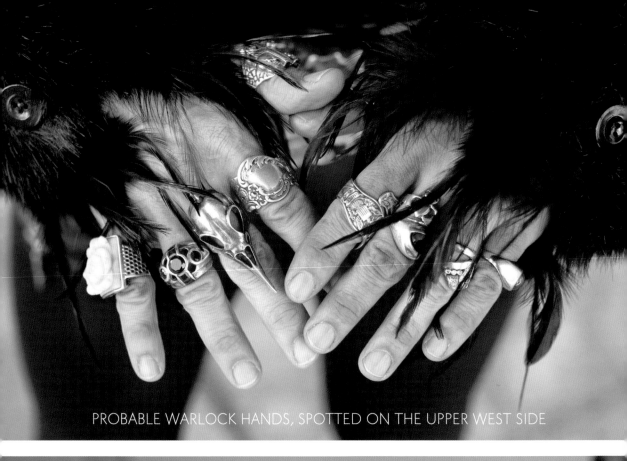

PROBABLE WARLOCK HANDS, SPOTTED ON THE UPPER WEST SIDE

SEEN AT THE METROPOLITAN MUSEUM OF ART

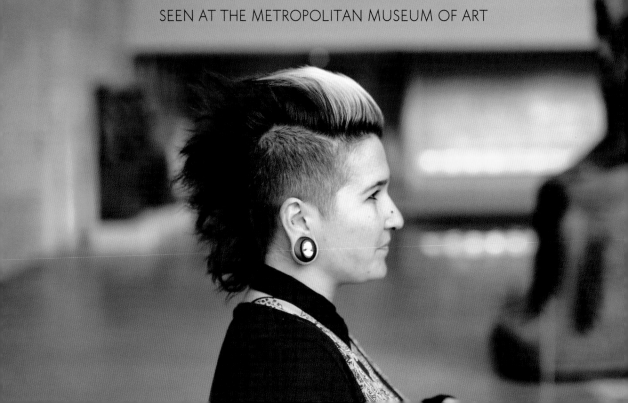

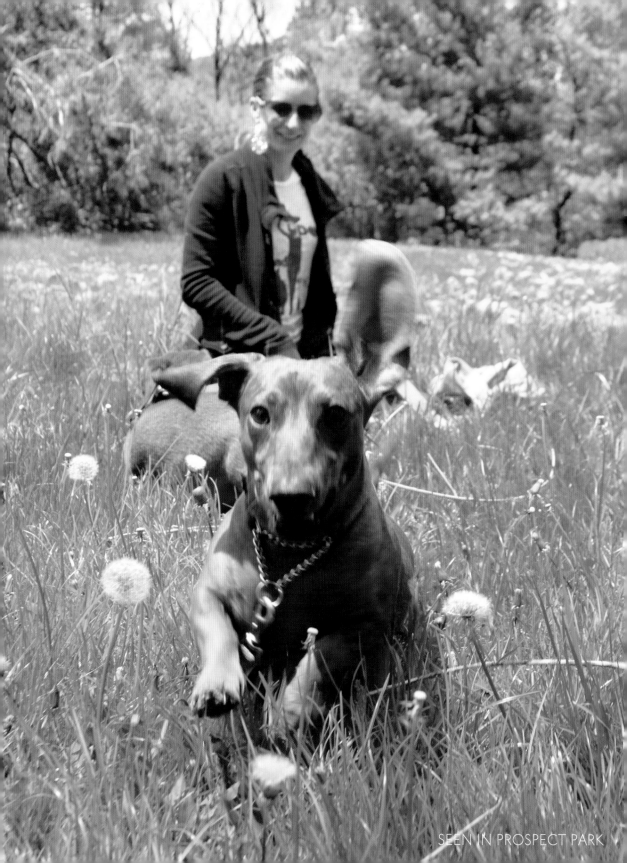

"MY HOUSE BLEW INTO THE OCEAN."

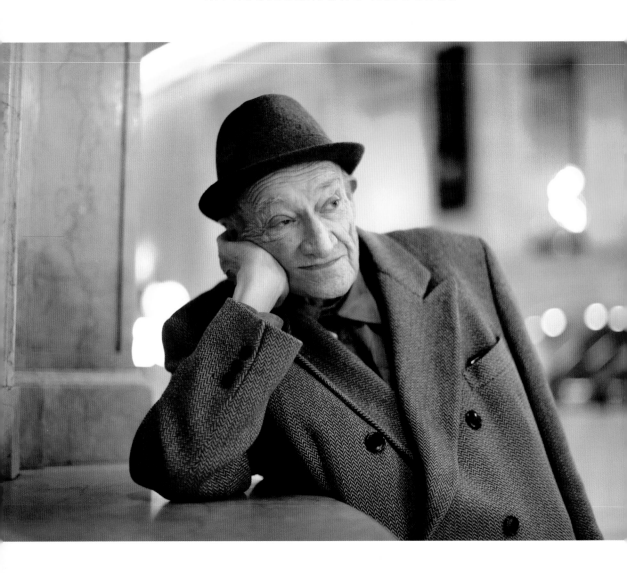

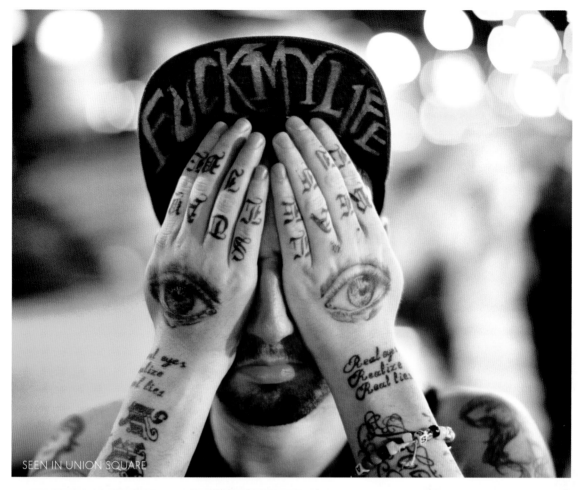

SEEN IN UNION SQUARE

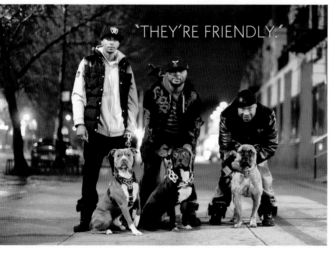

"THEY'RE FRIENDLY."

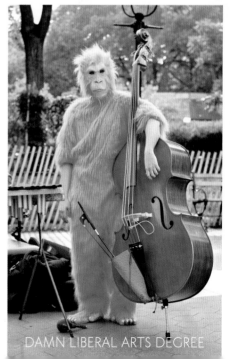

DAMN LIBERAL ARTS DEGREE

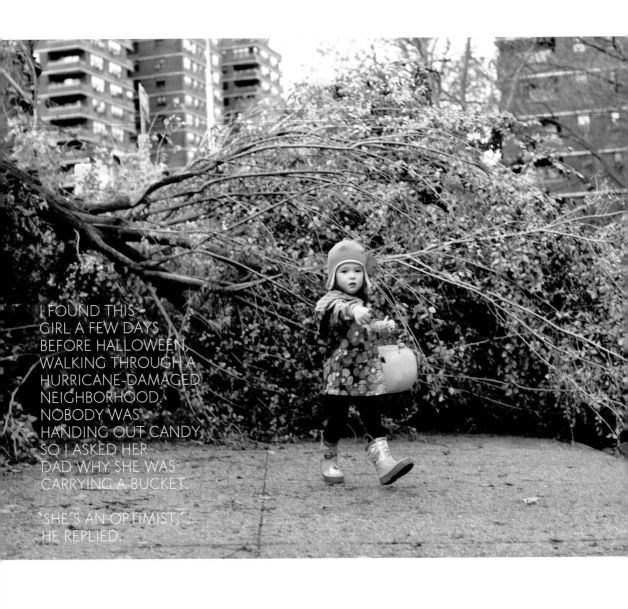

I FOUND THIS
GIRL A FEW DAYS
BEFORE HALLOWEEN,
WALKING THROUGH A
HURRICANE-DAMAGED
NEIGHBORHOOD.
NOBODY WAS
HANDING OUT CANDY,
SO I ASKED HER
DAD WHY SHE WAS
CARRYING A BUCKET.

"SHE'S AN OPTIMIST,"
HE REPLIED.

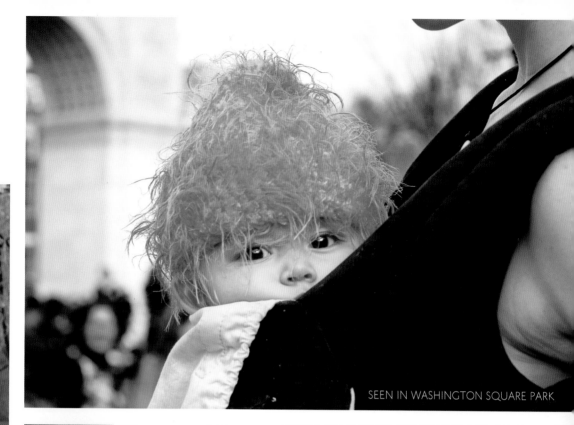

SEEN IN WASHINGTON SQUARE PARK

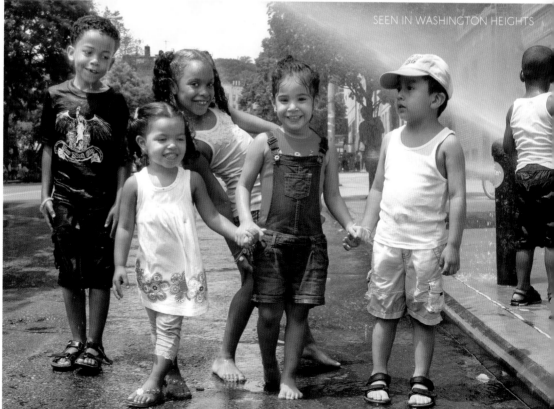

SEEN IN WASHINGTON HEIGHTS

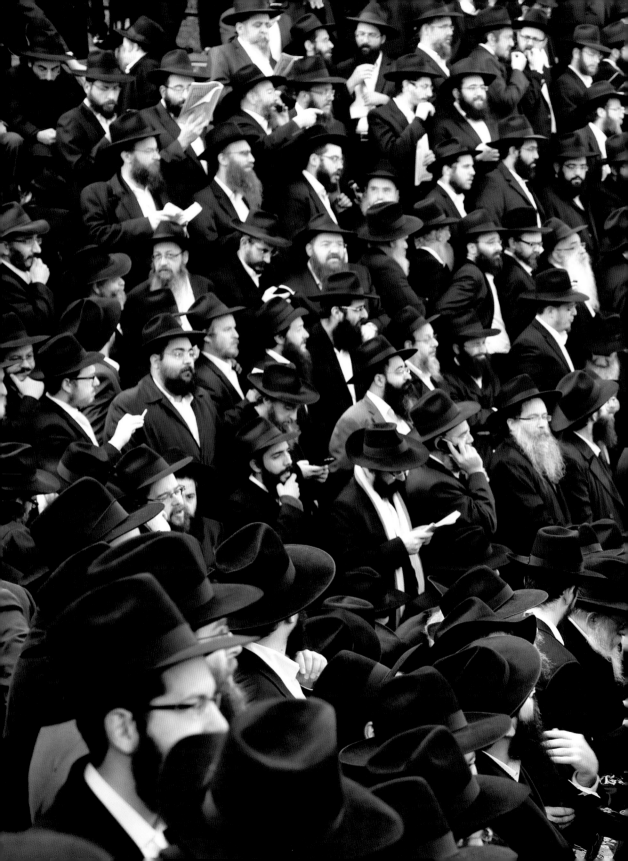

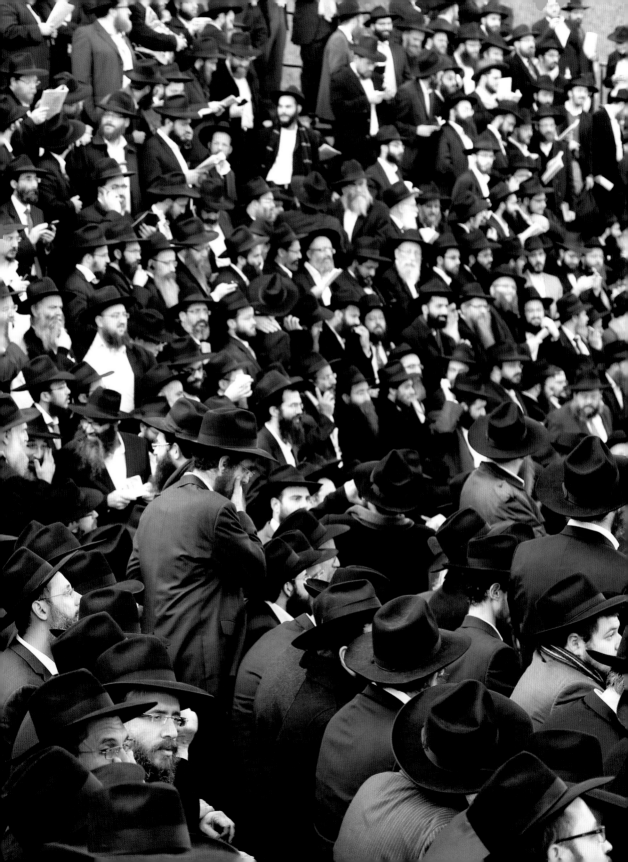

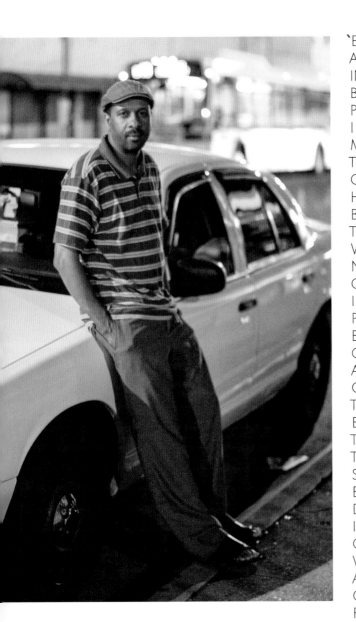

'EVERYONE WHO SEES MY RÉSUMÉ ASKS ME WHY I DRIVE A CAB. BACK IN NIGER, I WAS A FRENCH TEACHER. BUT THE GOVERNMENT STOPPED PAYING US FOR A FEW MONTHS, SO I DECIDED TO QUIT MY JOB AND MOVE TO AMERICA. THAT WAS TWELVE YEARS AGO. I THOUGHT I COULD TEACH FRENCH HERE, BUT I HAD NO IDEA HOW HARD IT WOULD BE TO GET A JOB WITHOUT PAPERS. THE ONLY PLACE I COULD FIND WORK WAS A CAR WASH. BACK IN NIGER, KIDS WOULD WASH MY CAR FOR ME. NOW ALL DAY LONG I WAS WASHING CARS FOR OTHER PEOPLE. I WAS VERY DEPRESSED. BUT I WAS TOO EMBARRASSED TO GO BACK HOME. THEN, ONE YEAR AFTER I ARRIVED, GEORGE BUSH GOT ELECTED AND EVERYONE WAS TELLING ME THAT IT MEANT VERY BAD THINGS FOR ME. THEY SAID THE REPUBLICANS WOULD MAKE TROUBLE FOR ME. SO I WAS VERY SCARED. AFTER THE CAR WASH, I BECAME A STOCK BOY. THEN, A DELIVERY DRIVER. FIVE YEARS AGO, I GOT MY PAPERS AND BECAME A CITIZEN, SO NOW I'M ABLE TO WORK AT THE AIRPORT. AT NIGHT, AND ON MY DAYS OFF, I DRIVE A CAB. JUST THIS YEAR I GRADUATED FROM BROOKLYN COLLEGE WITH A MASTER'S DEGREE IN FRENCH. I FINISHED THIRD IN MY CLASS. NOW I THINK I CAN BECOME A PROFESSOR.'

DISCOVERED THESE GUYS IN BREEZY POINT, QUEENS, AFTER HURRICANE SANDY. WHEN I WALKED UP, THEY WERE IN THE PROCESS OF DISMOUNTING FROM THE BOAT. BUT THEY HELPED ME OUT BY PILING BACK IN FOR THE PHOTO OP.

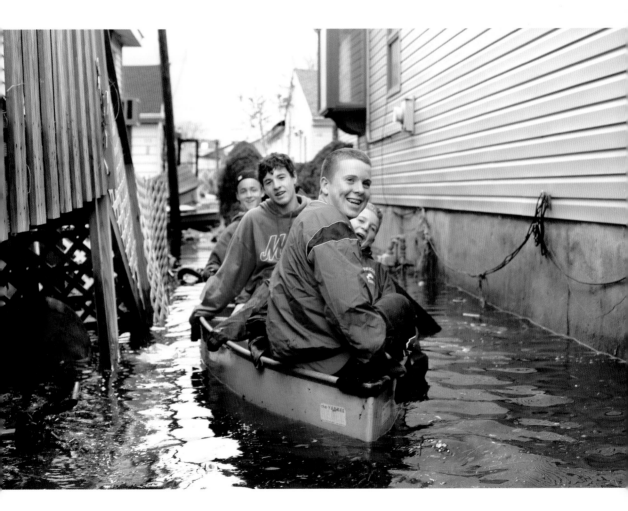

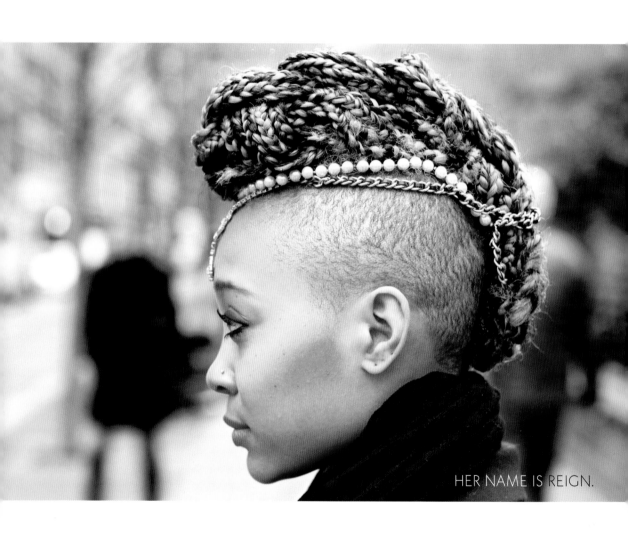

HER NAME IS REIGN.

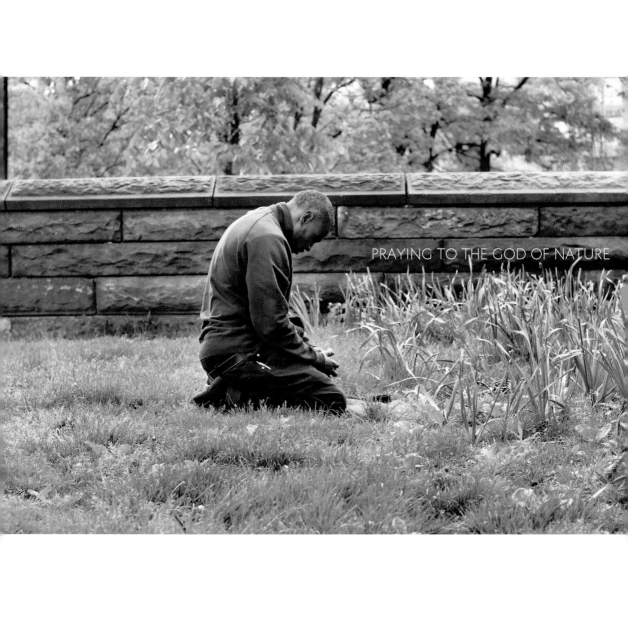

PRAYING TO THE GOD OF NATURE

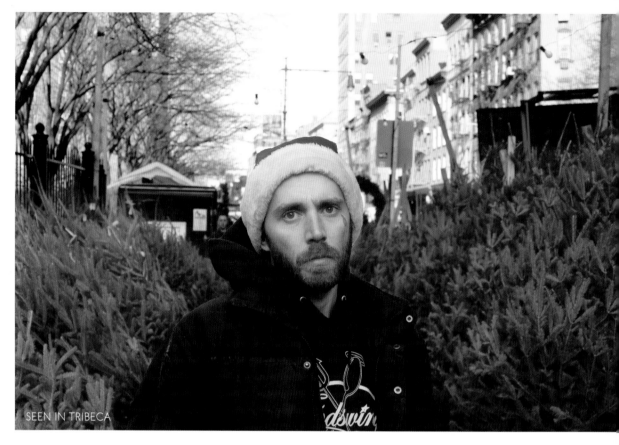

SEEN IN TRIBECA

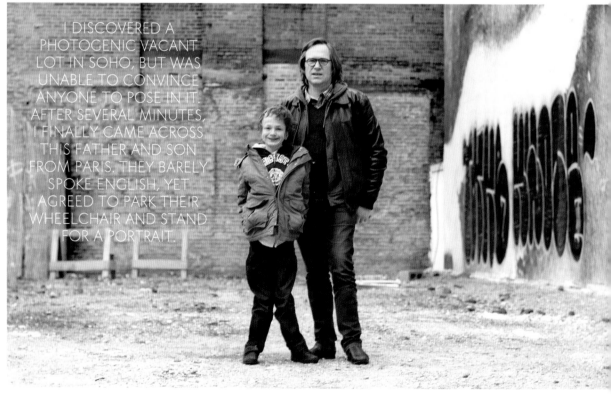

I DISCOVERED A PHOTOGENIC VACANT LOT IN SOHO, BUT WAS UNABLE TO CONVINCE ANYONE TO POSE IN IT. AFTER SEVERAL MINUTES, I FINALLY CAME ACROSS THIS FATHER AND SON FROM PARIS. THEY BARELY SPOKE ENGLISH, YET AGREED TO PARK THEIR WHEELCHAIR AND STAND FOR A PORTRAIT.

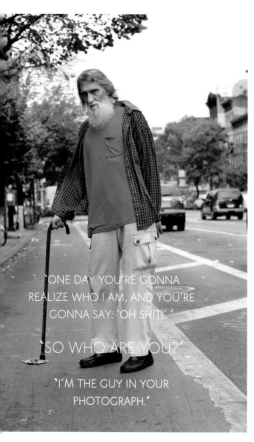

"ONE DAY YOU'RE GONNA REALIZE WHO I AM, AND YOU'RE GONNA SAY: 'OH SHIT!' "

"SO WHO ARE YOU?"

"I'M THE GUY IN YOUR PHOTOGRAPH."

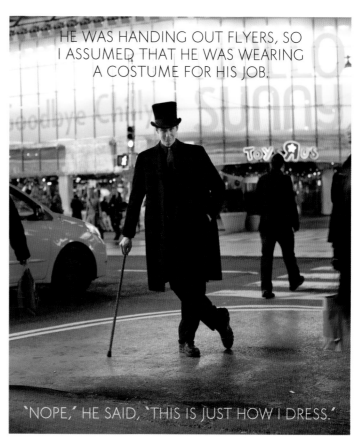

HE WAS HANDING OUT FLYERS, SO I ASSUMED THAT HE WAS WEARING A COSTUME FOR HIS JOB.

"NOPE," HE SAID, "THIS IS JUST HOW I DRESS."

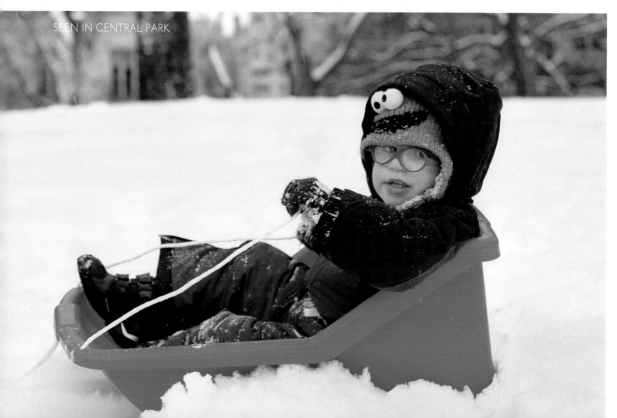

SEEN IN CENTRAL PARK

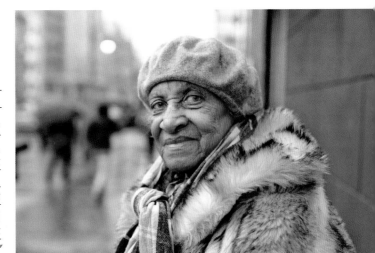

"I JUST GOT BACK FROM THE EYE DOCTOR. I HOPE HE CAN SAVE THEM."

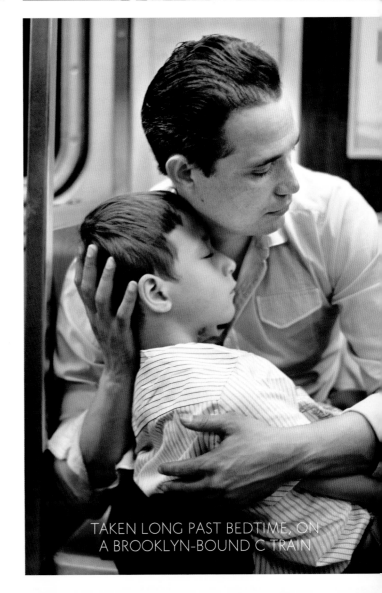

TAKEN LONG PAST BEDTIME, ON A BROOKLYN-BOUND C TRAIN

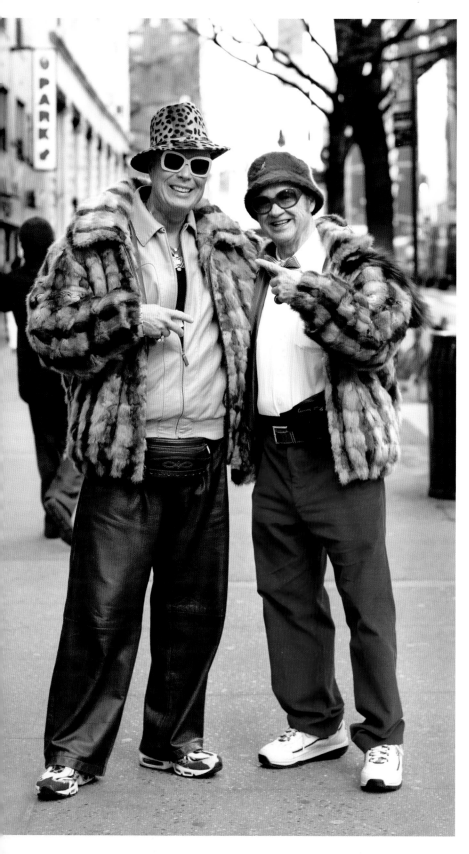

ON THE LEFT
WE HAVE
DONNY
DIAMONDS,
WORLD-CLASS
BILLIARDS
PLAYER.
ON THE RIGHT
WE HAVE
DOC ASTRO,
INTERNATIONAL
SLINGSHOT
CHAMPION.
I'M NOT
MAKING
THIS UP.

I WAS STANDING ON A BRONX SUBWAY PLATFORM WHEN A TRAIN PULLED INTO THE STATION. I NOTICED THESE TWO PUTTING ON QUITE A SHOW IN ONE OF THE WINDOWS. I SCRAMBLED FOR MY CAMERA, AND MANAGED TO SNAP ONE SHOT BEFORE THEY PULLED AWAY.

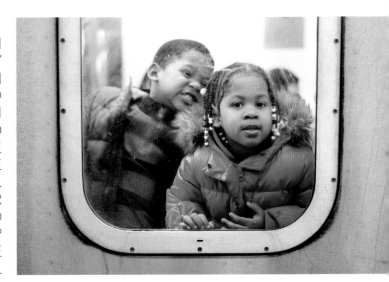

THIS KID LOOKS BETTER WALKING HOME FROM SCHOOL THAN I'VE EVER LOOKED IN MY LIFE.

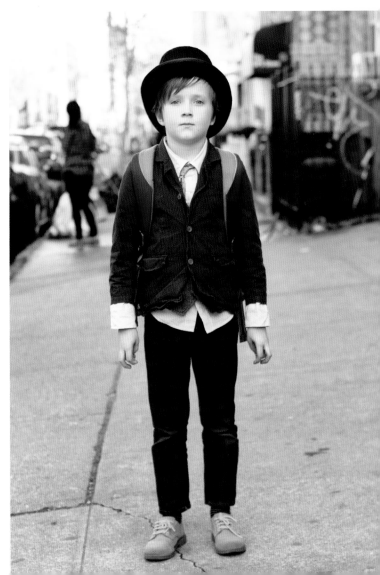

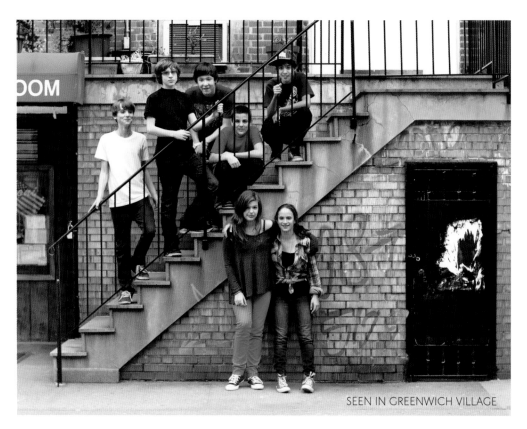

SEEN IN GREENWICH VILLAGE

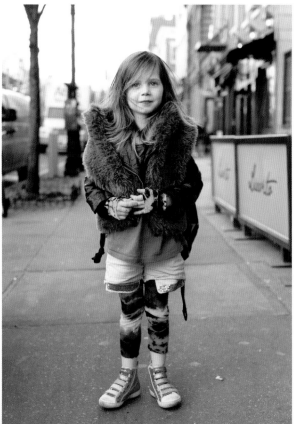

"WE ORDERED
HER THOSE PANTS,
AND AS SOON
AS THEY ARRIVED,
SHE CUT OFF THE
BOTTOMS AND
MADE A PAIR OF
GLOVES."

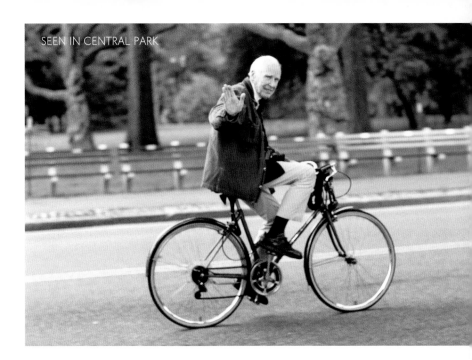

I FLAGGED THIS MAN DOWN WHILE HE WAS JOGGING ACROSS THE BROOKLYN BRIDGE. HE TURNED OUT TO BE A JAPANESE BOXER. HE THOUGHT I WAS LAUGHING AT HIM WHILE I WAS SETTING UP THE SHOT, BUT I ASSURED HIM THAT I WAS ONLY LAUGHING AT HOW AWESOME HE LOOKED.

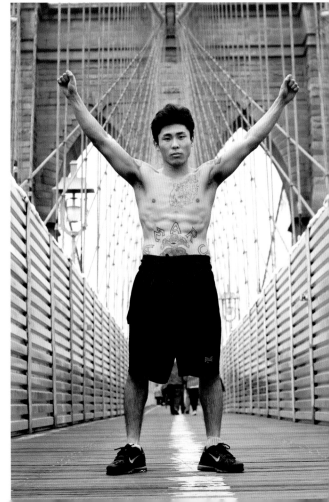

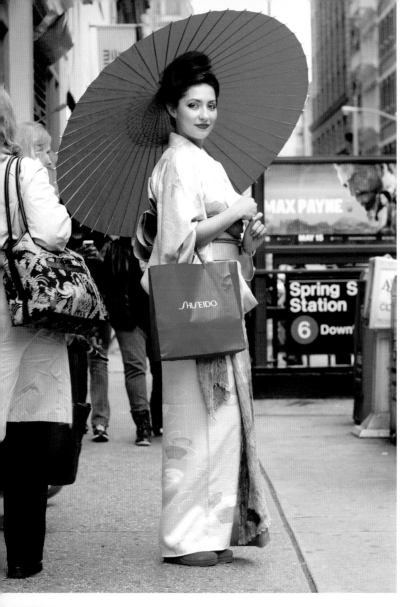

'MAKE SURE
YOU CAN SEE
THE BAG.'

'OH, I DIDN'T
REALIZE
YOU WERE
ADVERTISING
SOMETHING.'

'ISN'T
EVERYTHING
BEAUTIFUL
ADVERTISING
SOMETHING?'

SEEN ON THE SUBWAY

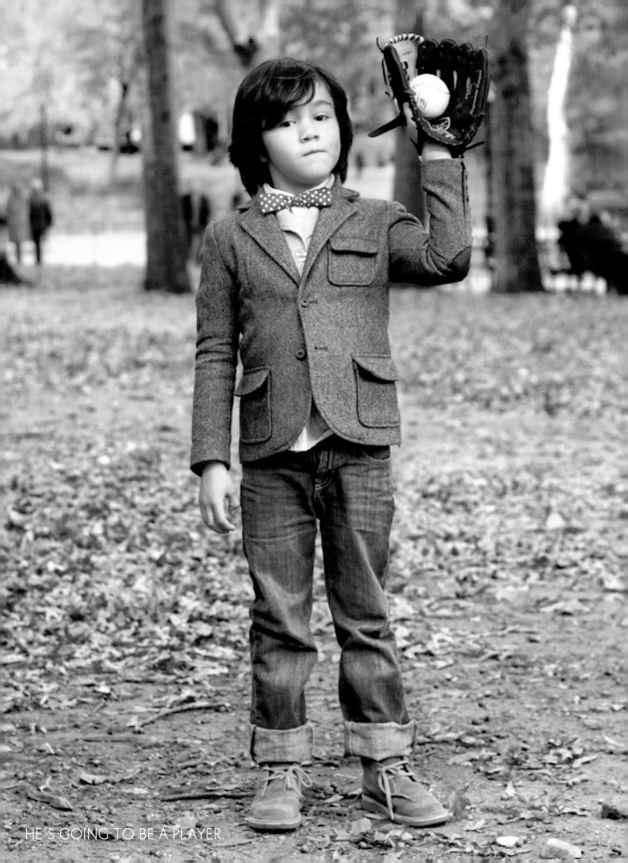

HE'S GOING TO BE A PLAYER.

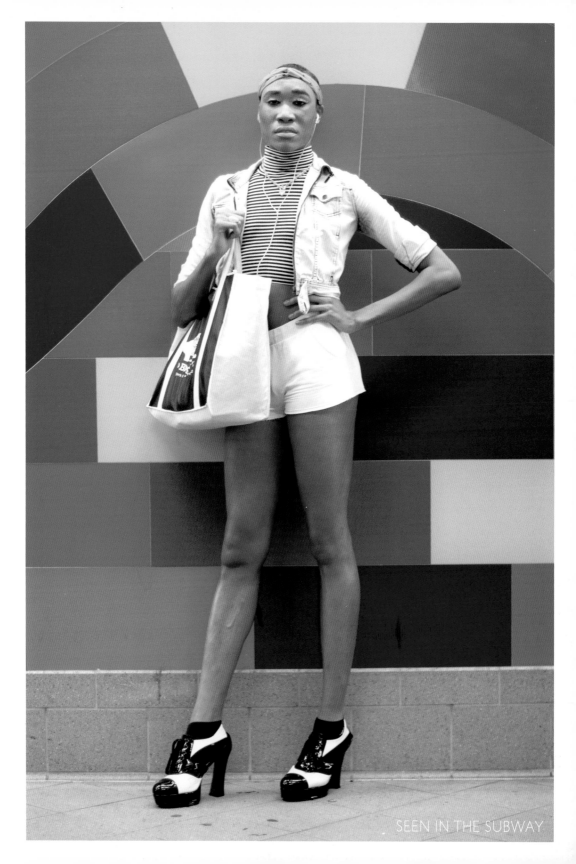

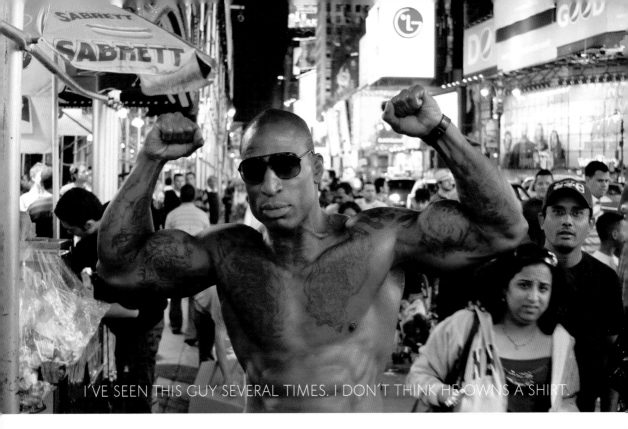

I'VE SEEN THIS GUY SEVERAL TIMES. I DON'T THINK HE OWNS A SHIRT.

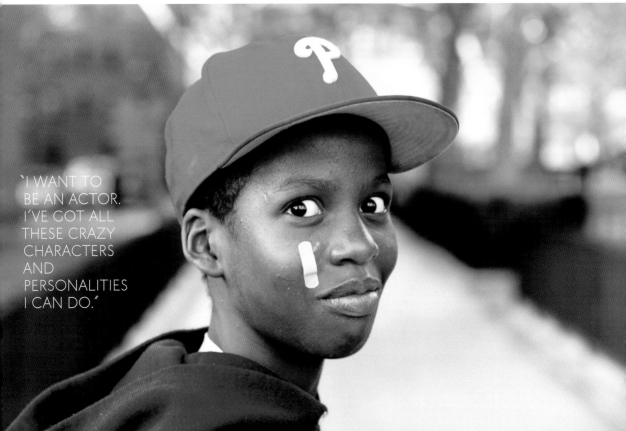

'I WANT TO BE AN ACTOR. I'VE GOT ALL THESE CRAZY CHARACTERS AND PERSONALITIES I CAN DO.'

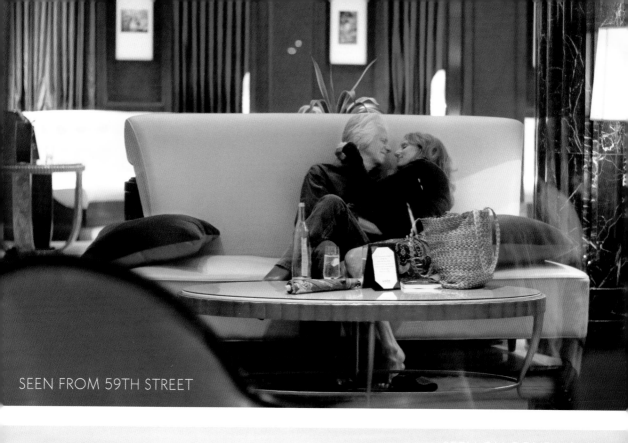

SEEN FROM 59TH STREET

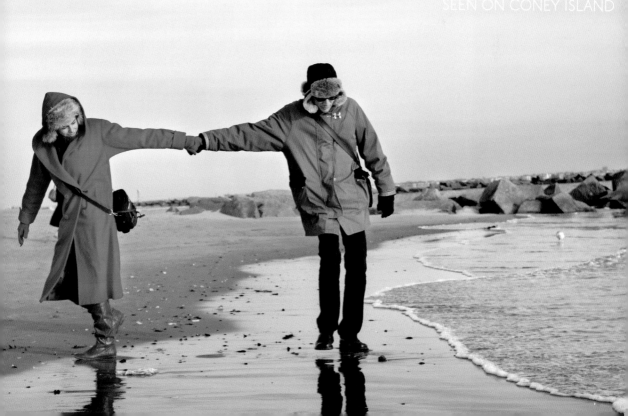

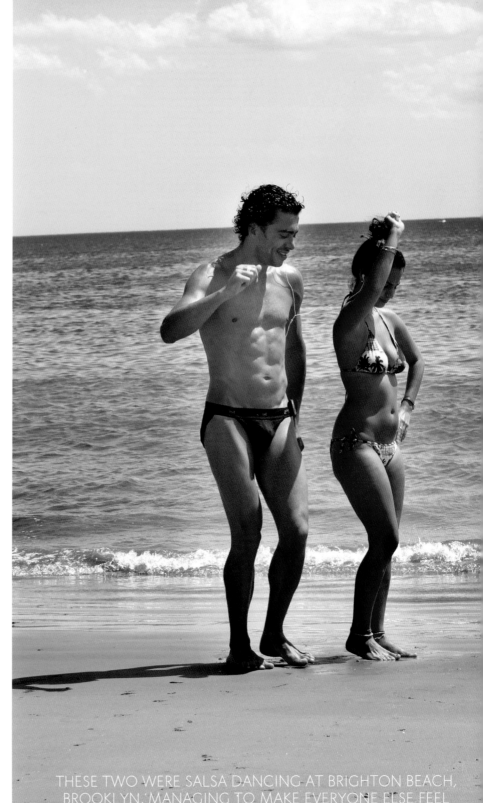

THESE TWO WERE SALSA DANCING AT BRIGHTON BEACH, BROOKLYN, MANAGING TO MAKE EVERYONE ELSE FEEL SIMULTANEOUSLY UGLY AND UNCOORDINATED.

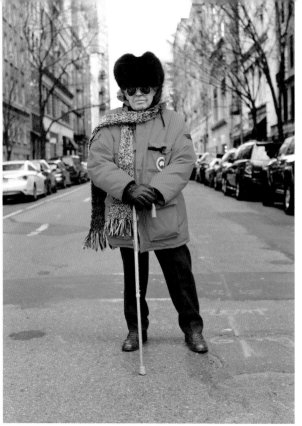

"I FOUGHT FOR TWENTY-SIX MONTHS. EIGHT COUNTRIES. THREE DIFFERENT UNITS. SIX CAMPAIGNS. ONE INVASION. THE FRENCH GAVE ME THE LEGION OF HONOR. THE U.S. GAVE ME THE BRONZE STAR. AND THE RUSSIANS GAVE ME THE ORDER OF THE GREAT PATRIOTIC WAR."

"IS THAT YOU?"

"KINDA."

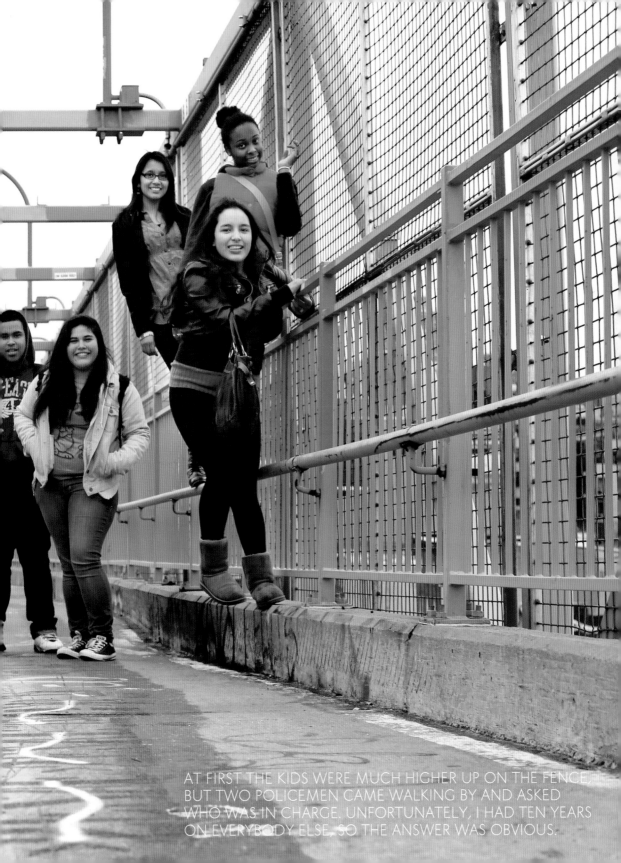

AT FIRST THE KIDS WERE MUCH HIGHER UP ON THE FENCE, BUT TWO POLICEMEN CAME WALKING BY AND ASKED WHO WAS IN CHARGE. UNFORTUNATELY, I HAD TEN YEARS ON EVERYBODY ELSE, SO THE ANSWER WAS OBVIOUS.

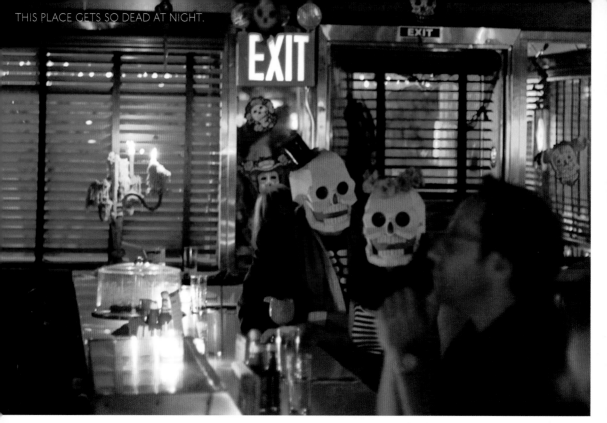

ONE AMAZING THING ABOUT NEW YORK IS THAT YOU PASS ALL THESE PEOPLE WITH ULTRA-MODERN CLOTHING AND HAIRCUTS, THEN TURN THE CORNER AND SEE SOMEONE FROM THE ANCIENT WORLD.

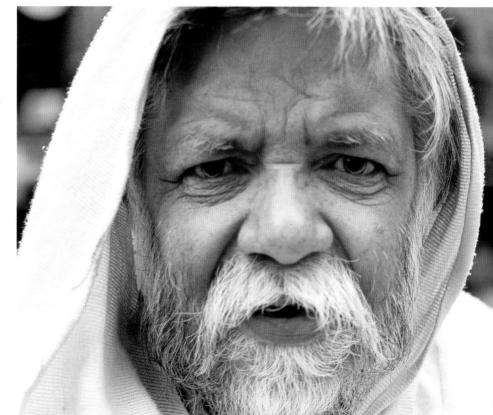

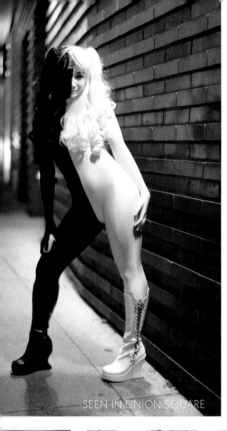

SEEN IN UNION SQUARE

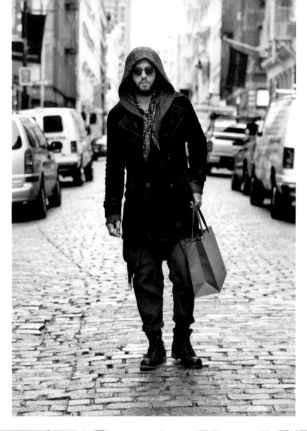

I'M NOT A FASHION EXPERT, BUT I DO KNOW WHAT "COOL AS SHIT" LOOKS LIKE.

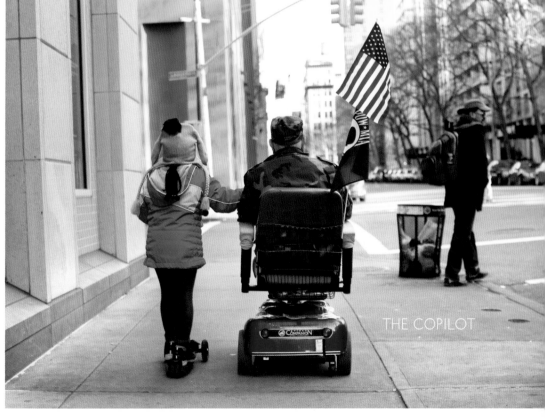

THE COPILOT

WHEN
THEY
CROSSED
THE
STREET,
HE WAS
CARRYING
HER DRESS.
JUST LIKE
THIS.

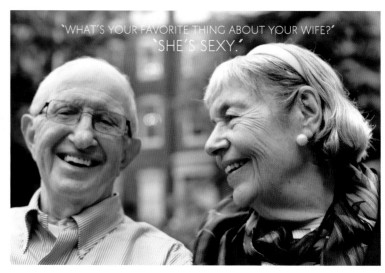

"WHAT'S YOUR FAVORITE THING ABOUT YOUR WIFE?"
"SHE'S SEXY."

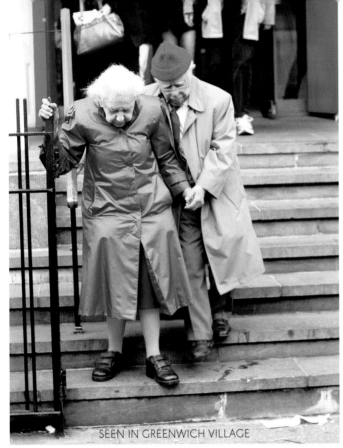

SEEN IN GREENWICH VILLAGE

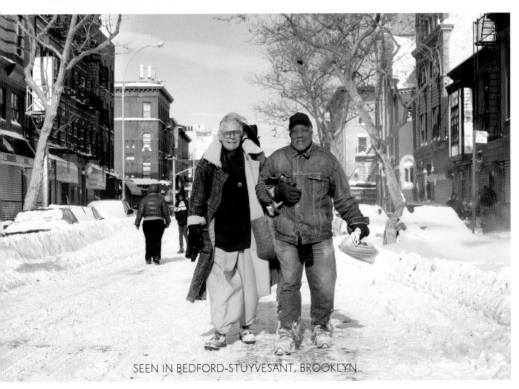

SEEN IN BEDFORD-STUYVESANT, BROOKLYN

I FOUND HIM.

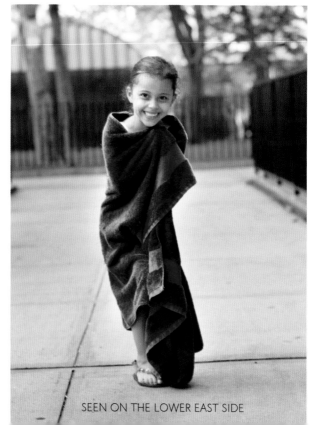

SEEN ON THE LOWER EAST SIDE

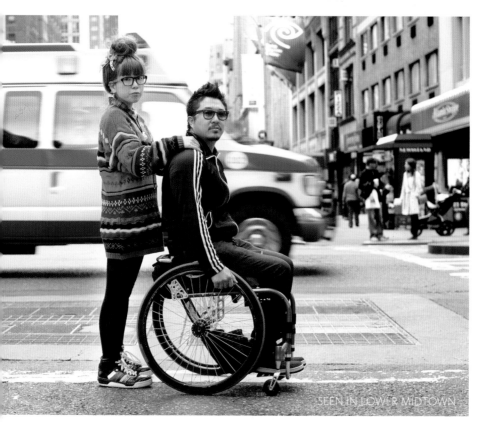

SEEN IN LOWER MIDTOWN

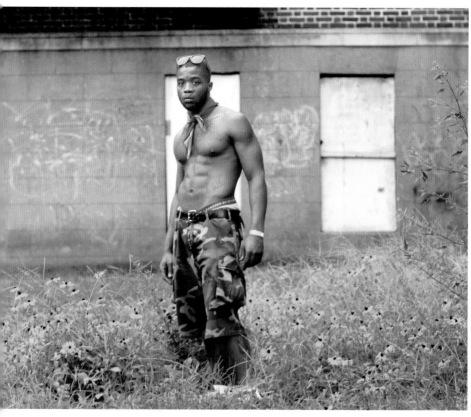

THIS GUY WAS A LITTLE HESITANT TO PARTICIPATE WHEN I TOLD HIM TO "JUST STAND RIGHT IN THE MIDDLE OF THE FLOWERS." LATER IN THE DAY, I PASSED HIM ON THE STREET AND HE SHOUTED: "YO! IT'S MY OFFICIAL PHOTOGRAPHER!"

ME: "WHAT'S
YOUR FAVORITE
THING ABOUT
YOUR BROTHER?"

RED GLASSES: "HE
PLAYS WITH ME."

BLUE GLASSES:
"DON'T FORGET
I'M A GOOD
SPELLER."

RED GLASSES:
"OH, YEAH."

BLUE GLASSES: "I
HELP HIM WITH
HIS HOMEWORK.
A LOT."

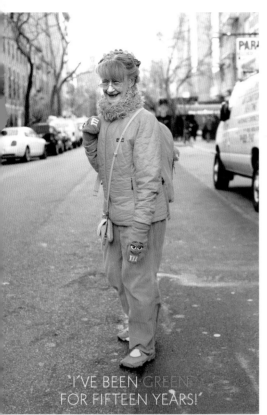

I'VE BEEN GREEN
FOR FIFTEEN YEARS!'

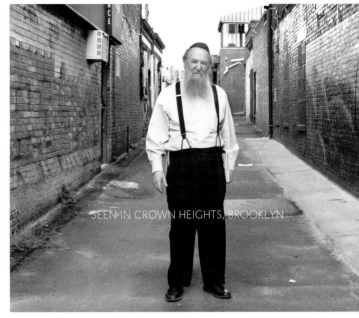

SEEN IN CROWN HEIGHTS, BROOKLYN

SEEN IN SOHO

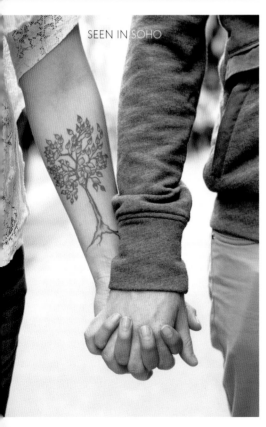

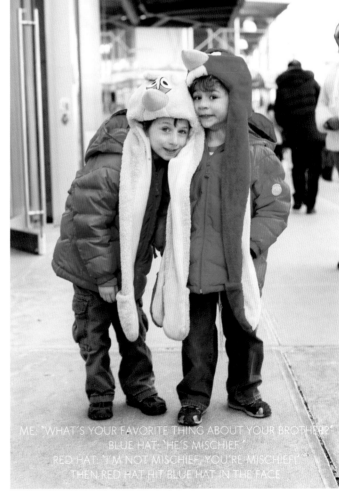

ME: "WHAT'S YOUR FAVORITE THING ABOUT YOUR BROTHER?"
BLUE HAT: "HE'S MISCHIEF"
RED HAT: "I'M NOT MISCHIEF, YOU'RE MISCHIEF!"
THEN RED HAT HIT BLUE HAT IN THE FACE

"I REALLY DON'T HAVE TIME TO TALK, THESE SHADOWS ARE CHANGING EVERY SECOND."

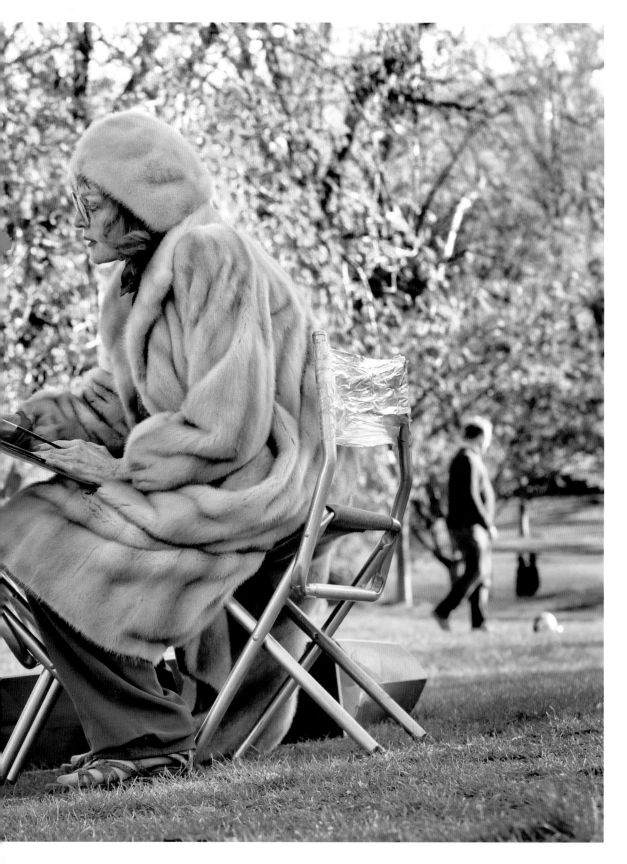

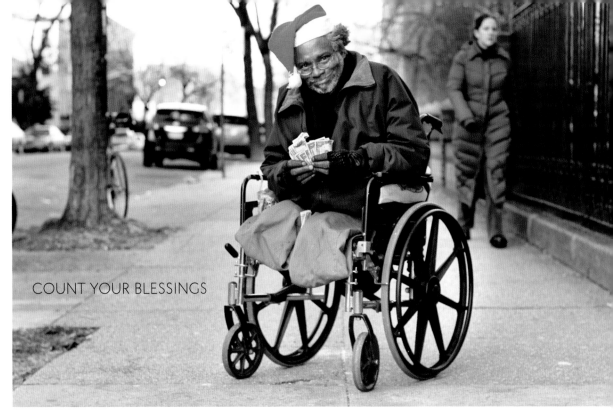

COUNT YOUR BLESSINGS

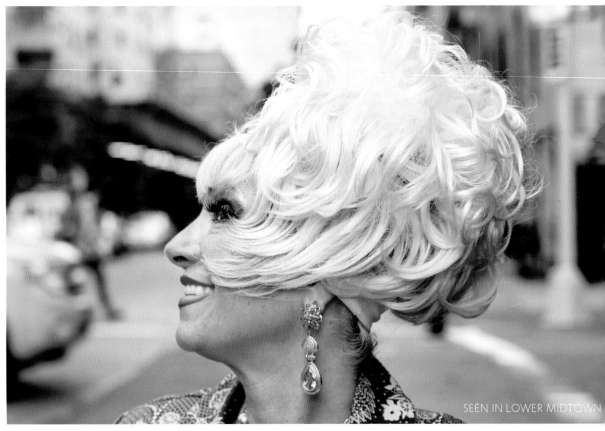

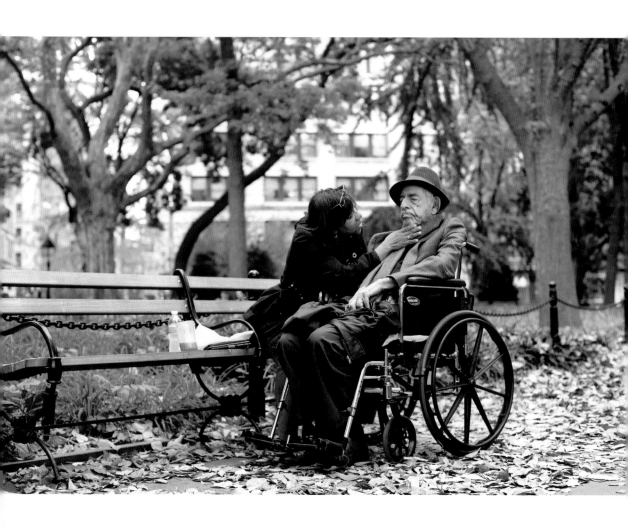

I LEANED DOWN AND ASKED THIS MAN FOR HIS PHOTOGRAPH,
BUT THERE WAS NO REPLY. HIS CARETAKER WAS SITTING NEARBY.
SHE SMILED AND SAID: `I'M THE ONE YOU NEED TO ASK.'

`OH,' I ANSWERED. `HE LOOKS WONDERFUL.'

SHE SAID, FONDLY: `THAT'S HOW I LIKE HIM TO LOOK.'

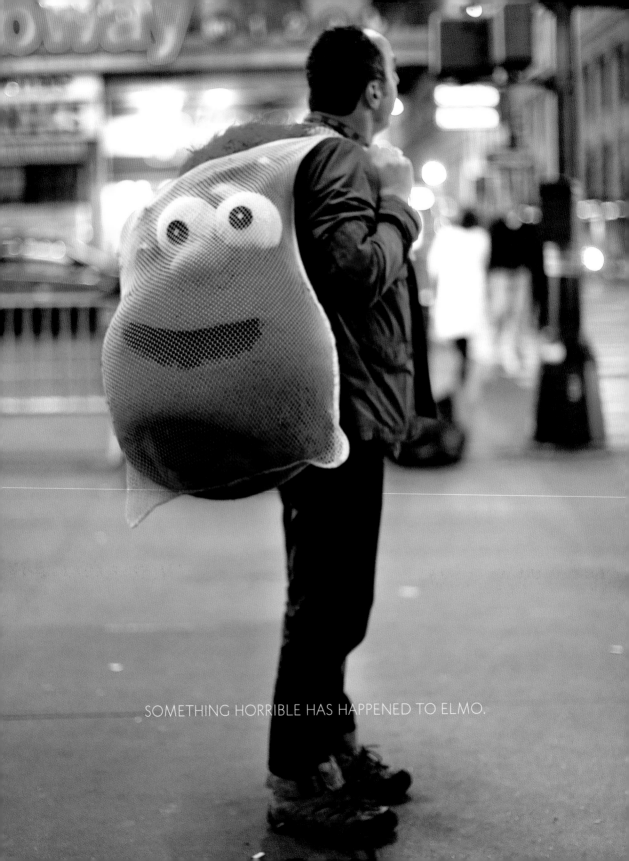

SOMETHING HORRIBLE HAS HAPPENED TO ELMO.

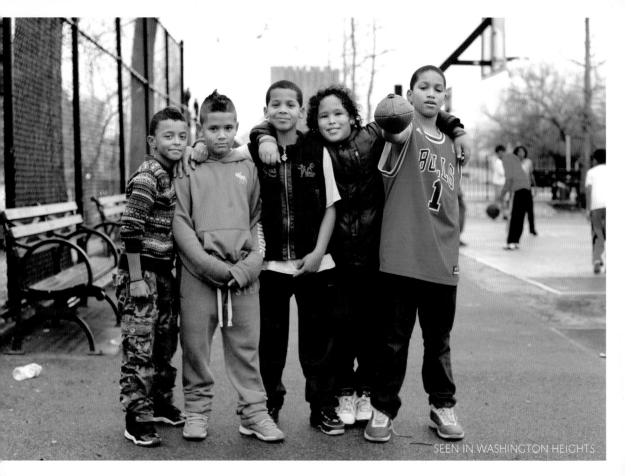

SEEN IN WASHINGTON HEIGHTS

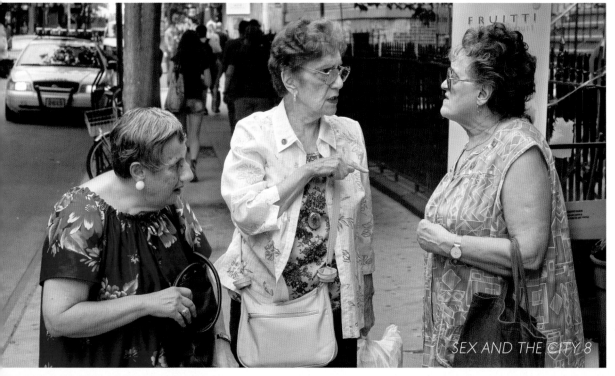

SEX AND THE CITY 8

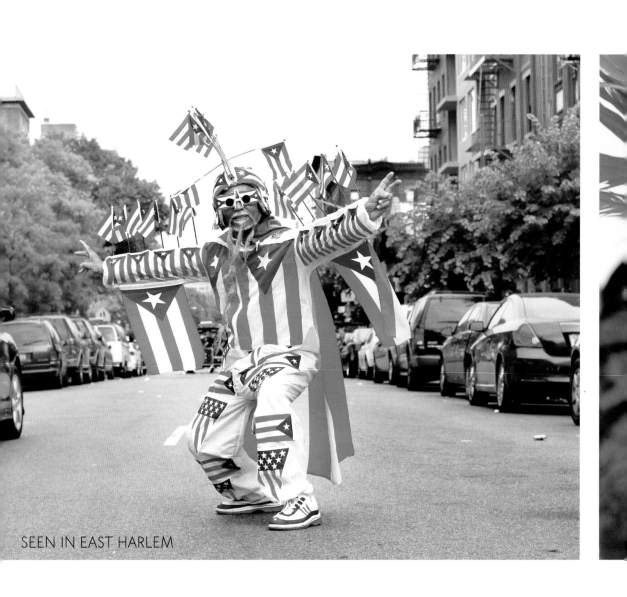

SEEN IN EAST HARLEM

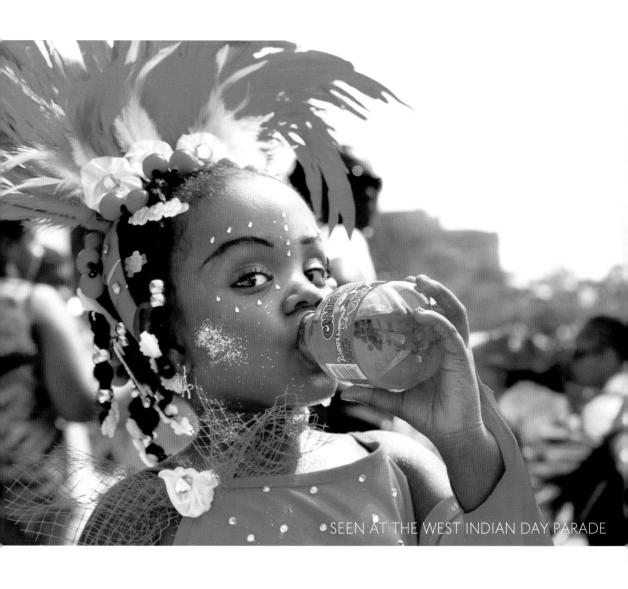

SEEN AT THE WEST INDIAN DAY PARADE

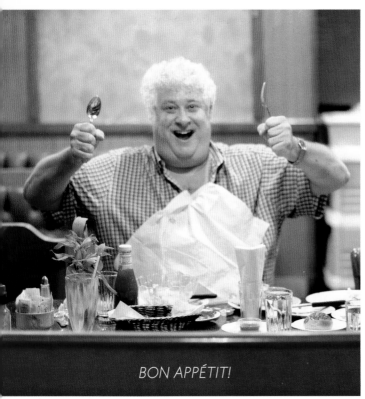

BON APPÉTIT!

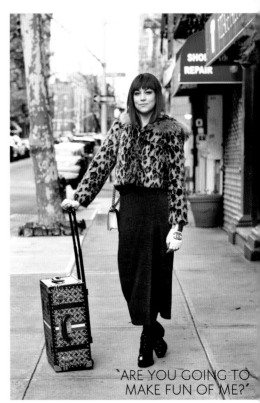

"ARE YOU GOING TO MAKE FUN OF ME?"

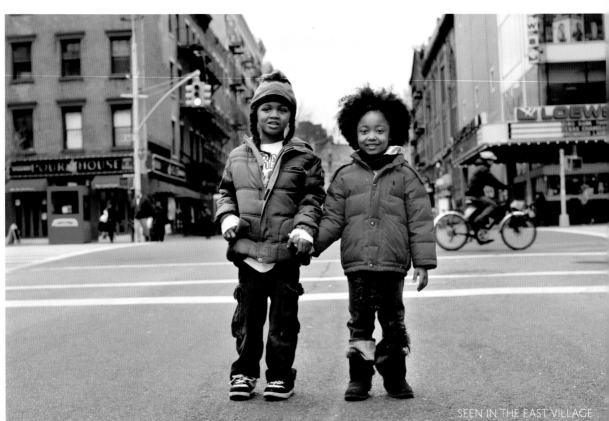

SEEN IN THE EAST VILLAGE

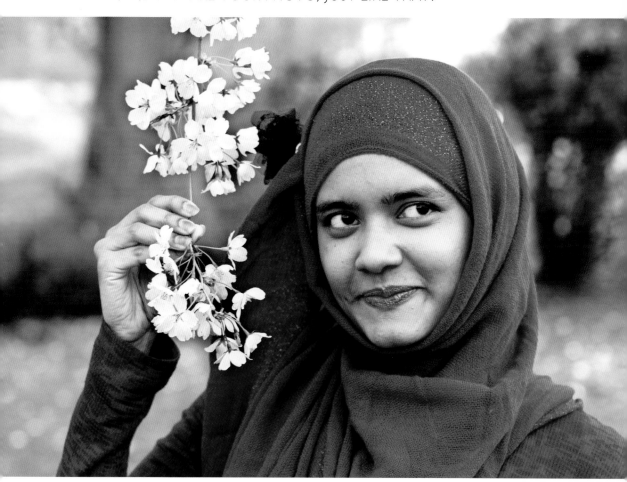

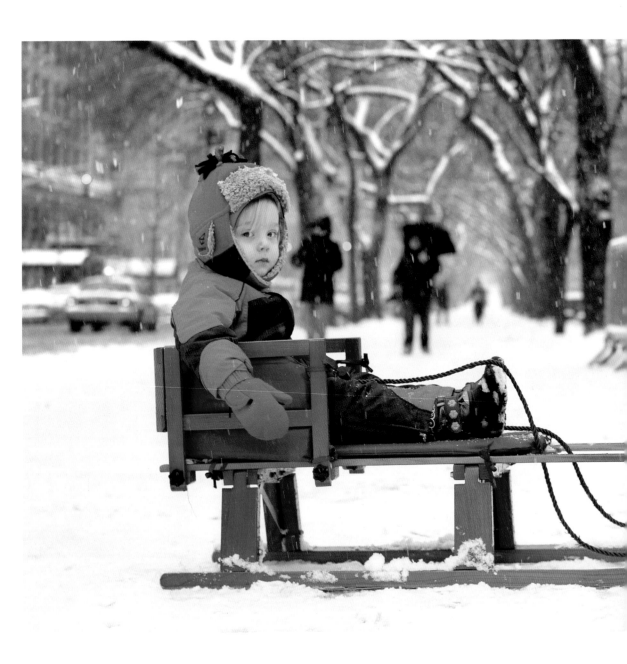

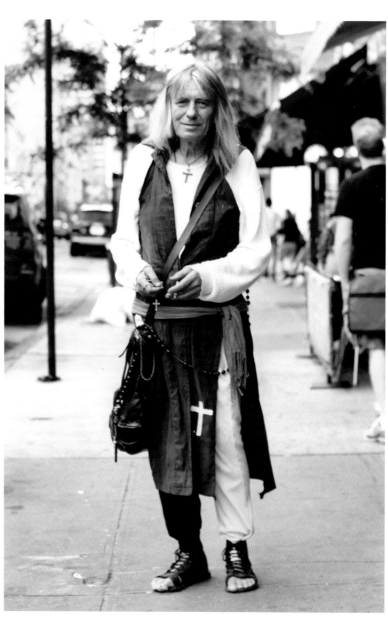

`I'M A CATHOLIC MONK. I LIVE A LIFE OF PRAYER.´
`WHAT ABOUT THE CIGARETTE?´
`SOMEBODY'S GOT TO MAKE THE CLOUDS.´

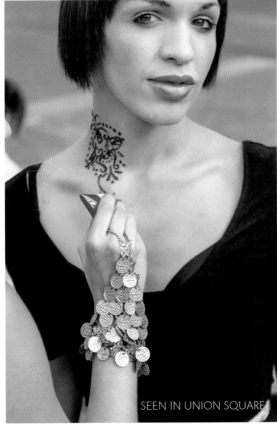

SEEN IN UNION SQUARE

THEY MAY
NOT BE
WINNING
ANY SAFETY
AWARDS,
BUT THEY
MADE FOR
A GREAT
PHOTO.

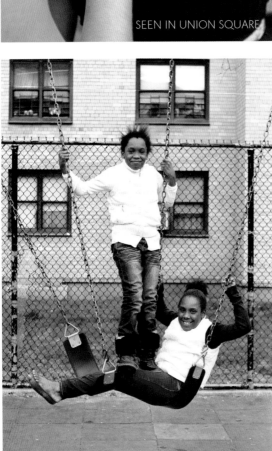

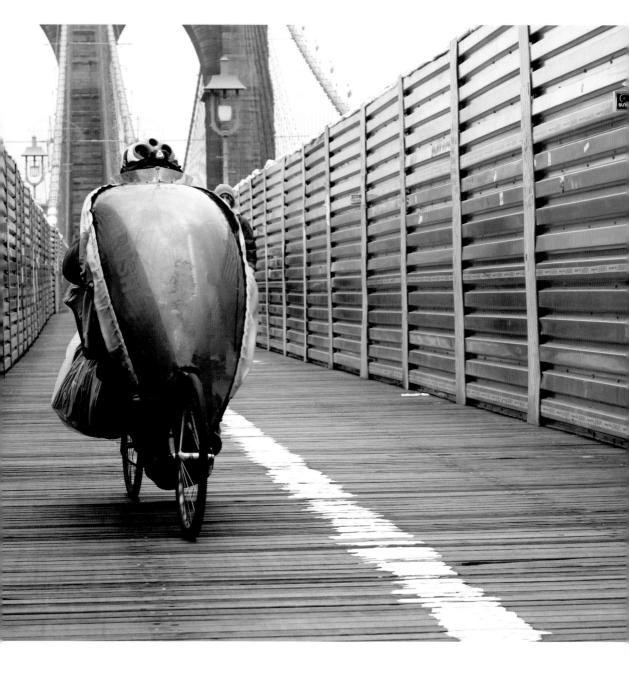

I WAS WALKING ACROSS THE BROOKLYN BRIDGE WHEN I NOTICED THIS STRANGE MISSILE COMING TOWARD ME AT A VERY HIGH SPEED. I PLANTED MYSELF DIRECTLY IN ITS PATH, HOPING TO CATCH A GREAT SHOT. THE VEHICLE VEERED AWAY AT THE LAST MOMENT, AND AS IT PASSED, THE RIDER SHOUTED THESE WORDS: "COO-COO! CAH-CAH! WOO-HOO!"

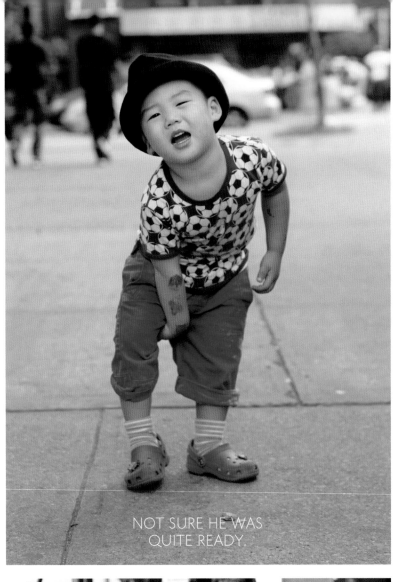

NOT SURE HE WAS
QUITE READY.

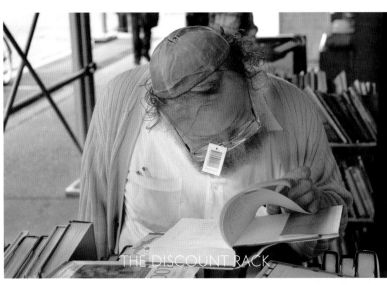

THE DISCOUNT RACK

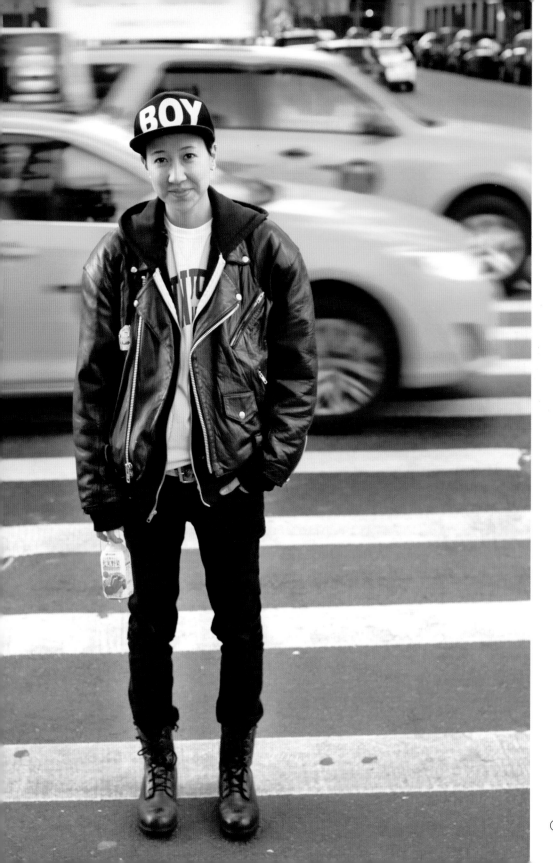

GIRL

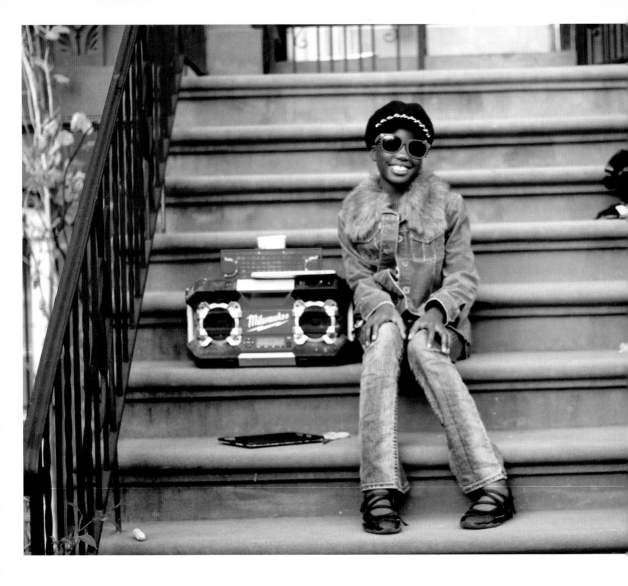

WHEN I WALKED BY, SHE WAS REALLY MOVING TO THE MUSIC—HANDS UP, HEAD NODDING, SHOULDERS SWINGING. I REALLY WANTED TO TAKE HER PHOTO, SO I WALKED UP TO THE NEAREST ADULT AND ASKED: "DOES SHE BELONG TO YOU?"

SUDDENLY THE MUSIC STOPPED, AND I HEARD: "I BELONG TO MYSELF!"

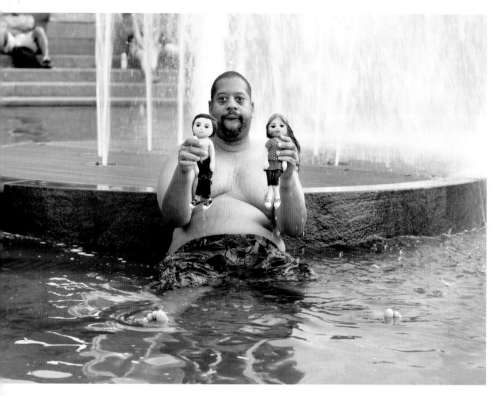

ON SUMMER DAYS, THIS MAN CAN OFTEN BE SEEN IN THE FOUNTAIN AT WASHINGTON SQUARE PARK.

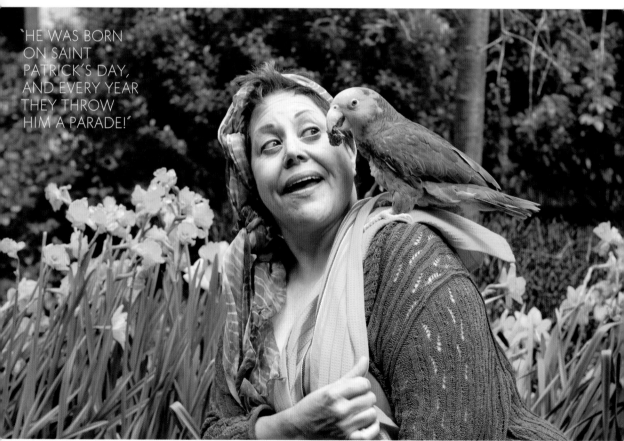

"HE WAS BORN ON SAINT PATRICK'S DAY, AND EVERY YEAR THEY THROW HIM A PARADE!"

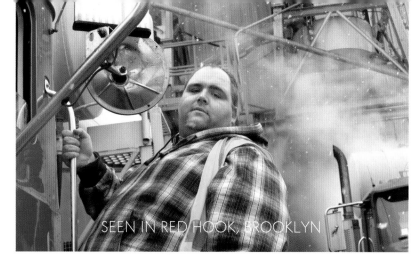

SEEN IN RED HOOK, BROOKLYN

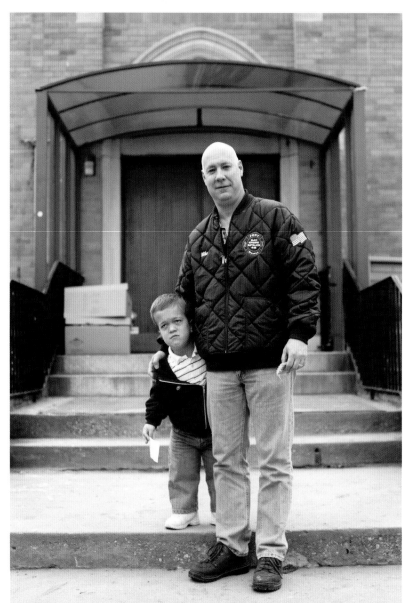

"I'M THE CHIEF OF PERSONNEL FOR THE FIRE DEPARTMENT. I'M MAKING SURE EVERYONE IS WHERE THEY NEED TO BE AND HAS WHAT THEY NEED."

"DO YOU MIND IF I TAKE YOUR PHOTO?"

"CAN MY SON BE IN THE PICTURE?"

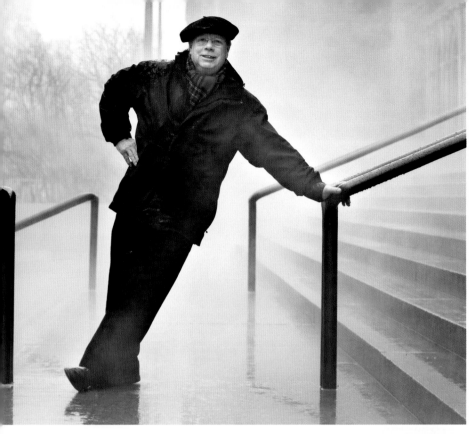

STEAM WAS COMING OFF THE STEPS OF THE MET THAT MORNING—IT MADE FOR A VERY SURREAL SCENE. I ASKED A COUPLE OF PEOPLE FOR A PORTRAIT, BUT BOTH SAID NO. THANKFULLY I WAS BAILED OUT BY THIS ADVENTUROUS MAN WITH A FRENCH ACCENT.

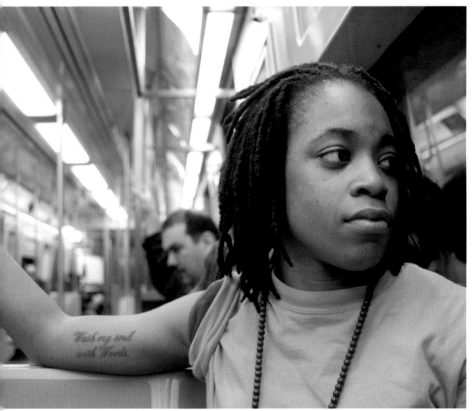

SHE WAS RECITING SOME UP-TEMPO SPOKEN-WORD POETRY ON THE SUBWAY. 'IT'S FREE THIS TIME,' SHE ANNOUNCED. 'BUT Y'ALL GONNA HAVE TO PAY WHEN I GET TO THE APOLLO!'

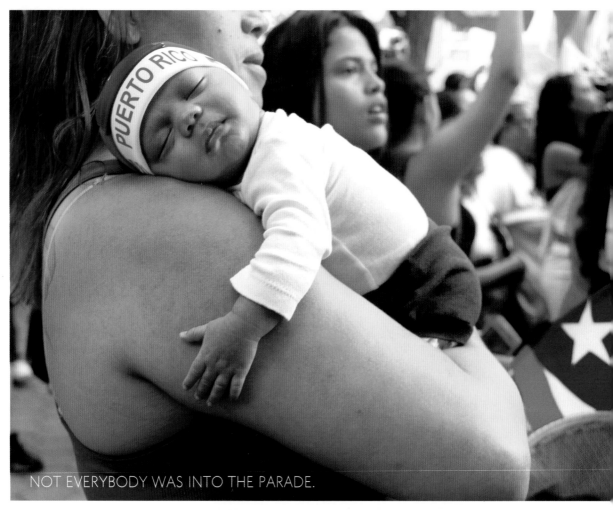

NOT EVERYBODY WAS INTO THE PARADE.

FOUND THESE TWO OLD FRIENDS WRESTLING ON A SIDEWALK IN BEDFORD-STUYVESANT, BROOKLYN.

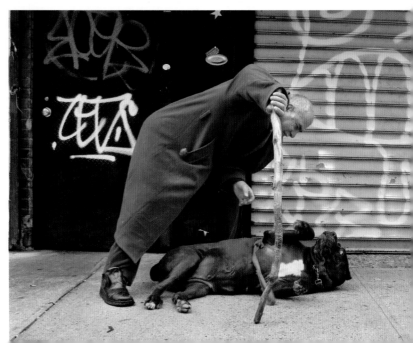

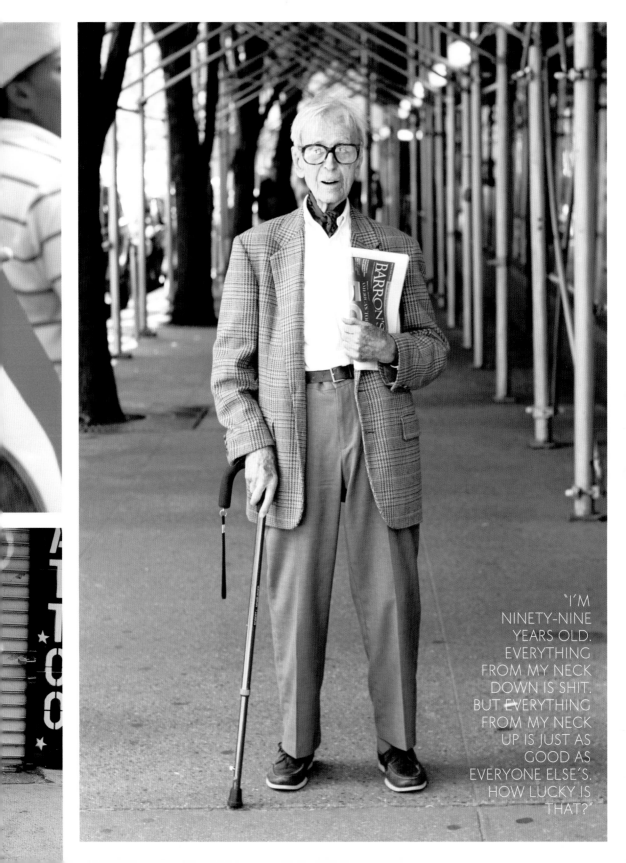

"I'M NINETY-NINE YEARS OLD. EVERYTHING FROM MY NECK DOWN IS SHIT. BUT EVERYTHING FROM MY NECK UP IS JUST AS GOOD AS EVERYONE ELSE'S. HOW LUCKY IS THAT?"

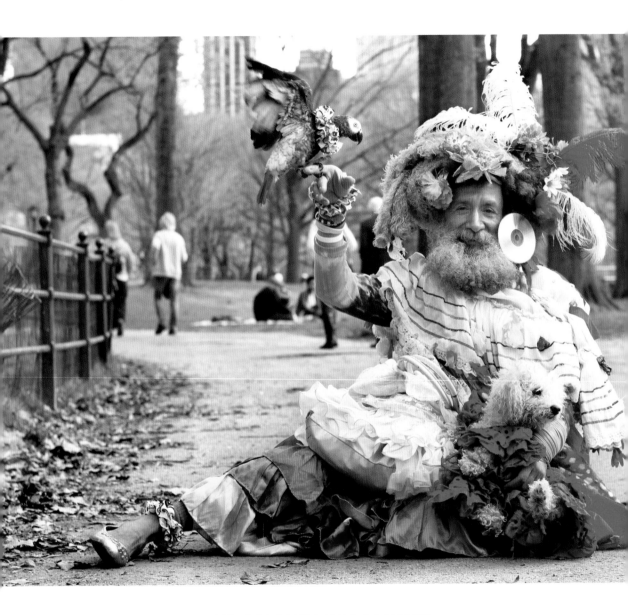

MS. COLOMBIA WAS A LAWYER,
UNTIL SHE LEARNED THAT SHE HAD HIV.

THEN SHE BECAME MS. COLOMBIA.

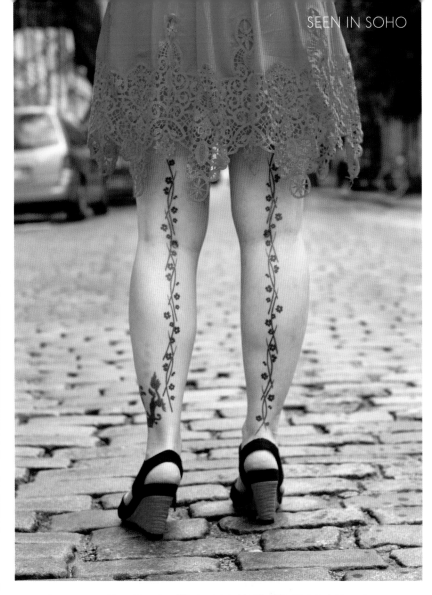

ANONYMOUS HERO PERFORMS PUBLIC KARATE RITUAL IN THUNDERSTORM WHILE WEARING BUSINESS ATTIRE.

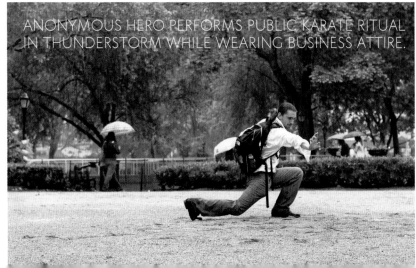

THE MORNING
COMMUTE CAN
BE HELL FOR A
GERMOPHOBE.

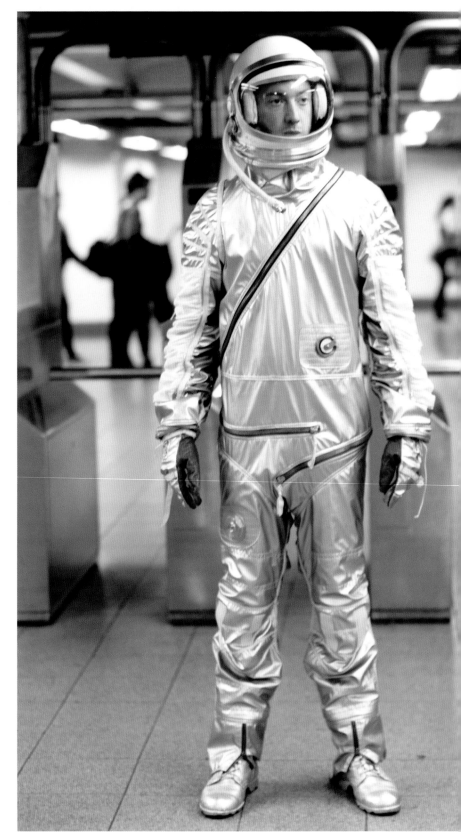

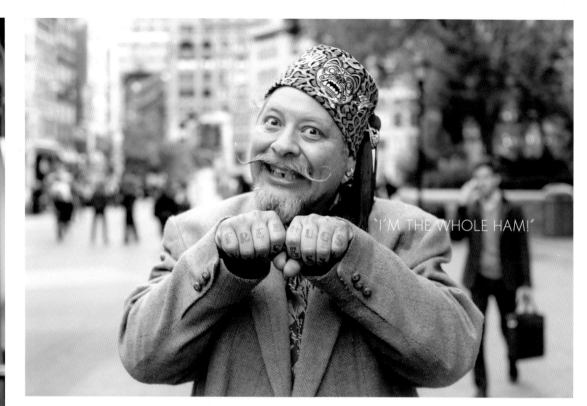

"I'M THE WHOLE HAM!"

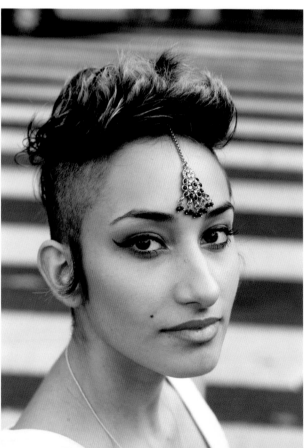

"IT SEEMS
THAT A LOT
OF PEOPLE
MY AGE
TRY TO BE
INTERESTING
BY HAVING
PROBLEMS
OR STARTING
CONFLICTS.
I'D RATHER BE
INTERESTING
BECAUSE I
CREATED
SOMETHING
BEAUTIFUL."

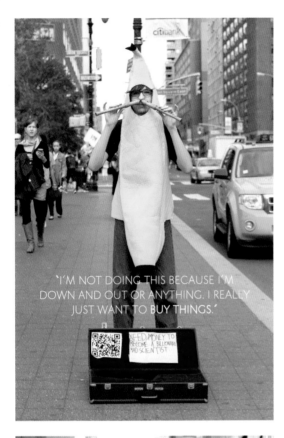

'I'M NOT DOING THIS BECAUSE I'M DOWN AND OUT OR ANYTHING. I REALLY JUST WANT TO BUY THINGS.'

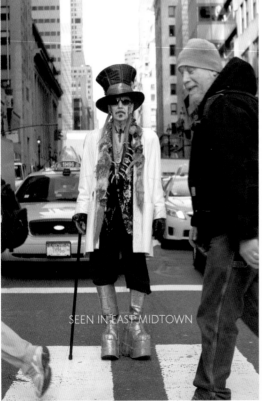

SEEN IN EAST MIDTOWN

'MY MOM DIED WHEN I WAS EIGHTEEN. I ACTED LIKE IT DIDN'T BOTHER ME 'CAUSE I WAS A PUNK ROCK KID. BUT I THINK IT CAME BACK TO ME LATER IN WEIRD WAYS.'

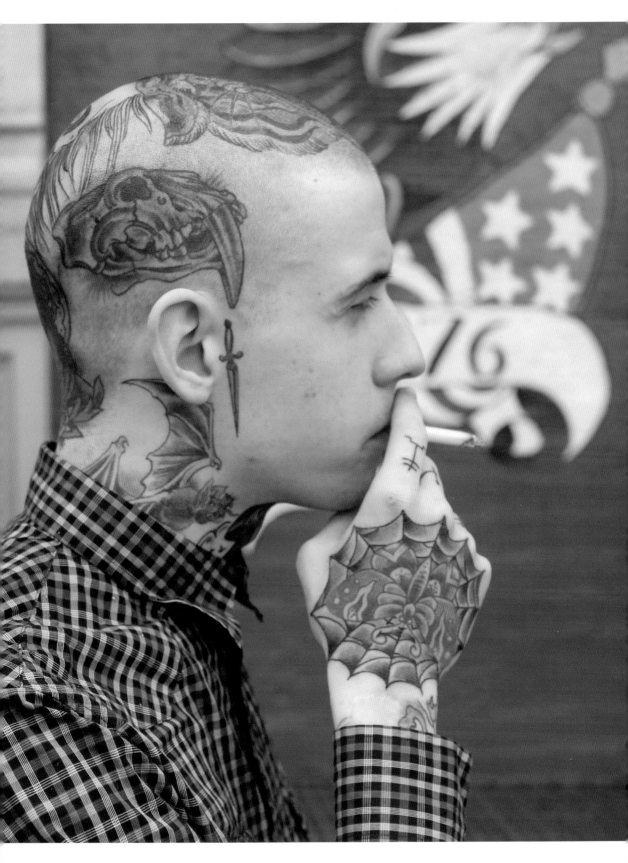

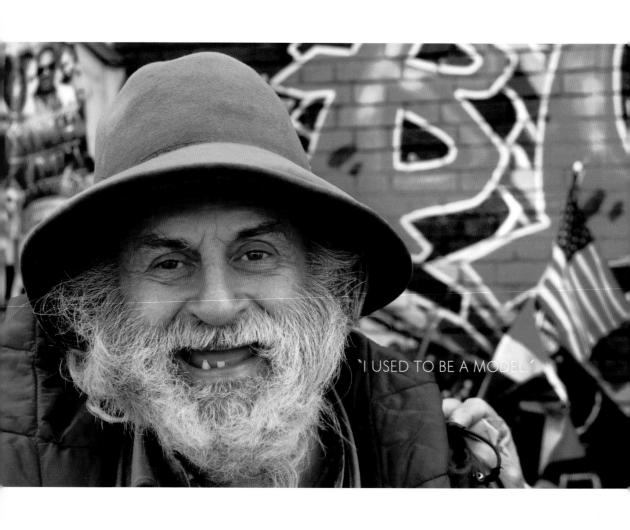

`I USED TO BE A MODEL`

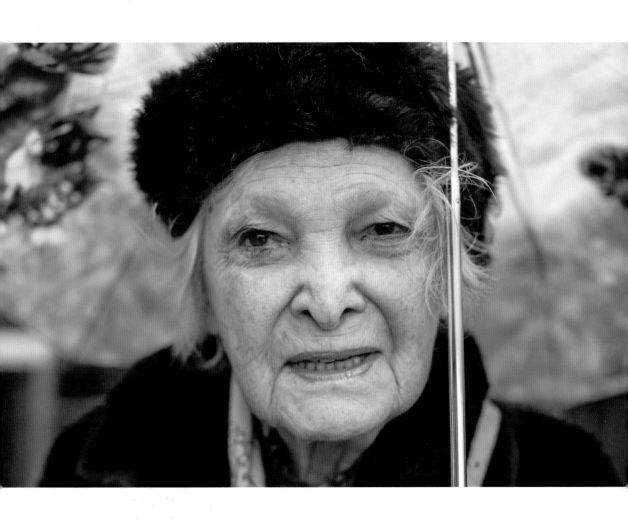

"WHEN MY HUSBAND WAS DYING, I SAID: 'MOE, HOW AM I
SUPPOSED TO LIVE WITHOUT YOU?' HE TOLD ME: 'TAKE THE
LOVE YOU HAVE FOR ME AND SPREAD IT AROUND.' "

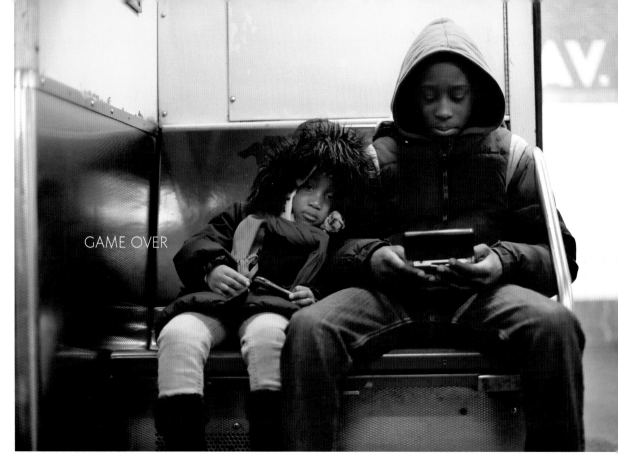

GAME OVER

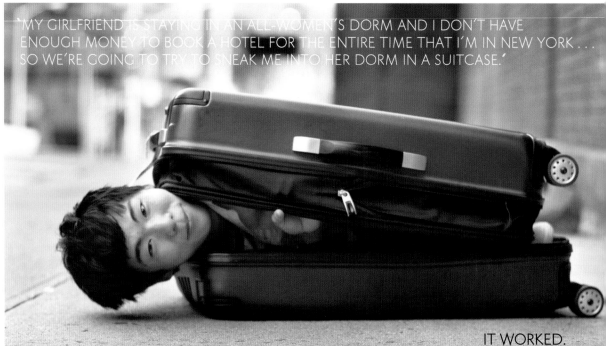

'MY GIRLFRIEND IS STAYING IN AN ALL-WOMEN'S DORM AND I DON'T HAVE ENOUGH MONEY TO BOOK A HOTEL FOR THE ENTIRE TIME THAT I'M IN NEW YORK . . . SO WE'RE GOING TO TRY TO SNEAK ME INTO HER DORM IN A SUITCASE.'

IT WORKED.

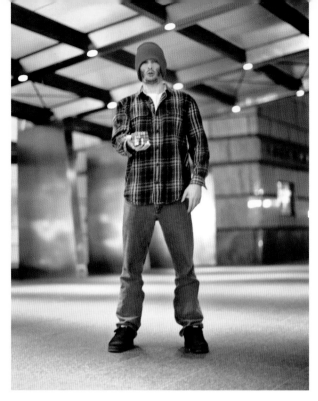

"THERE
ARE MORE
COMBINATIONS
IN THIS CUBE
THAN THERE ARE
SECONDS IN THE
HISTORY OF THE
UNIVERSE."

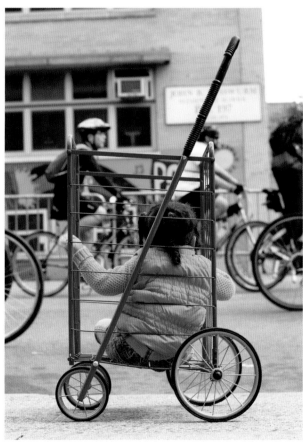

DREAM
BIG

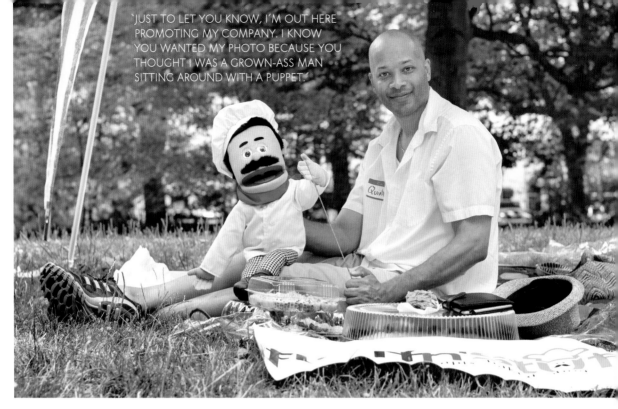

"JUST TO LET YOU KNOW, I'M OUT HERE PROMOTING MY COMPANY. I KNOW YOU WANTED MY PHOTO BECAUSE YOU THOUGHT I WAS A GROWN-ASS MAN SITTING AROUND WITH A PUPPET."

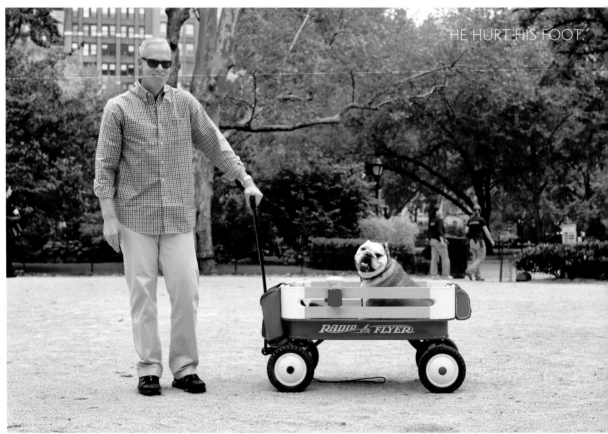

"HE HURT HIS FOOT."

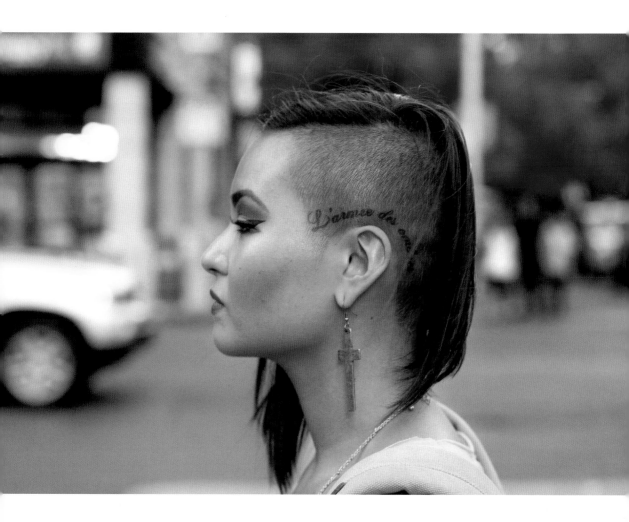

'IT'S FRENCH FOR 'ARMY OF SHADOWS.' '

'AND WHAT DOES THAT MEAN TO YOU?'

'I WAS GOING THROUGH A REALLY ROUGH TIME IN MY LIFE, AND IT FELT LIKE A WHOLE ARMY WAS AFTER ME. BUT WHEN I STARTED FEELING BETTER, I REALIZED IT WAS NOTHING BUT AN ARMY OF SHADOWS.'

I DISCOVERED A YOUNG DANCE TROUPE FROM CHINA POSING FOR A PORTRAIT OUTSIDE OF LINCOLN CENTER. THE CHAPERONES NOTICED ME TAKING PHOTOS, AND BEGAN WHISPERING TO EACH OTHER. SUDDENLY ONE OF THE ADULTS BLEW A WHISTLE, THE CHILDREN LINED UP, AND A VERY PRIVATE PERFORMANCE COMMENCED.

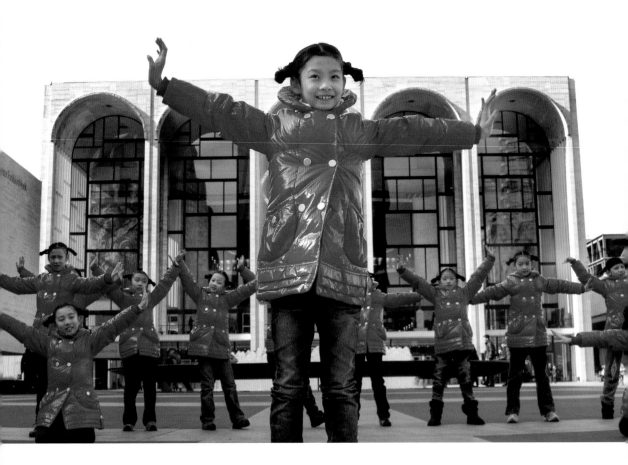

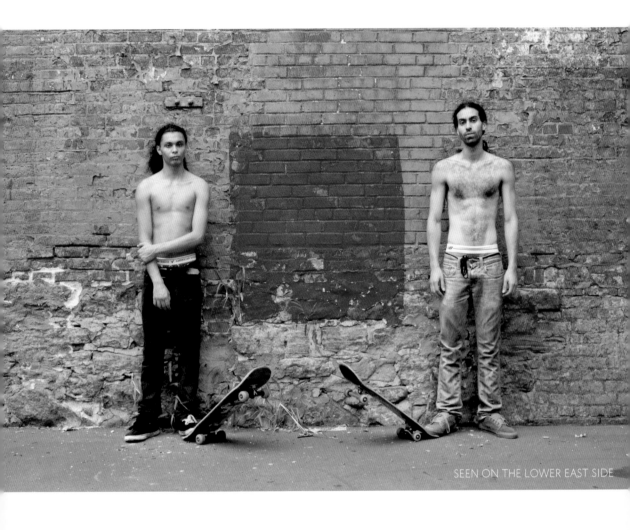

SEEN ON THE LOWER EAST SIDE

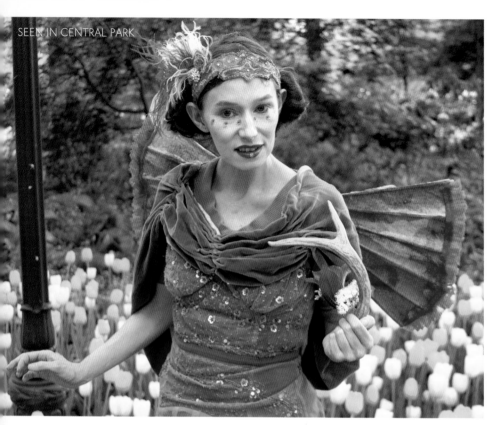
SEEN IN CENTRAL PARK

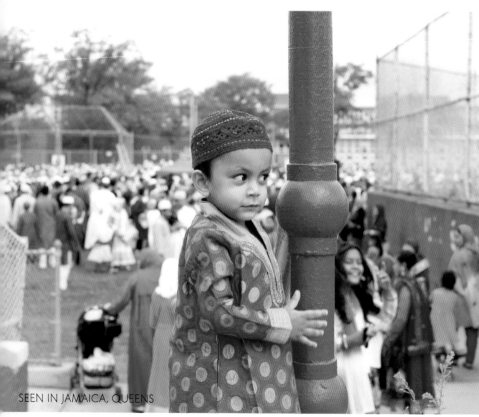
SEEN IN JAMAICA, QUEENS

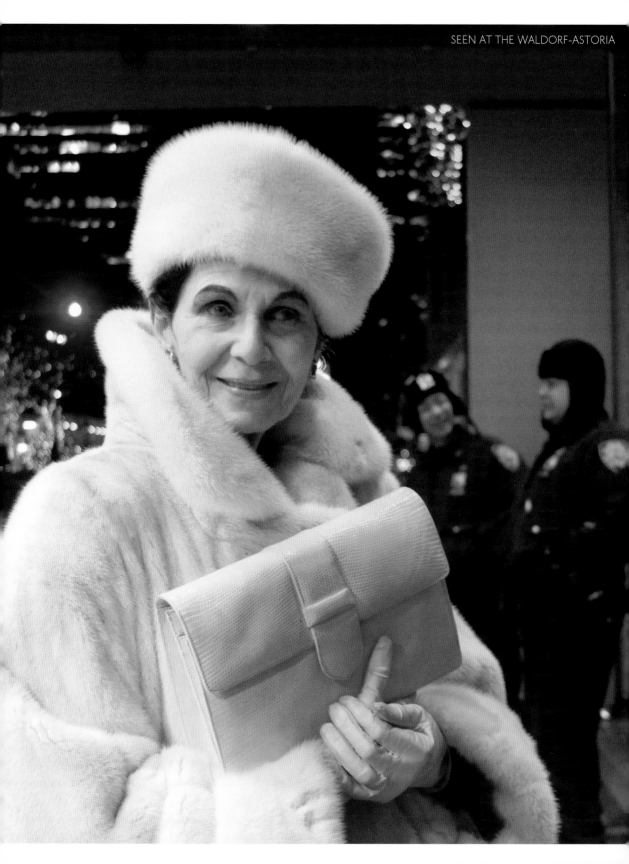

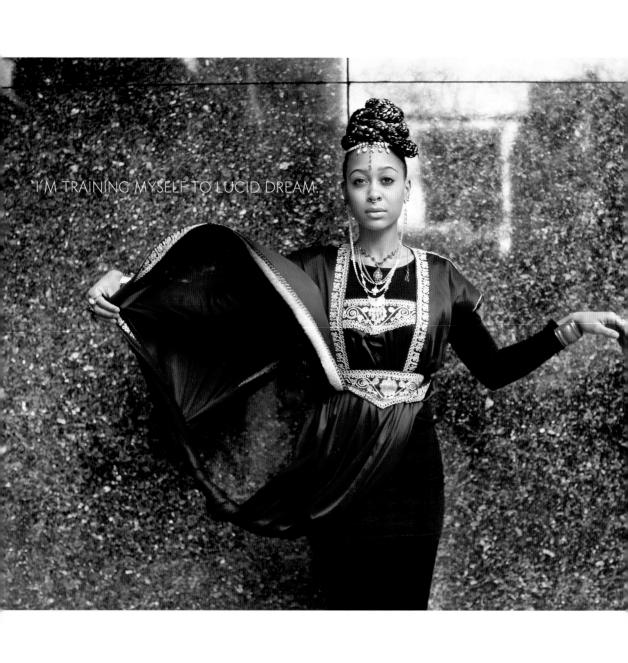

"I'M TRAINING MYSELF TO LUCID DREAM."

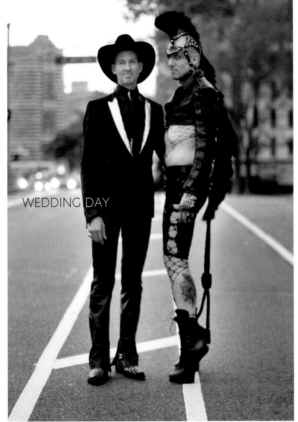

WEDDING DAY

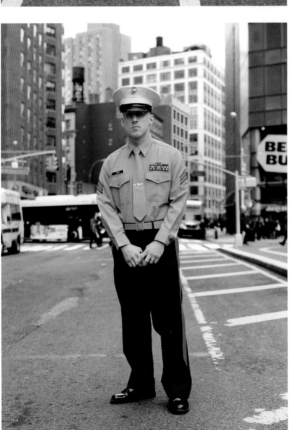

"IT'S TAUGHT
ME TO
BE MORE
RESPECTFUL OF
ALL PEOPLE. IF
I MEET A MAN
ON THE STREET
NOW, NO
MATTER HOW
OLD HE IS, I'LL
CALL HIM SIR."

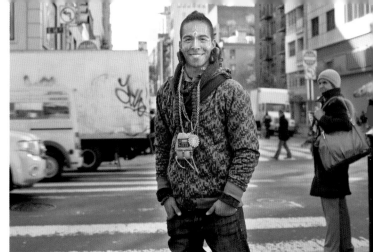

"I'M GOING TO ISRAEL NEXT WEEK."

"ARE YOU JEWISH?"

"I AM."

"JEWISH AND WHAT?"

"JEWISH AND GERMAN, IRAQI, AFRICAN, IRISH, PORTUGUESE, FRENCH, CHEROKEE, LENAPE, AND BLACKFOOT."

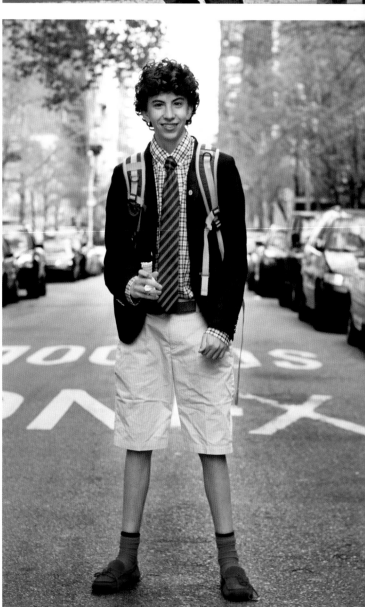

"A KID WORE SHORTS TO SCHOOL YESTERDAY AND THE HEADMASTER GOT REALLY MAD, SO TODAY THE WHOLE CLASS WORE THEM."

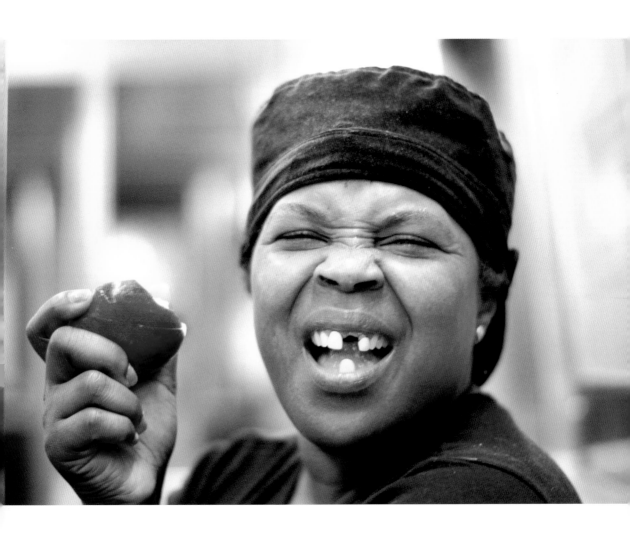

"I DON'T MIND THE WHITE PEOPLE MOVING INTO OUR NEIGHBORHOOD. THEY'RE LIKE THE INDIANS—THEY COME IN PEACE. AND THEY BROUGHT SOME WHOLE FOODS WITH 'EM. AND FLEETWOOD MAC. PLUS THE POLICE DON'T BREAK UP OUR BLOCK PARTIES ANYMORE."

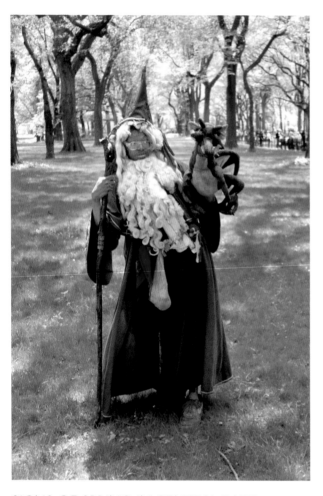

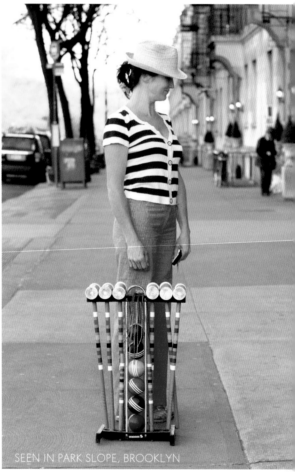

SEEN IN PARK SLOPE, BROOKLYN

SIGNS OF SPRING IN CENTRAL PARK:

1. TREES TURN GREEN.
2. FLOWERS BLOOM.
3. BLACKWOLF THE DRAGONMASTER BEGINS
 ASKING PEOPLE TO FEED CASH TO HIS DRAGON.

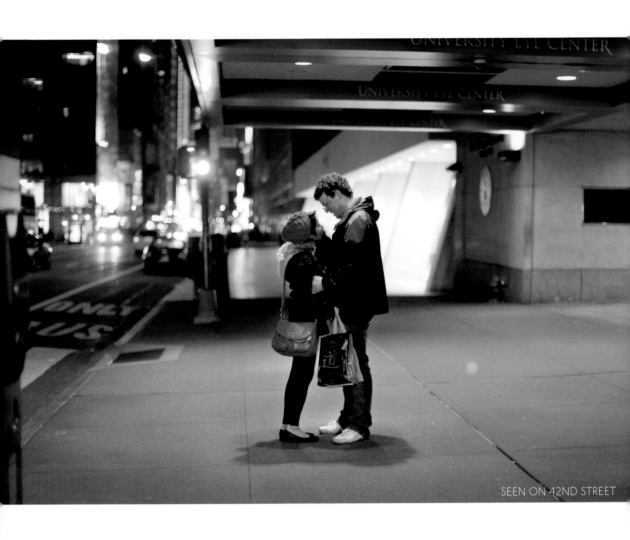

SEEN ON 42ND STREET

'JEALOUSY. DEPRESSION. LOVE. THEY PRETTY MUCH DEMONSTRATE THE WHOLE RANGE OF HUMAN EMOTION.'

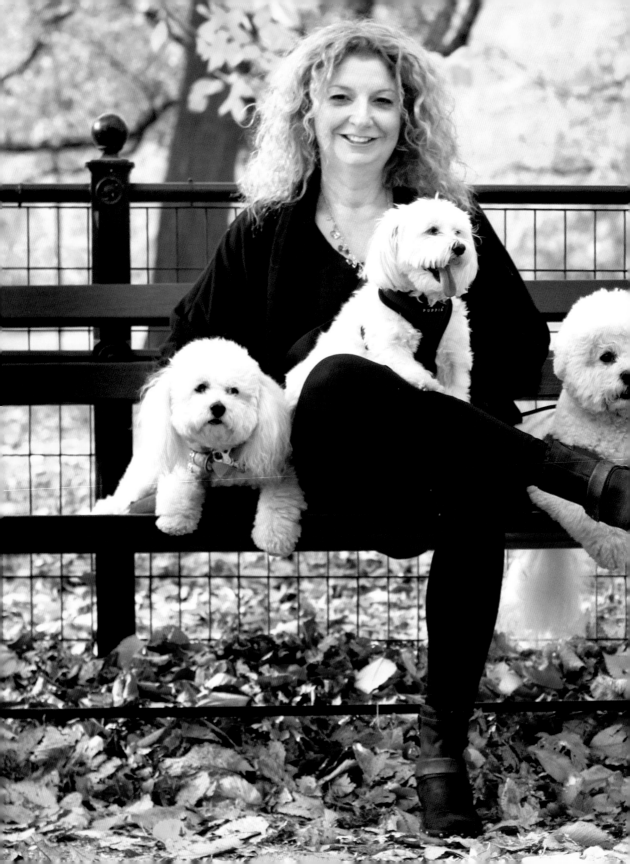

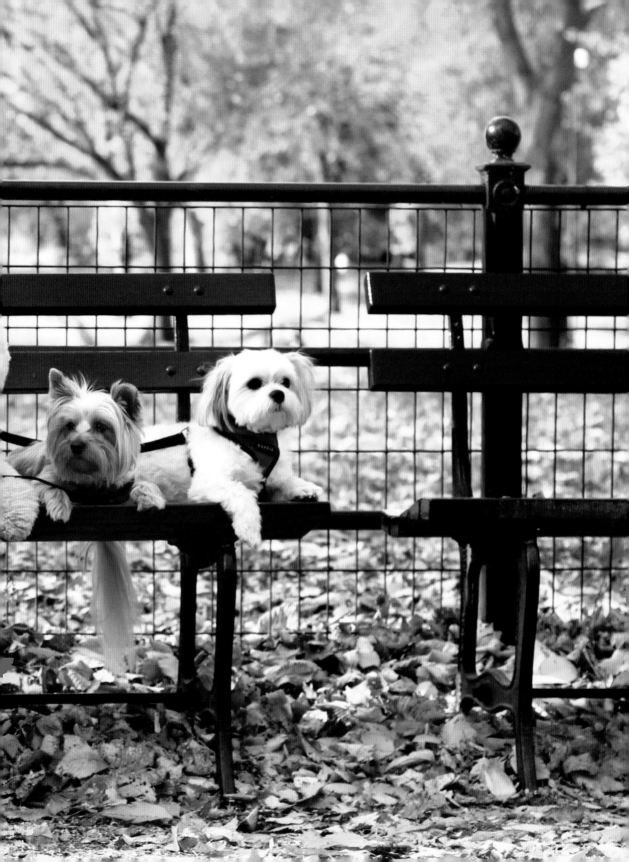

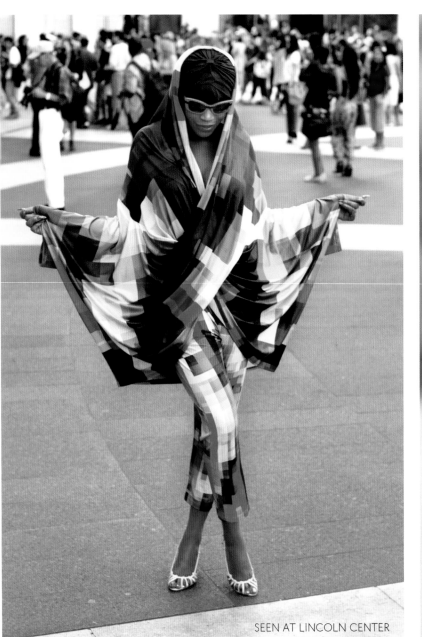

SEEN AT LINCOLN CENTER

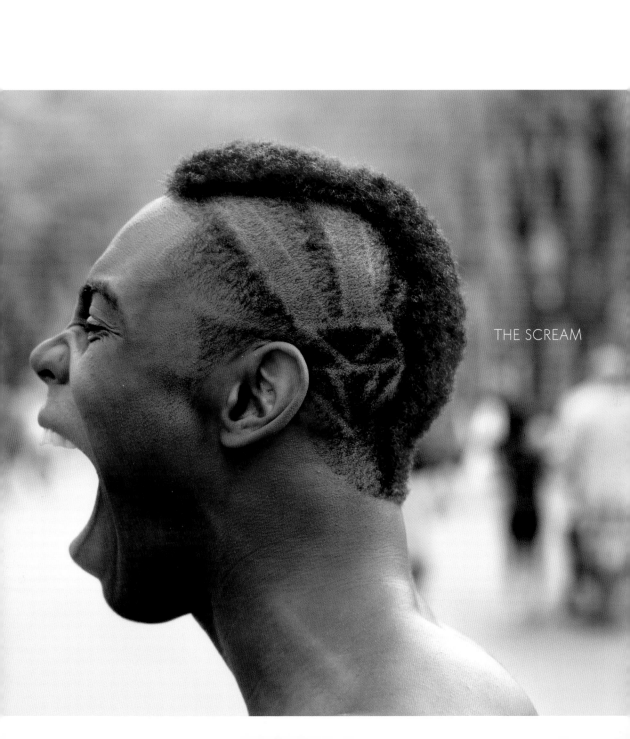

THE SCREAM

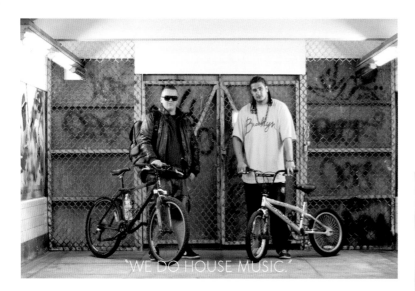

"WE DO HOUSE MUSIC."

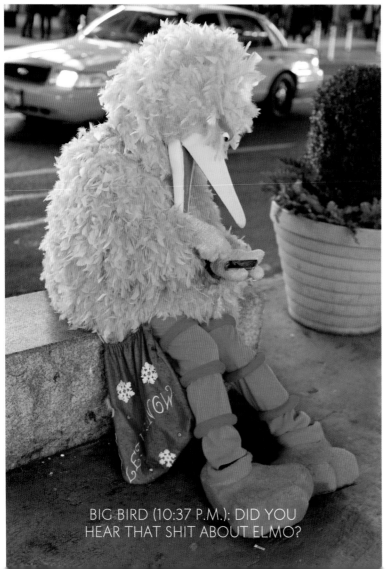

BIG BIRD (10:37 P.M.): DID YOU HEAR THAT SHIT ABOUT ELMO?

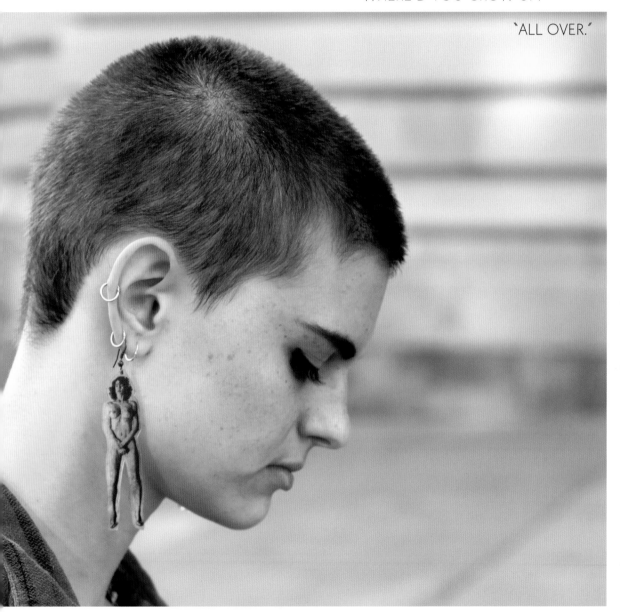

"WHERE'D YOU GROW UP?"

"ALL OVER."

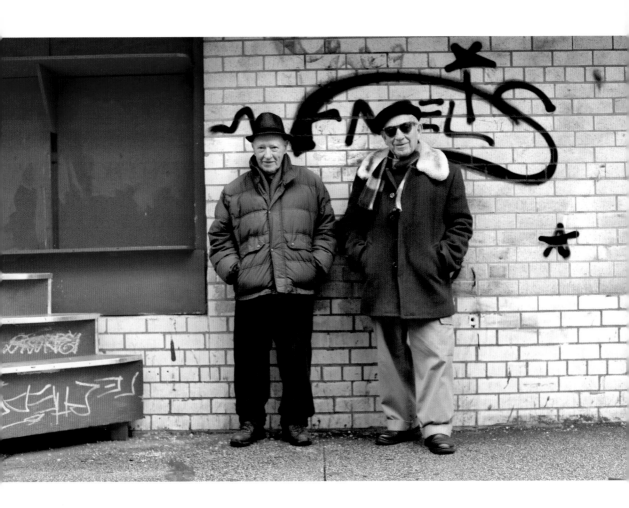

THESE MEN HAD VERY HEAVY ACCENTS, SO I COULD BARELY UNDERSTAND THEM. I TRIED MY BEST TO FOLLOW ALONG AS THE MAN ON THE RIGHT TOLD ME HIS LIFE STORY. AFTER ASKING HIM TO REPEAT SEVERAL SENTENCES, I FINALLY CONCLUDED THAT HE'D GROWN UP IN PORTUGAL AND IMMIGRATED TO AMERICA AS A YOUNG MAN. "WHAT YEAR DID YOU COME TO AMERICA?" I ASKED.

"HE WAS BORN IN RHODE ISLAND," SAID THE MAN ON THE LEFT.

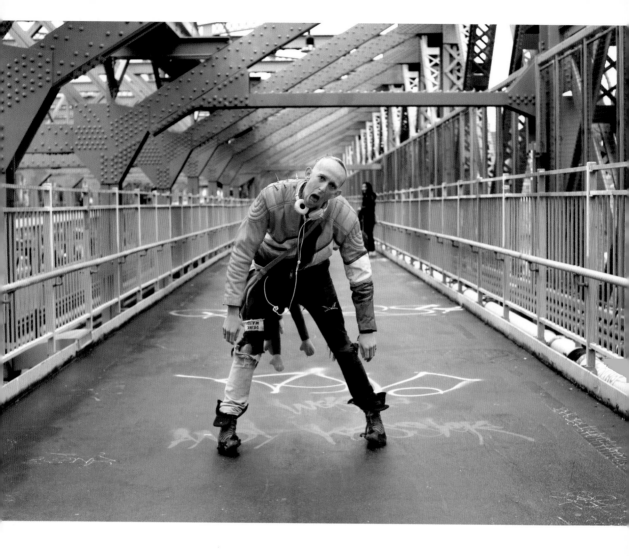

HE INTRODUCED HIMSELF AS CIRCUS, THE TRAVELING MAGICIAN. HE THEN HANDED ME A BOOK OF SPELLS. HERE ARE SOME OF THE HIGHLIGHTS:

THE SPELL TO MAKE STRANGERS WISH YOU A 'HAPPY BIRTHDAY': MAKE A SIGN THAT SAYS 'IT'S MY BIRTHDAY,' AND HANG IT AROUND YOUR NECK.

THE CUDDLE-INDUCING SPELL: SIMPLY HANG UP A SIGN THAT SAYS 'CUDDLE ZONE.' PUT A FEW SOFT PILLOWS AND BLANKETS UNDER IT.

SPELL TO MAKE OBJECTS MOVE THROUGH THE AIR: MAKE SURE THERE IS A NICE PERSON IN CLOSE PROXIMITY, BOTH TO YOU AND THE OBJECT YOU DESIRE. THEN SIMPLY STRETCH YOUR ARM OUT TOWARD THE OBJECT AND, IN LESS THAN A MINUTE, IT WILL FLOAT MAGICALLY INTO YOUR HAND.

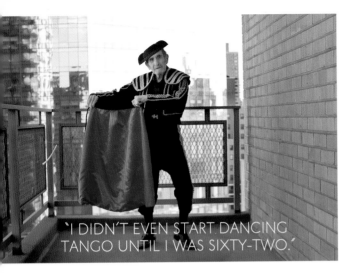

"I DIDN'T EVEN START DANCING TANGO UNTIL I WAS SIXTY-TWO."

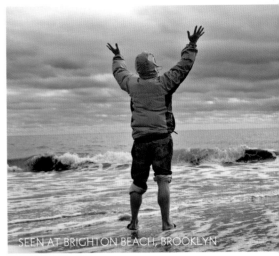

SEEN AT BRIGHTON BEACH, BROOKLYN

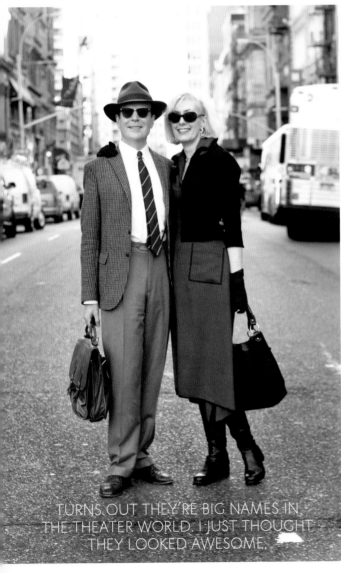

TURNS OUT THEY'RE BIG NAMES IN THE THEATER WORLD. I JUST THOUGHT THEY LOOKED AWESOME.

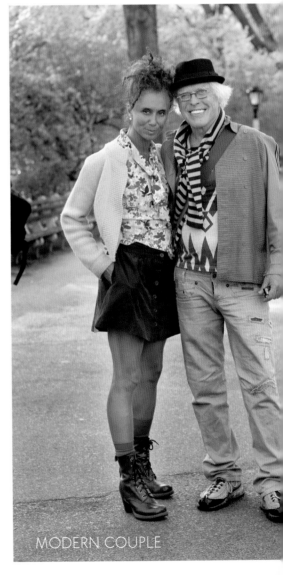

MODERN COUPLE

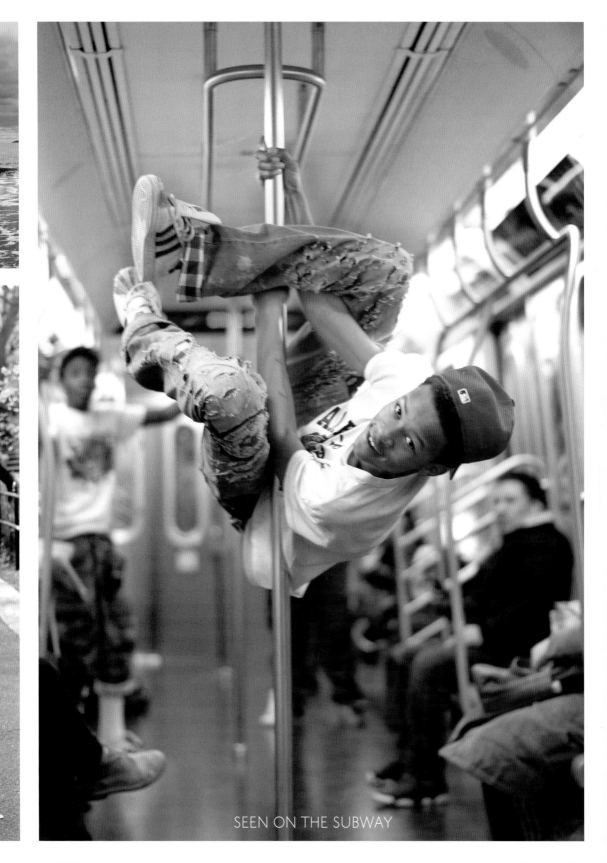

SEEN ON THE SUBWAY

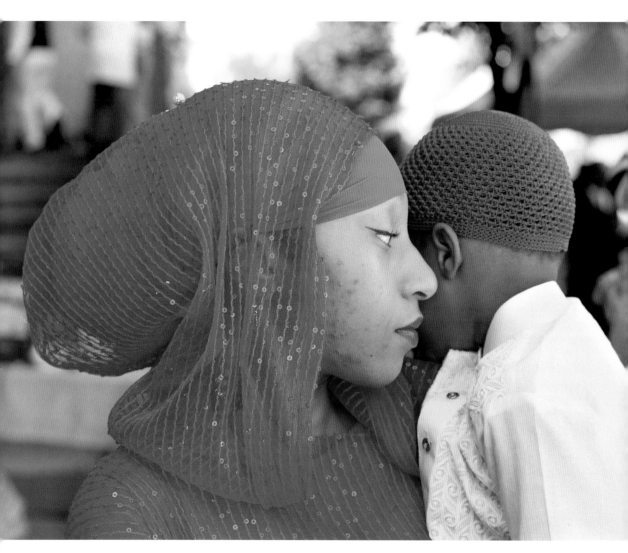

"SORRY HE'S SO SHY."

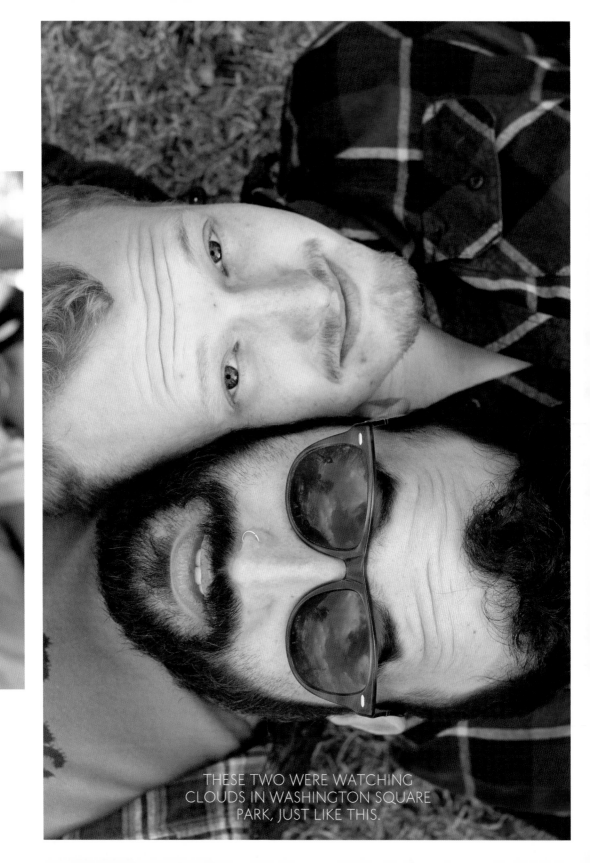

THESE TWO WERE WATCHING CLOUDS IN WASHINGTON SQUARE PARK, JUST LIKE THIS.

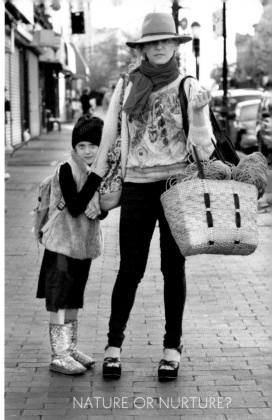

NATURE OR NURTURE?

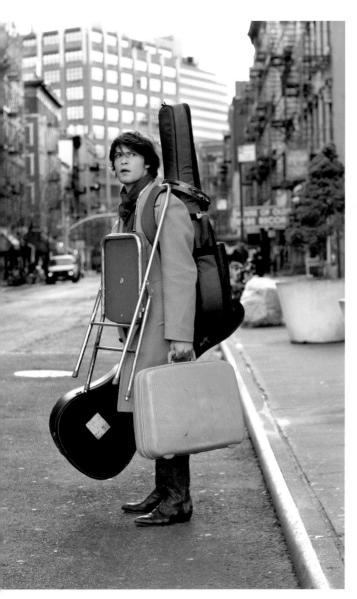

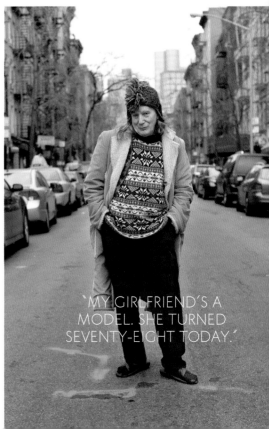

HE SAID: "I'VE GOT TO FIND A NEW SYSTEM FOR CARRYING MY STUFF."

AN OLD LADY WALKED BY, AND SAID: "CLOSE YOUR MOUTH!"

"MY GIRLFRIEND'S A MODEL. SHE TURNED SEVENTY-EIGHT TODAY."

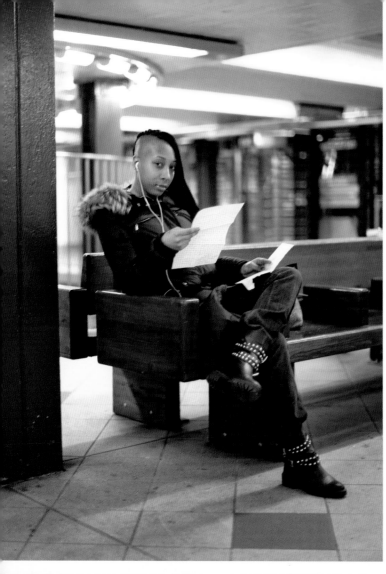

THIS GIRL CAUGHT MY ATTENTION BECAUSE SHE WAS READING A FULL-PAGE, TIGHTLY SPACED, HANDWRITTEN LETTER. I ASKED HER IF IT WAS A HAPPY LETTER OR A SAD LETTER. "IT'S A VERY HAPPY LETTER," SHE SAID. "IT'S FROM MY BOYFRIEND IN JAIL."

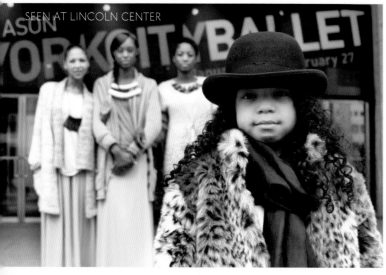

SEEN AT LINCOLN CENTER

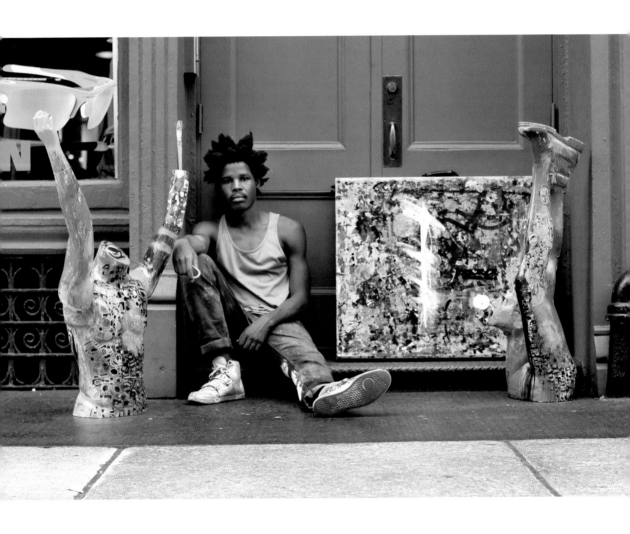

SOME ART COSTS AN ARM AND A LEG.
SOME ART IS AN ARM AND A LEG.

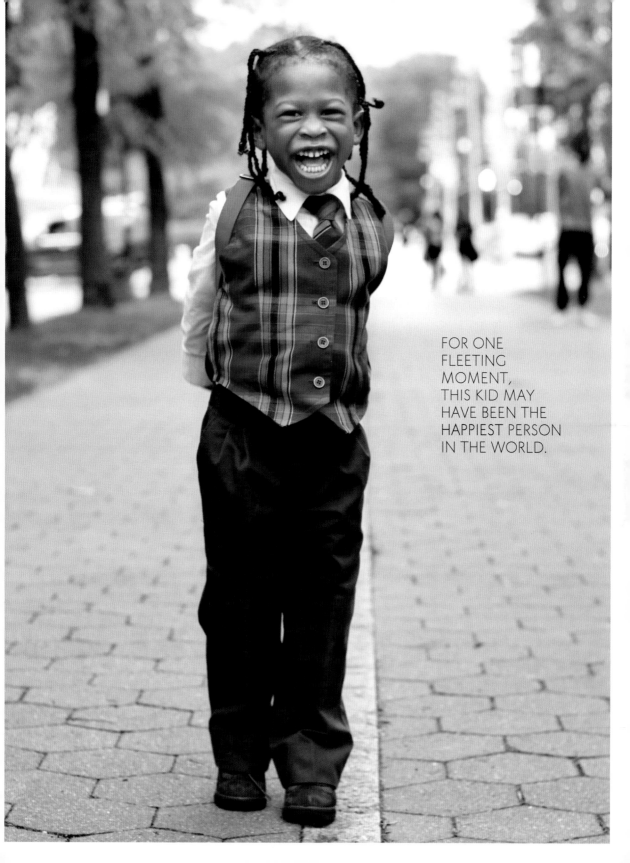

FOR ONE
FLEETING
MOMENT,
THIS KID MAY
HAVE BEEN THE
HAPPIEST PERSON
IN THE WORLD.

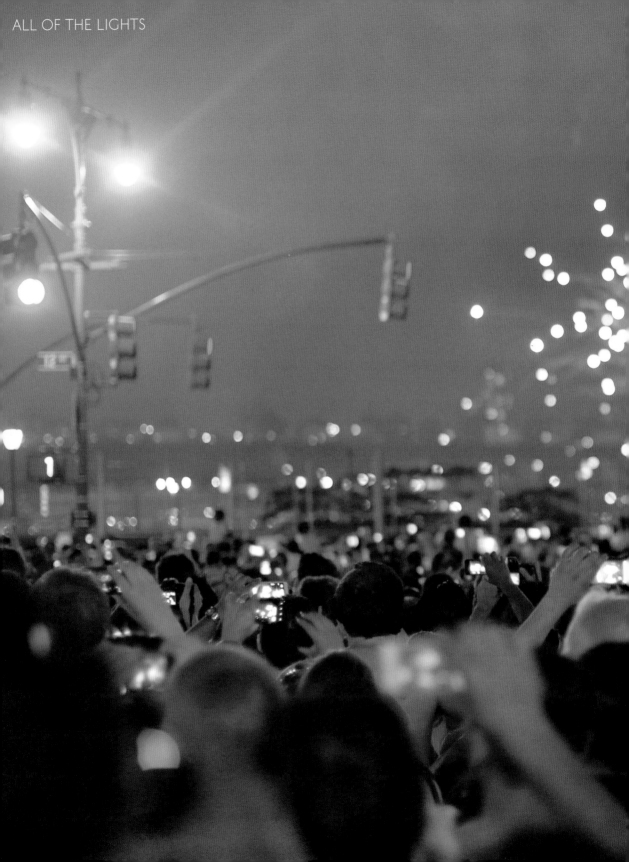

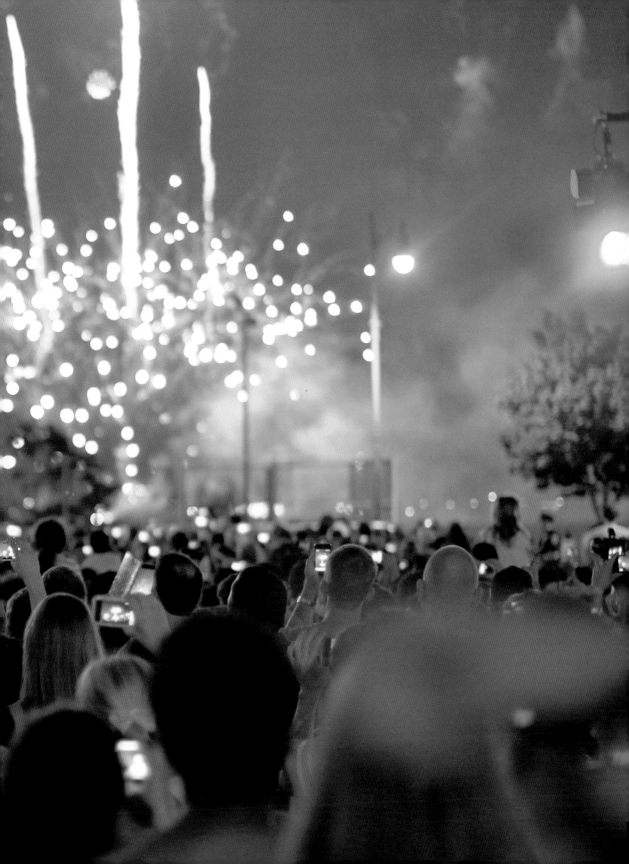

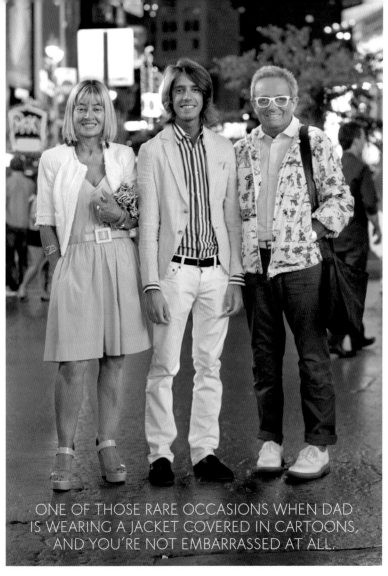

ONE OF THOSE RARE OCCASIONS WHEN DAD
IS WEARING A JACKET COVERED IN CARTOONS,
AND YOU'RE NOT EMBARRASSED AT ALL.

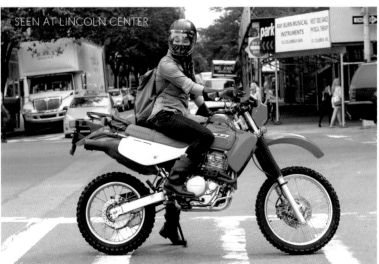

SEEN AT LINCOLN CENTER

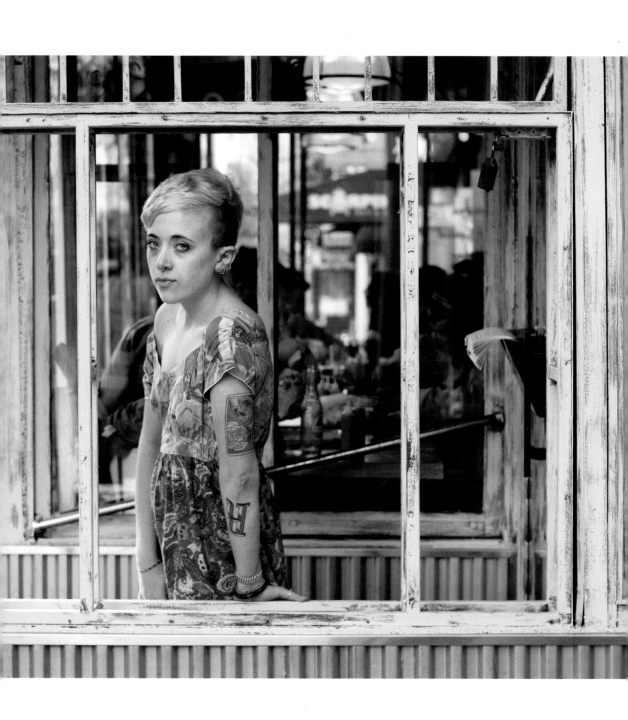

SHE HAD THE MOST BEAUTIFUL AWKWARDNESS.

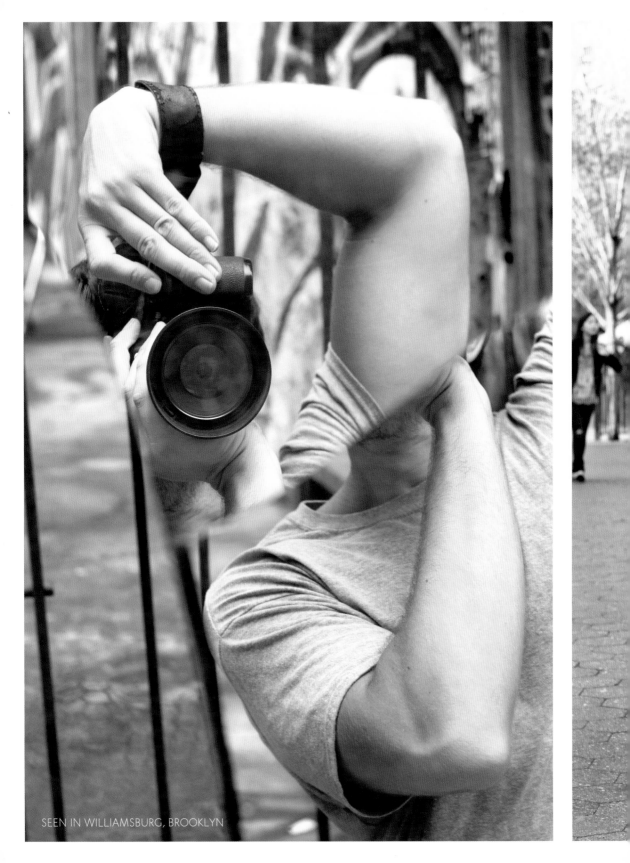

SEEN IN WILLIAMSBURG, BROOKLYN

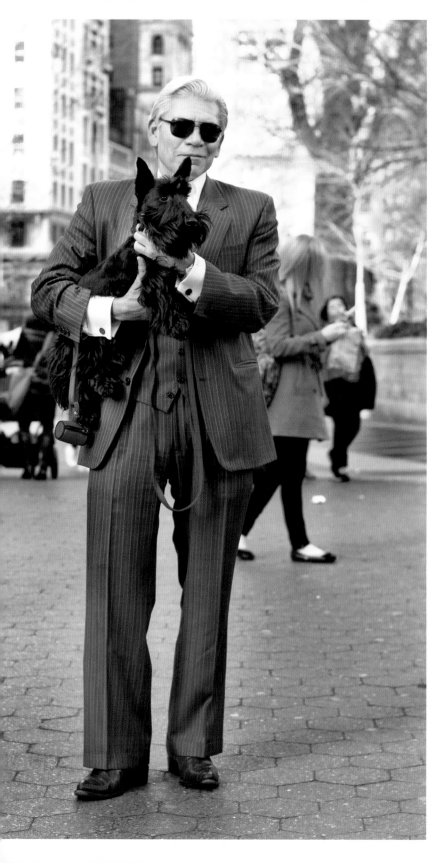

"I ALWAYS WORK
MY DOG'S NAME
INTO MY CLOSING
ARGUMENT."

"THAT'S SO
AWESOME."

"YEAH, BUT YOU
NEVER WANT ME
AS YOUR LAWYER."

"WHY'S THAT?"

"'CAUSE THAT
MEANS YOU'RE
IN DEEP, DEEP
FUCKING
TROUBLE."

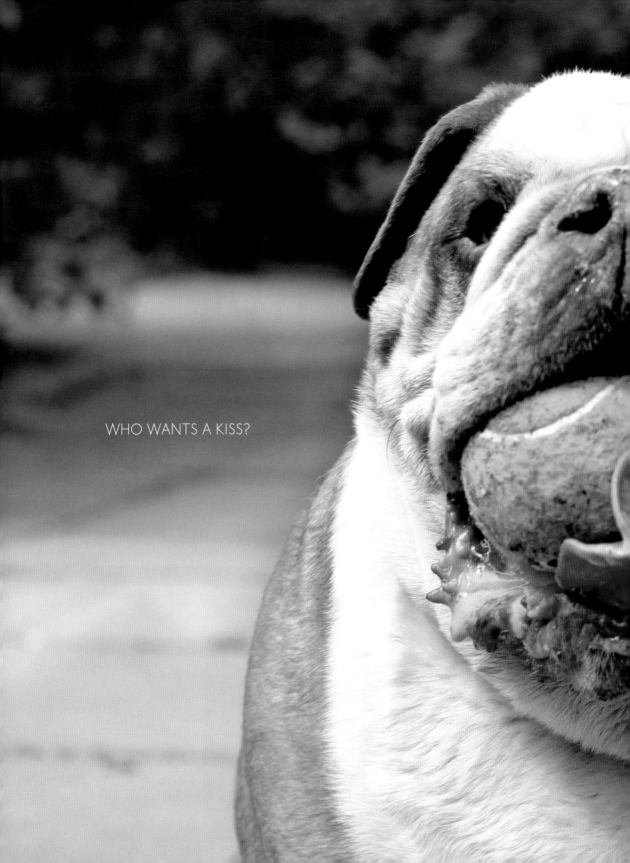

WHO WANTS A KISS?

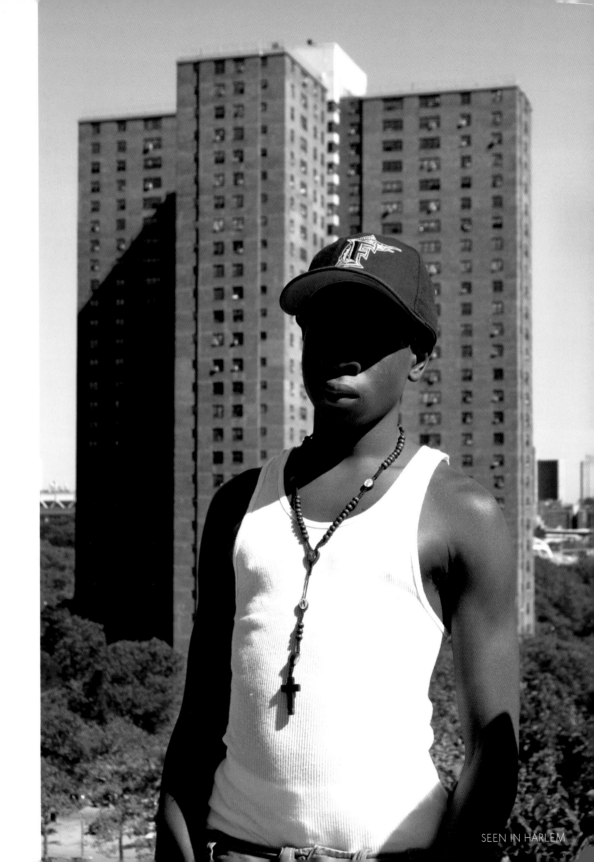

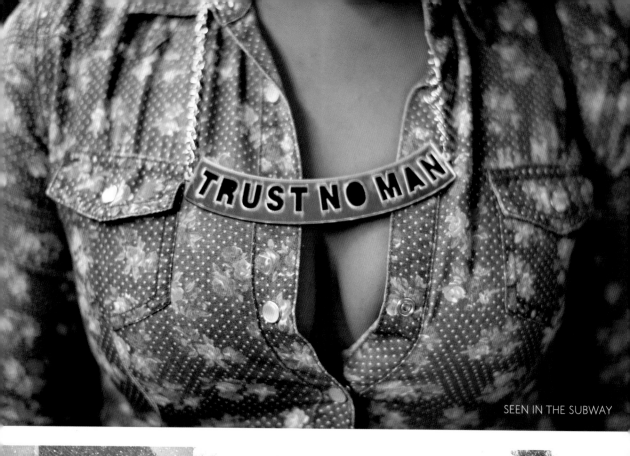

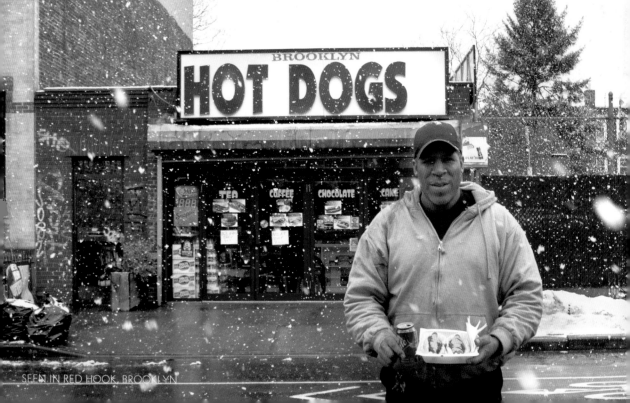

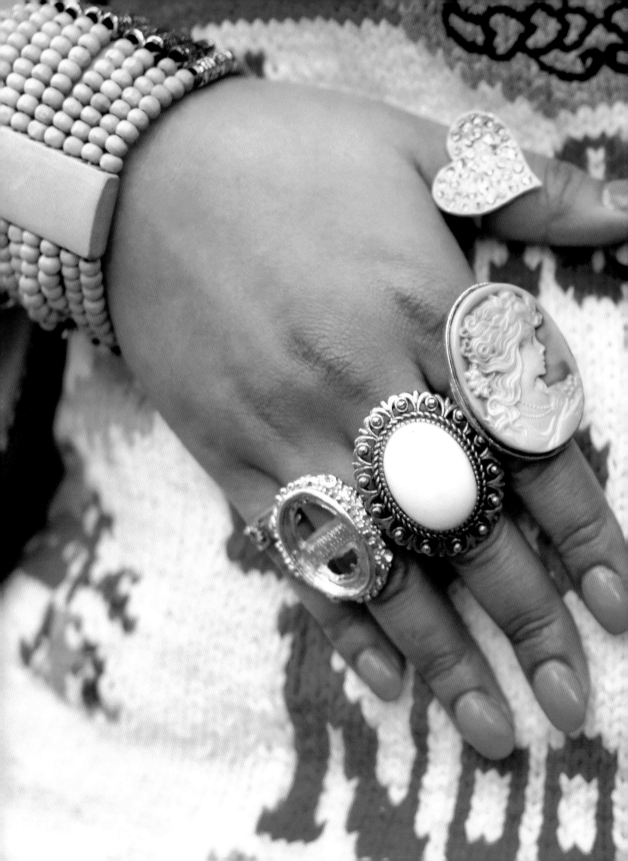

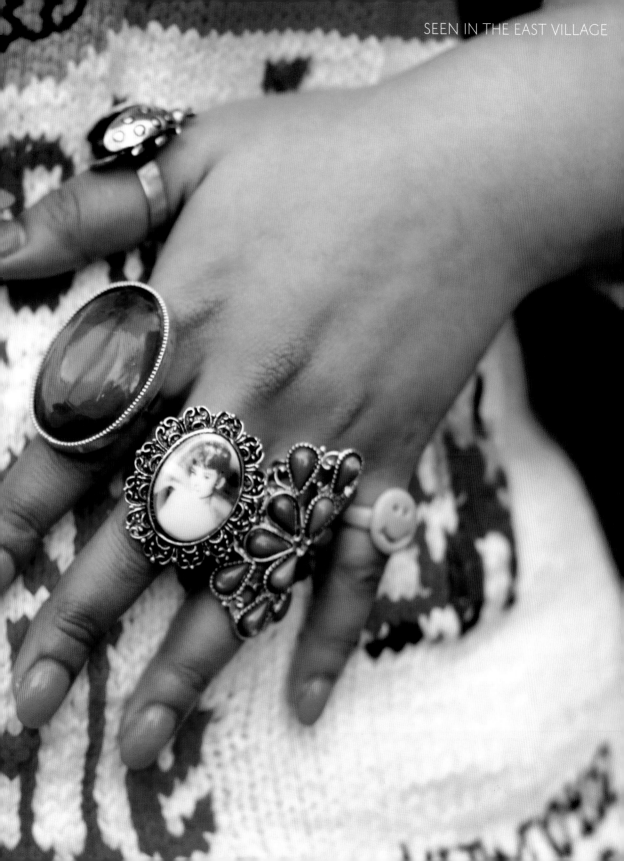

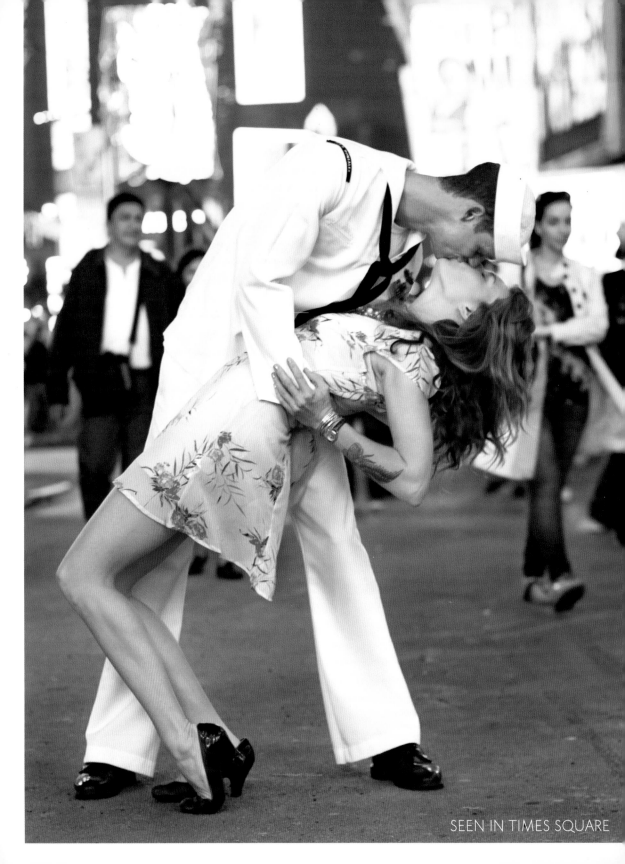

SEEN IN TIMES SQUARE

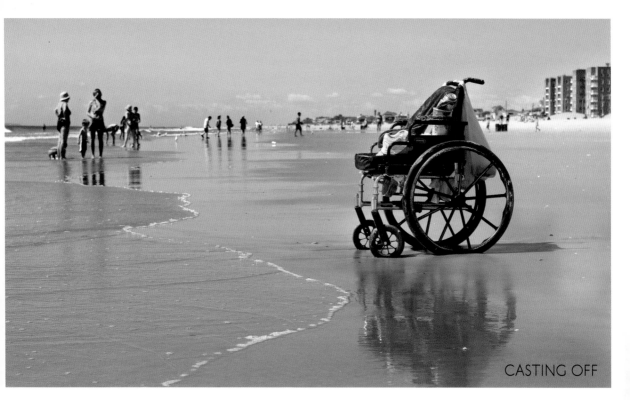

CASTING OFF

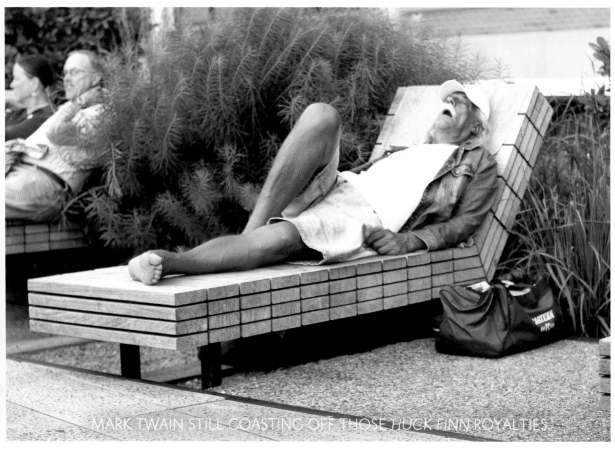

MARK TWAIN STILL COASTING OFF THOSE *HUCK FINN* ROYALTIES.

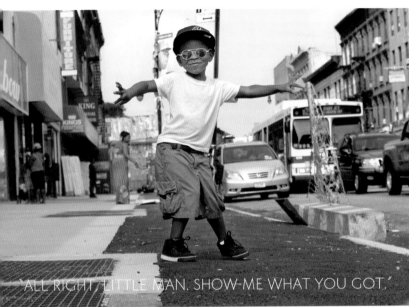

'ALL RIGHT, LITTLE MAN. SHOW-ME WHAT YOU GOT.'

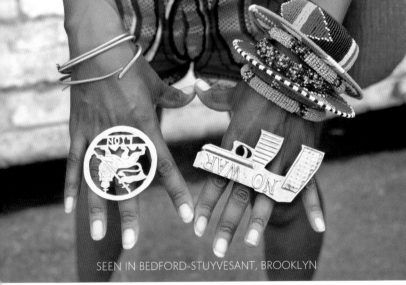

SEEN IN BEDFORD-STUYVESANT, BROOKLYN

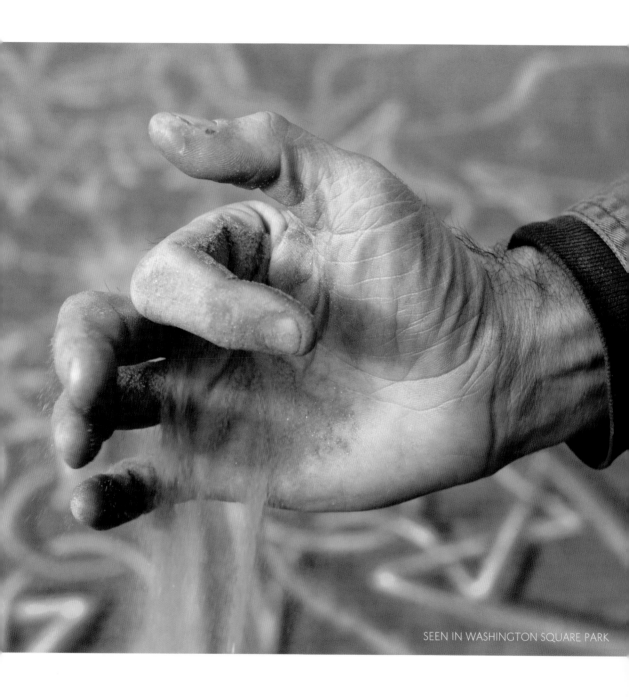

TESTOSTERONE REARED ITS HEAD ON AN UPTOWN 5 TRAIN LAST NIGHT.

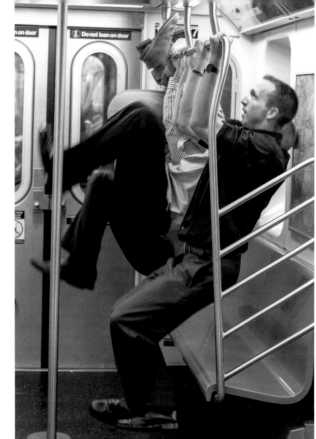

"I'M AN ILLUSTRATOR."

"WHERE CAN I SEE YOUR WORK?"

"TRUST ME, YOU'VE ALREADY SEEN IT."

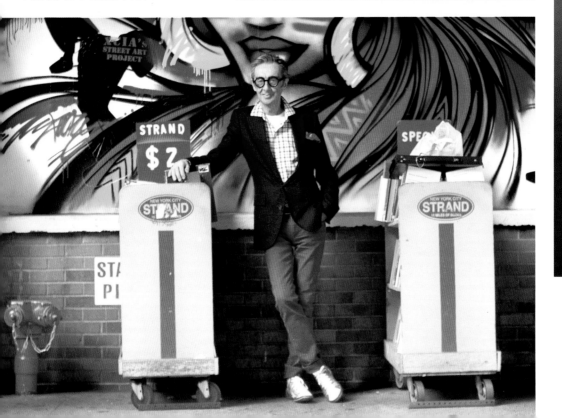

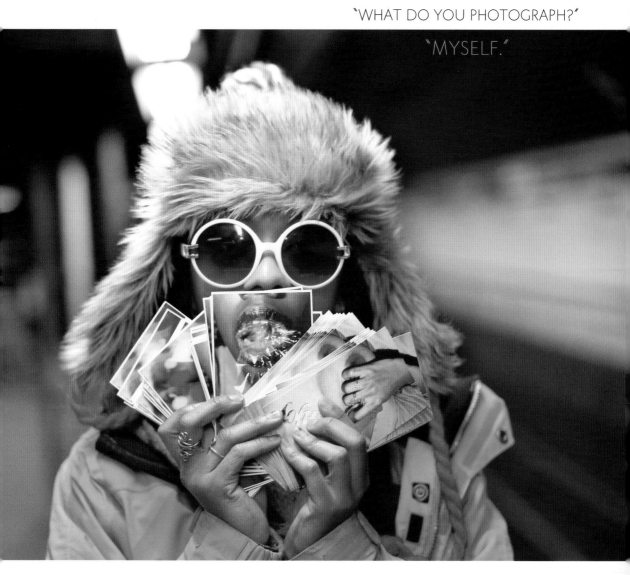

"I'M A PHOTOGRAPHER."

"WHAT DO YOU PHOTOGRAPH?"

"MYSELF."

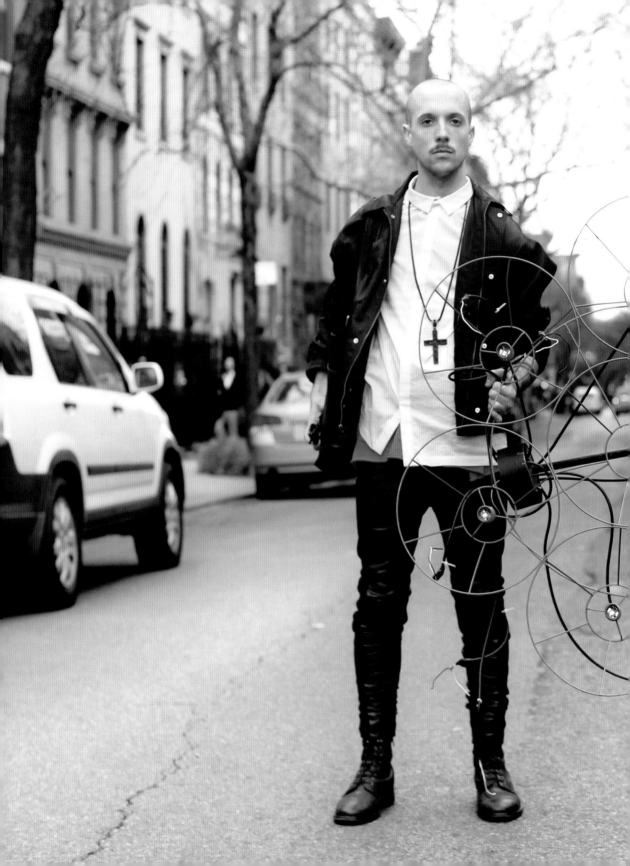

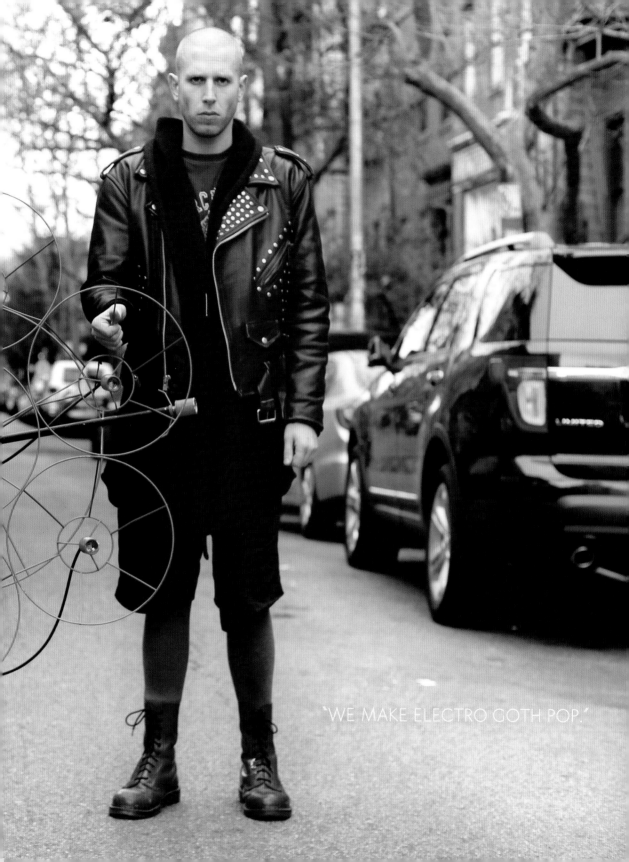

"WE MAKE ELECTRO GOTH POP."

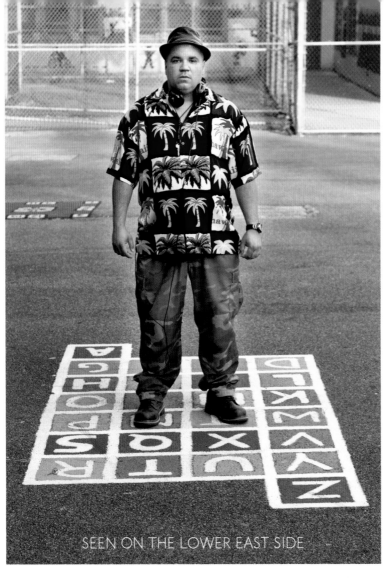

SEEN ON THE LOWER EAST SIDE

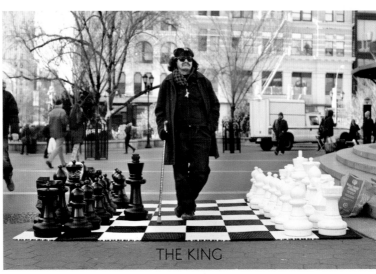

THE KING

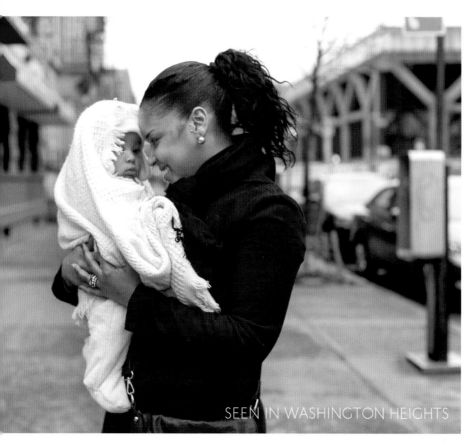

SEEN IN WASHINGTON HEIGHTS

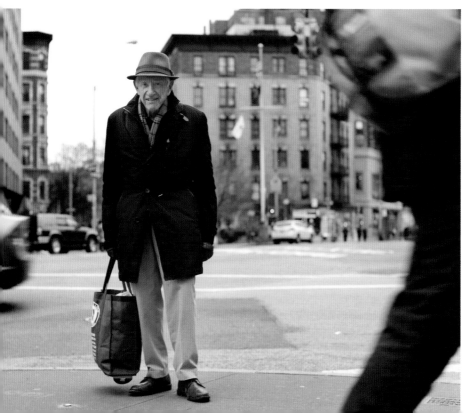

"I'VE BEEN MARRIED FIFTY YEARS. IF I WAS TO GIVE ONE PIECE OF ADVICE TO YOUNG COUPLES, IT'D BE THIS: NEVER LOSE YOUR TEMPER AT THE SAME TIME. IF SOMEBODY'S REALLY MAD, THE OTHER ONE BETTER MAKE A RETREAT."

I FOUND THESE TWO HUNCHED OVER ON BROADWAY, JUST LIKE THIS. IT SEEMED LIKE AN INTERESTING MOMENT, SO I QUICKLY SNAPPED THE PHOTO, THEN APPROACHED THEM TO FIND OUT WHAT WAS SO INTERESTING ABOUT TODAY'S PAPER. THE MAN SEEMED SHEEPISH WHEN HE ANSWERED: "MY FILM JUST GOT REVIEWED BY *THE NEW YORK TIMES*," HE SAID, "SO I'M SHOWING MY DAUGHTER."

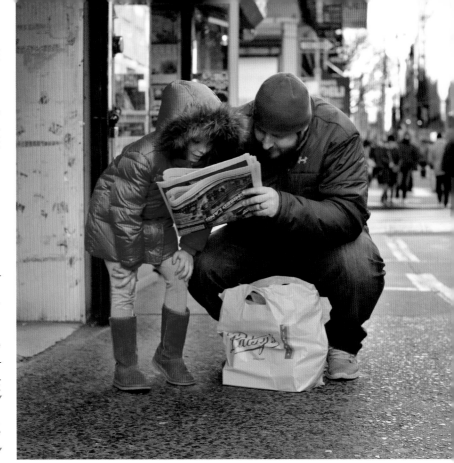

SOMETIMES THE LOUDEST PERSONAS BELONG TO THE QUIETEST PEOPLE.

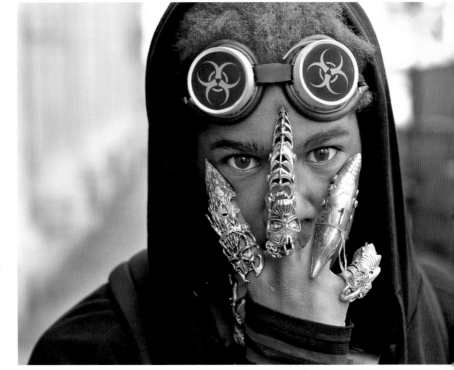

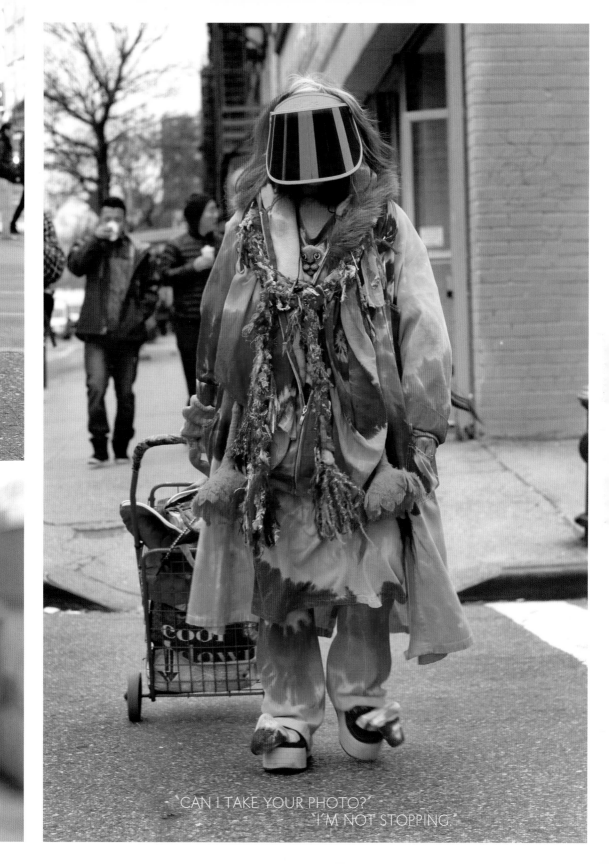

'CAN I TAKE YOUR PHOTO?'
'I'M NOT STOPPING.'

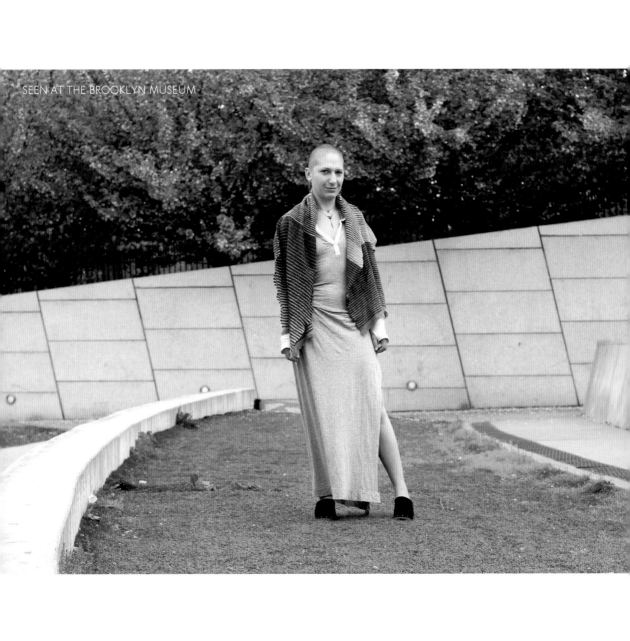

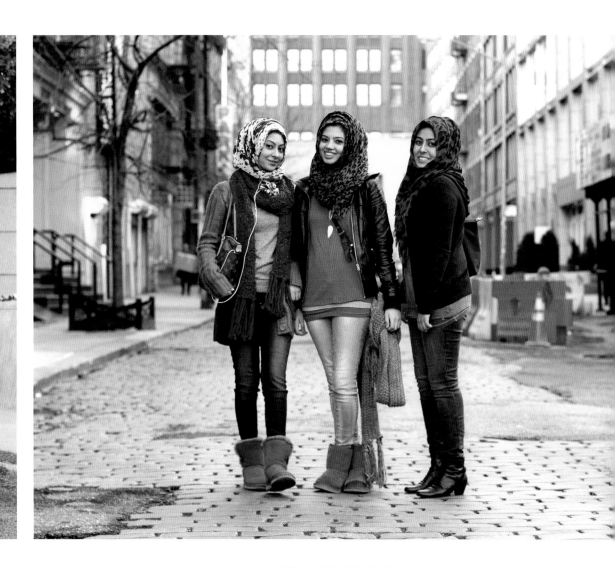

THE WILDFLOWERS

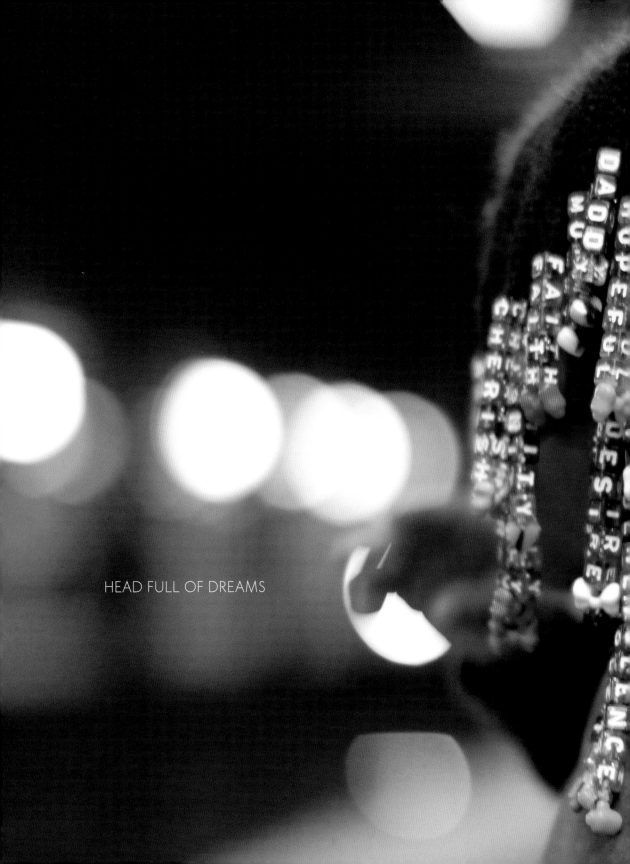

HEAD FULL OF DREAMS

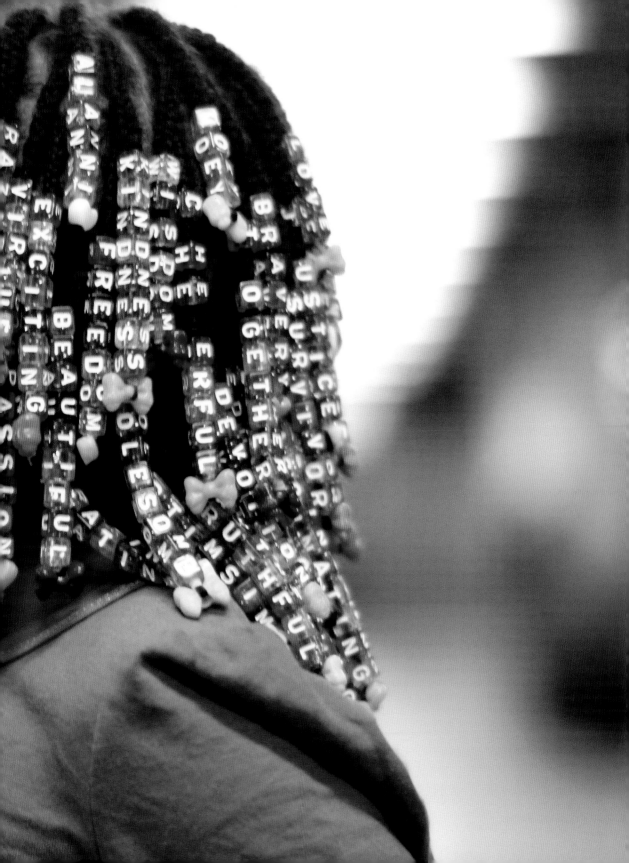

"I'M NINETY YEARS OLD AND I RIDE THIS THING AROUND EVERYWHERE. I DON'T SEE WHY MORE PEOPLE DON'T USE THEM. I CARRY MY CANE IN THE BASKET, I GET ALL MY SHOPPING DONE, I CAN GO EVERYWHERE. I'VE NEVER HIT ANYONE AND NEVER BEEN HIT. OF COURSE, I RIDE ON THE SIDEWALK, WHICH I DON'T THINK I'M SUPPOSED TO DO, BUT STILL . . ."

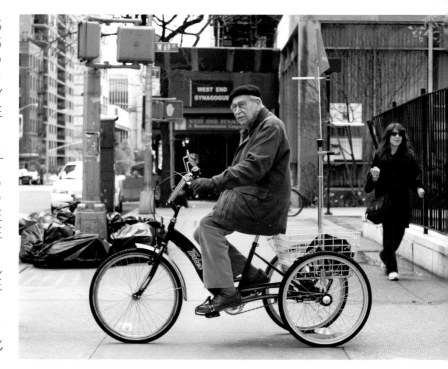

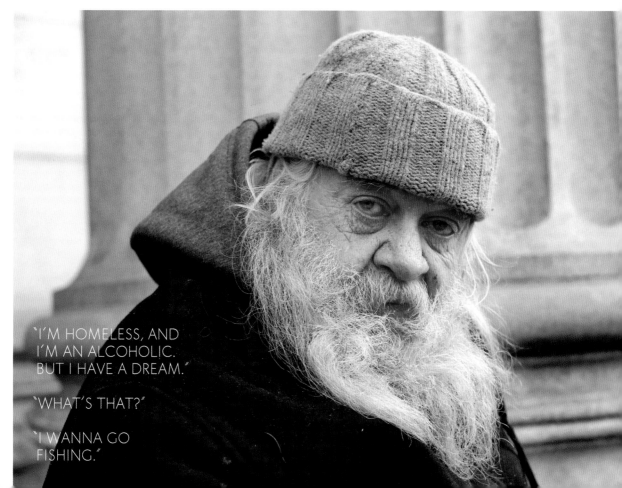

"I'M HOMELESS, AND I'M AN ALCOHOLIC. BUT I HAVE A DREAM."

"WHAT'S THAT?"

"I WANNA GO FISHING."

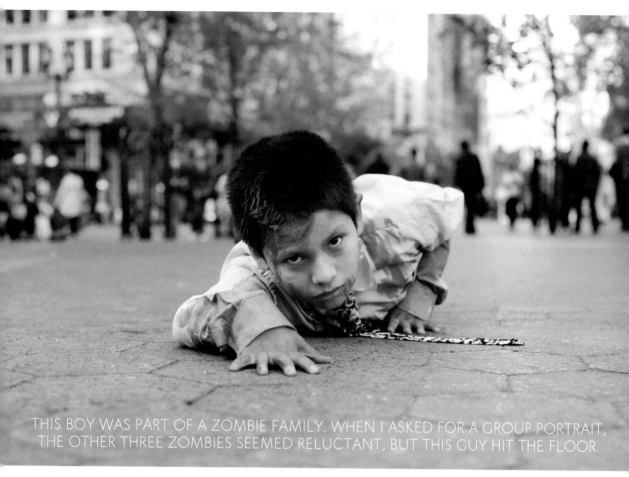

THIS BOY WAS PART OF A ZOMBIE FAMILY. WHEN I ASKED FOR A GROUP PORTRAIT, THE OTHER THREE ZOMBIES SEEMED RELUCTANT, BUT THIS GUY HIT THE FLOOR.

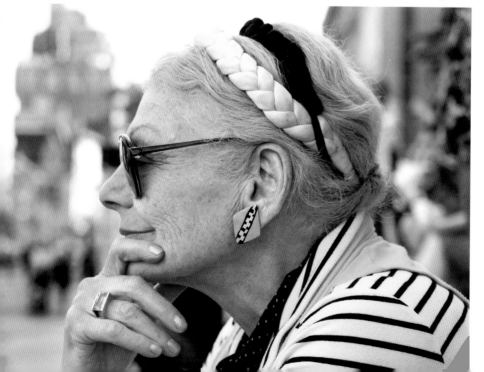

`I'M EIGHTY YEARS OLD. AN EIGHTY-SIX-YEAR-OLD MAN WAS JUST SPEAKING TO ME IN A FLIRTATIOUS MANNER, I BELIEVE. BUT HIS DAUGHTER PULLED HIM AWAY.'

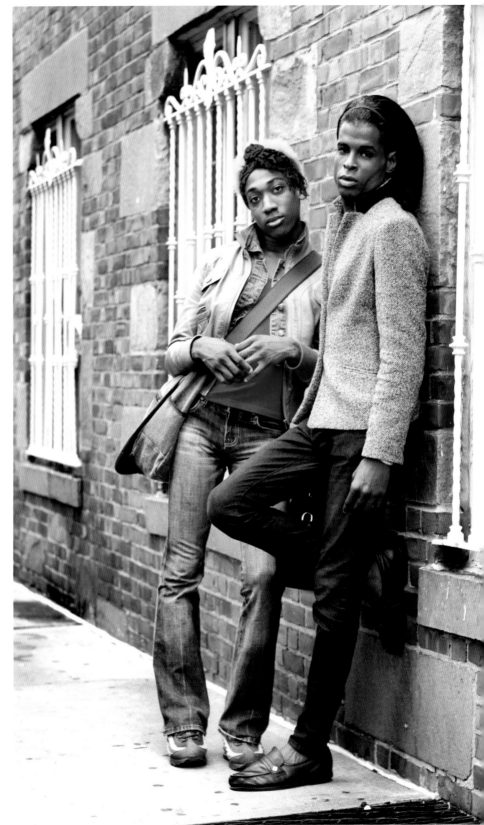

THEY WERE
HAPPY WITH
HOW THE
PHOTO CAME
OUT, IF THE
SHRIEKING
WAS ANY
INDICATION.

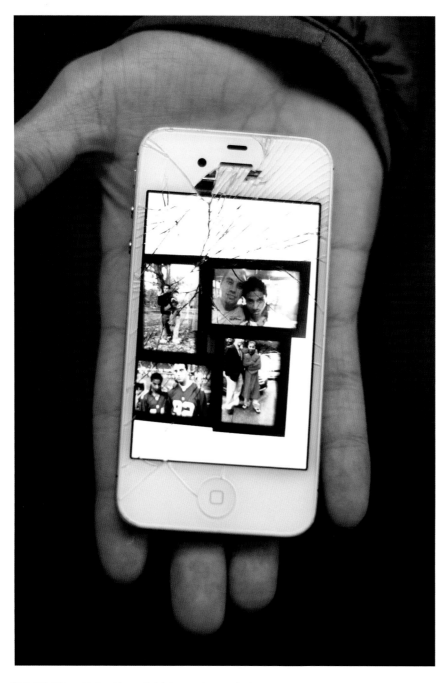

"I NEVER HAD ANY FAMILY GROWING UP. BUT I STILL WENT TO SCHOOL EVERY DAY. ONE DAY, WHEN I WAS IN ELEVENTH GRADE, MY ENGLISH TEACHER CAME UP TO ME AND SAID: 'IF YOU GRADUATE, I'LL ADOPT YOU. I'LL SHOW YOU THE LIFE. YOU'LL DO THINGS YOU NEVER DREAMED OF.' AND HE KEPT HIS PROMISE. HE MADE IT LEGAL AND EVERYTHING. ON THE DAY I GRADUATED, HE WAS THE ONLY FAMILY I HAD THERE. HE'S TAKEN ME EVERYWHERE SINCE THEN. I'VE DONE ALL KINDS OF THINGS."

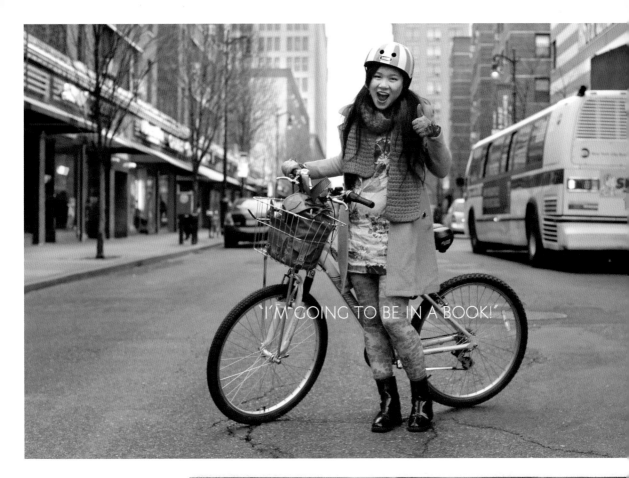

"I'M GOING TO BE IN A BOOK!"

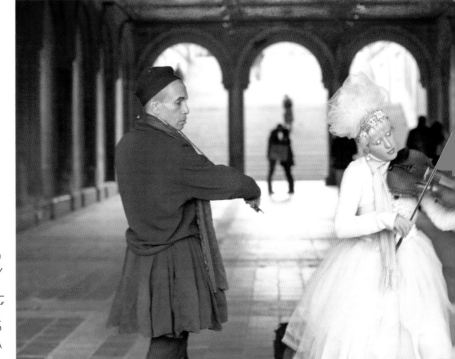

THESE TWO
PERFORM A VERY
UNCONVENTIONAL
"PRAYERFORMANCE,"
WHICH INVOLVES
CHANTING IN A
MADE-UP LANGUAGE.

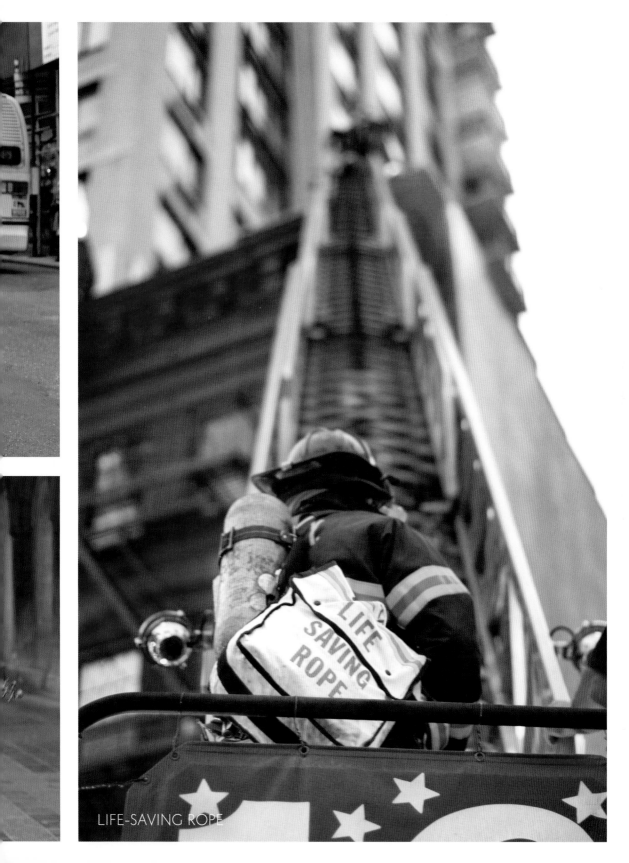

LIFE-SAVING ROPE

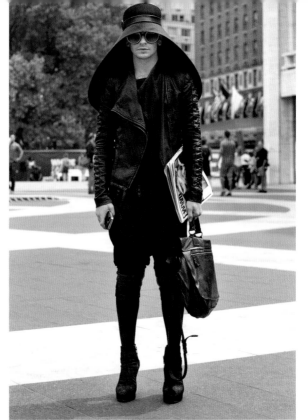

GARTH VADER
DISAPPOINTS
HIS FATHER BY
SHUNNING
THE THRONE
AND PURSUING
A FASHION
CAREER.

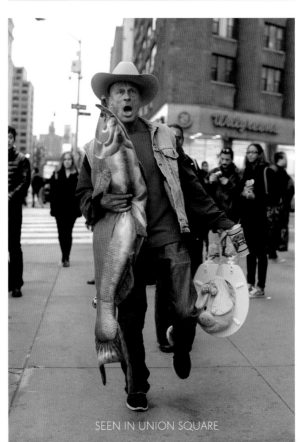

SEEN IN UNION SQUARE

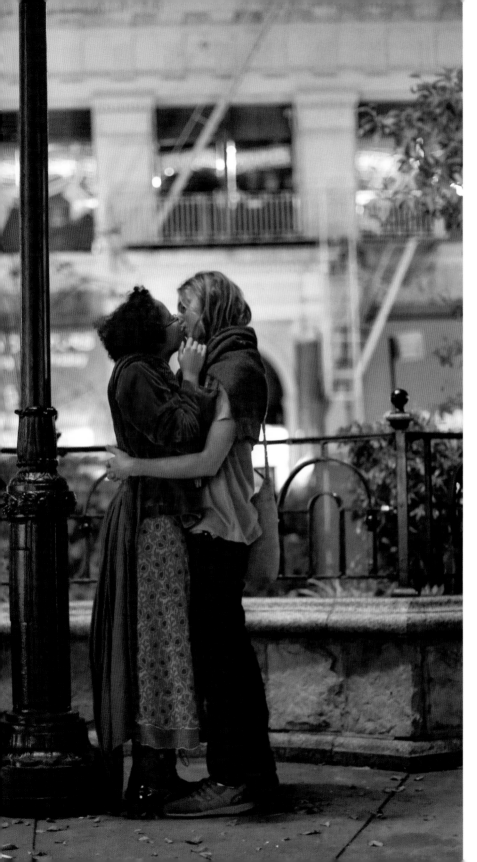

AFTER THEY
FINISHED KISSING,
SHE TOOK OFF
HER BLUE CAPE
AND LAID IT
OVER A WOMAN
SLEEPING ON A
NEARBY BENCH.
IT WAS SUCH A
POETIC MOMENT,
I ACTUALLY
CHASED THEM
DOWN TO
FACT-CHECK
MY OWN EYES.

`EXCUSE ME.
WAS THAT YOUR
BLUE BLANKET?´

`YES.´

`AND YOU JUST
GAVE IT TO HER?´

`YES, WHY?´

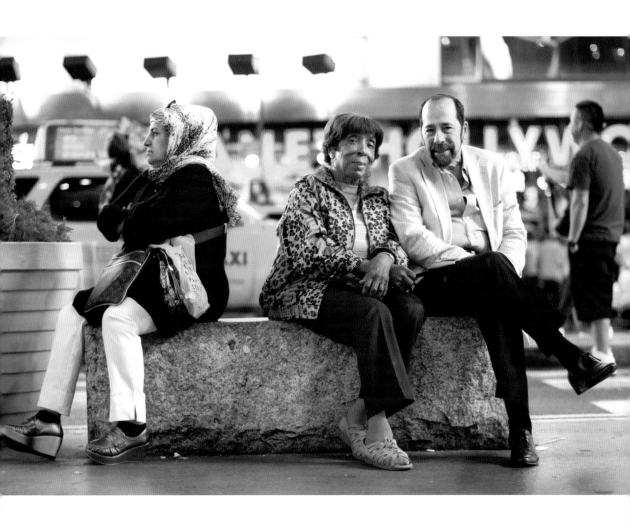

"HE DOES ABSOLUTELY EVERYTHING FOR ME. I'M COMPLETELY SPOILED."

"I USED TO BE A BUTCHER. SHE USED TO COME INTO MY STORE. EVERY WEEK I WOULD SET APART THE BEST PIECE OF MEAT FOR HER. AND LOOK HOW IT TURNED OUT—I ENDED UP WITH THE **BEST PIECE OF MEAT OF THEM ALL**."

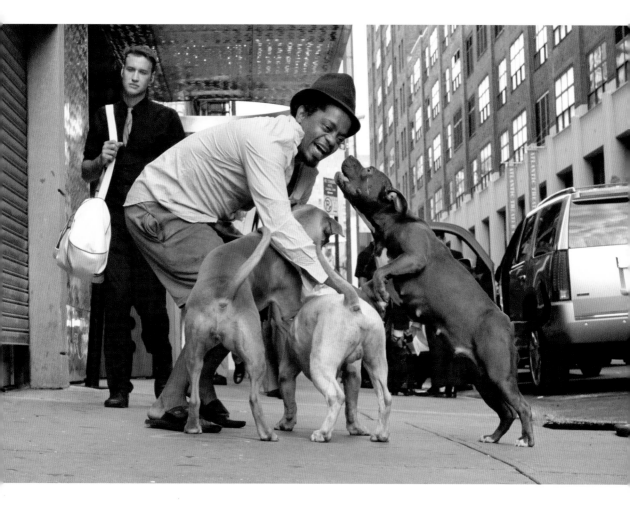

ONE NANOSECOND LATER, AN UNFORTUNATE HEAD-BUTT
BROUGHT THIS PHOTO SHOOT TO A SCREECHING HALT.

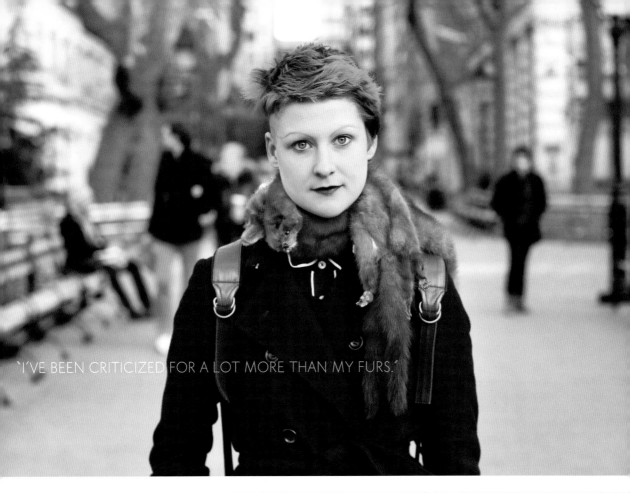

"I'VE BEEN CRITICIZED FOR A LOT MORE THAN MY FURS."

THIS MAN
NEEDED
A BREAK
FROM THE
MUSEUM
EXHIBITS,
SO HE
TURNED TO
SOMETHING
MORE
AMUSING.

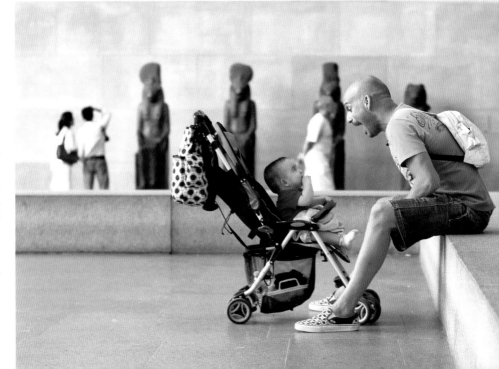

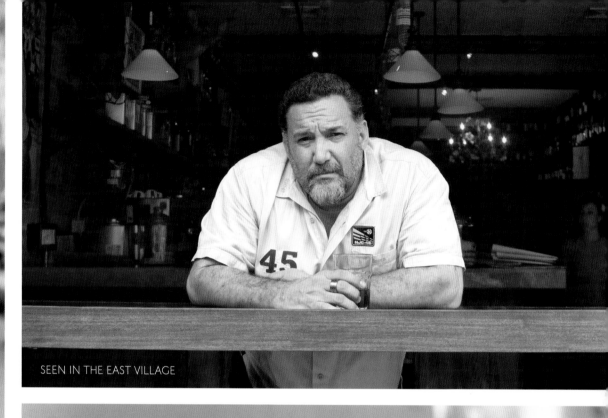

SEEN IN THE EAST VILLAGE

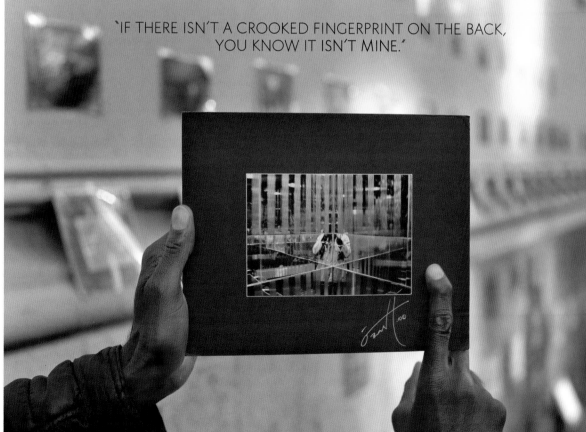

"IF THERE ISN'T A CROOKED FINGERPRINT ON THE BACK,
YOU KNOW IT ISN'T MINE."

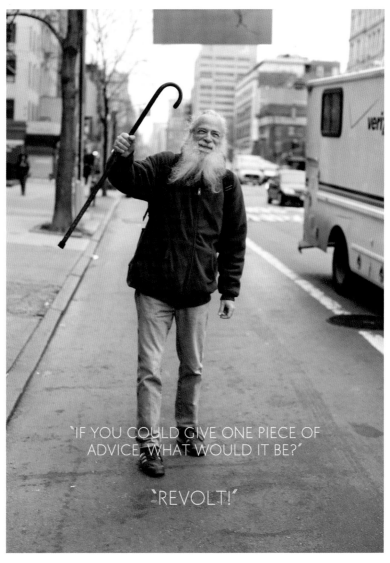

"IF YOU COULD GIVE ONE PIECE OF ADVICE, WHAT WOULD IT BE?"

"REVOLT!"

AUTUMN

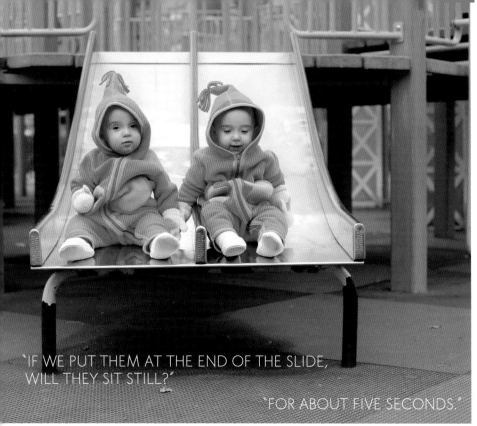

`IF WE PUT THEM AT THE END OF THE SLIDE,
WILL THEY SIT STILL?`

`FOR ABOUT FIVE SECONDS.`

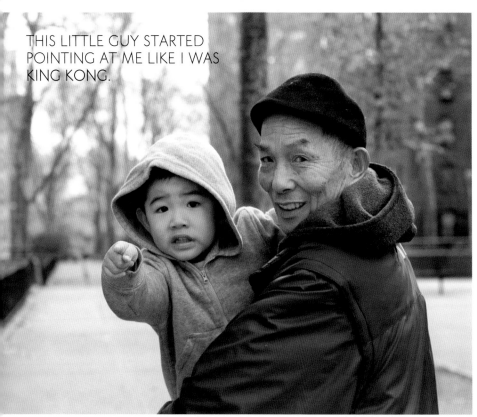

THIS LITTLE GUY STARTED
POINTING AT ME LIKE I WAS
KING KONG.

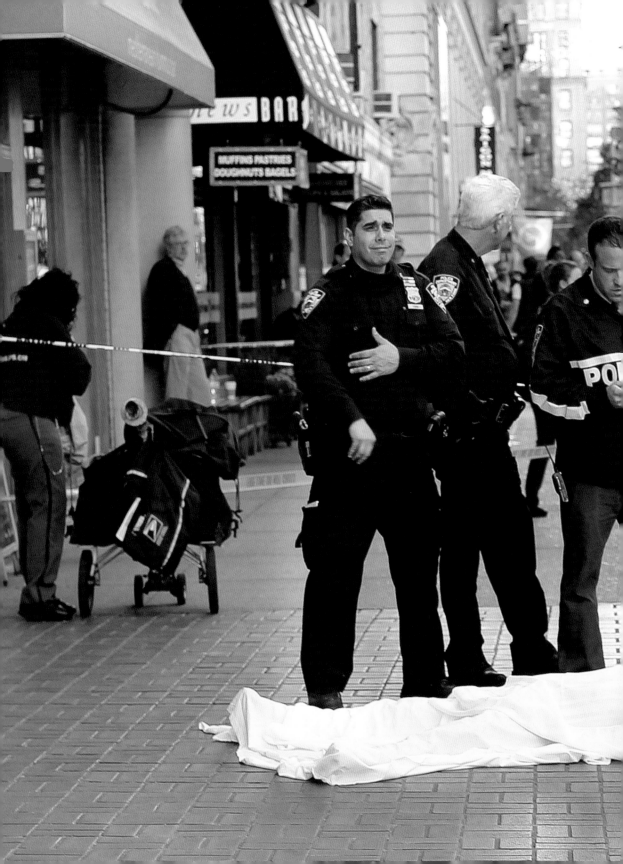

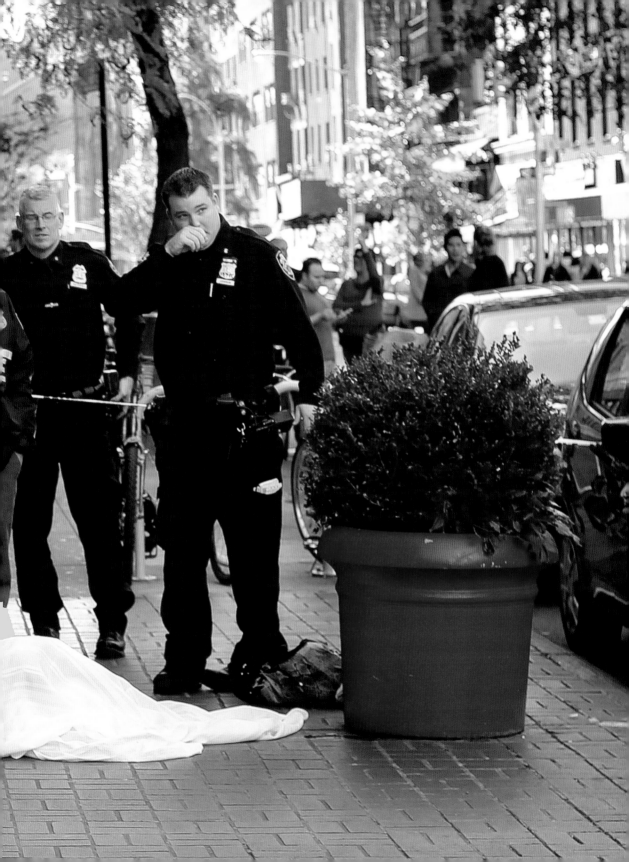

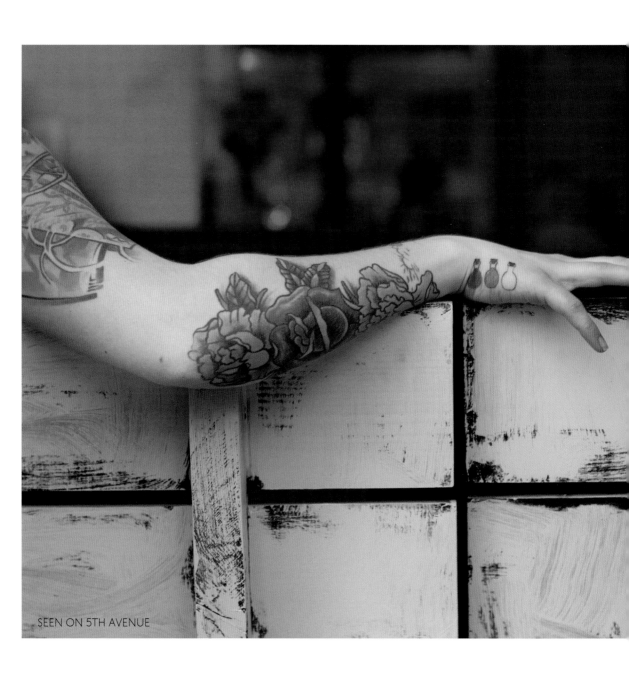

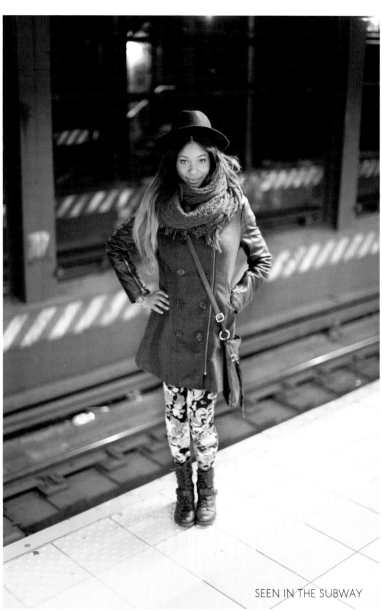

SEEN IN THE SUBWAY

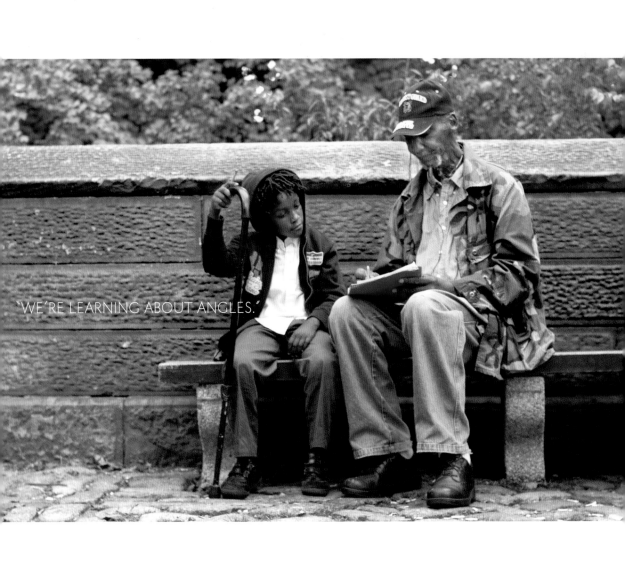

"WE'RE LEARNING ABOUT ANGLES."

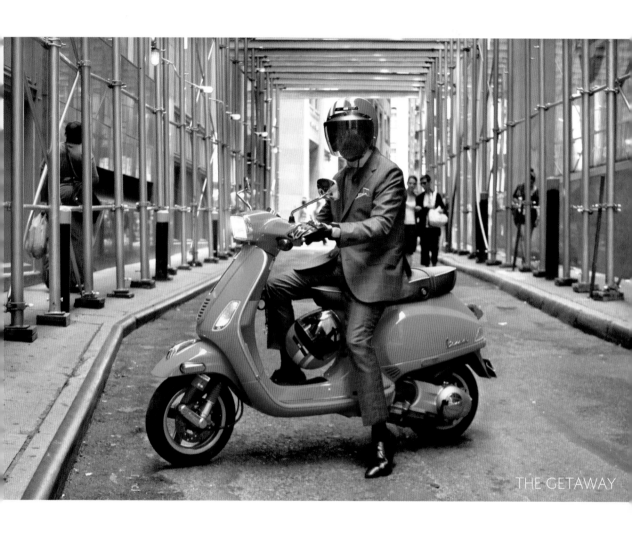

THE GETAWAY

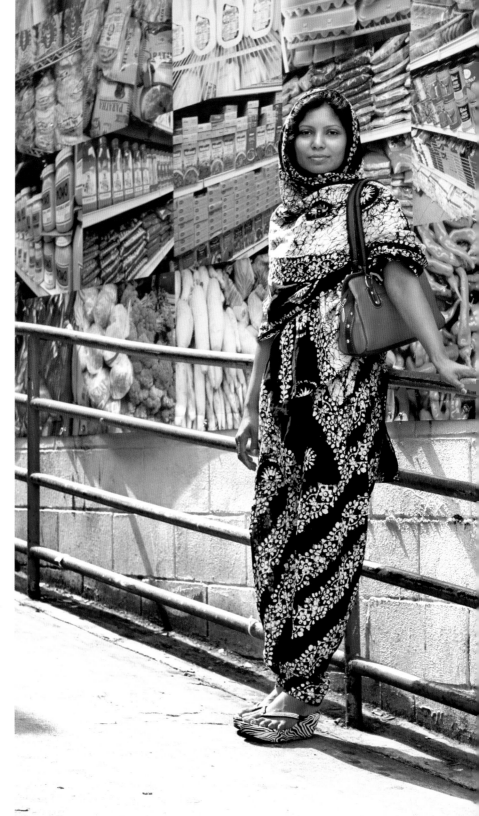

SHE WAS
GUIDING HER
TWO CHILDREN
DOWN A
SIDEWALK
IN JACKSON
HEIGHTS,
QUEENS.
NORMALLY I'D
HAVE ASKED
FOR A GROUP
PORTRAIT, BUT
THIS TIME I
THOUGHT MOM
DESERVED A
STANDALONE.

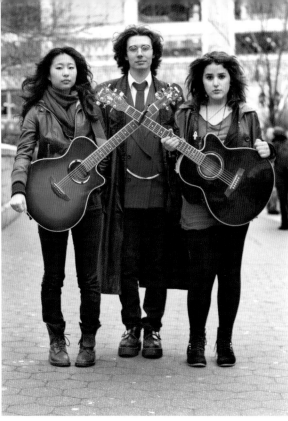

AFTER THE
PHOTO WAS
TAKEN, THE
GUY LOOKED
AT IT AND SAID:
"I'VE NEVER
FELT LIKE MORE
OF A MAN."

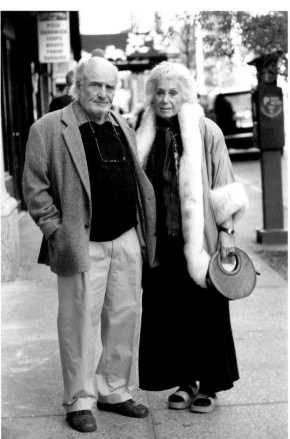

"ARE YOU MARRIED?"

"WE'RE PRACTICING."

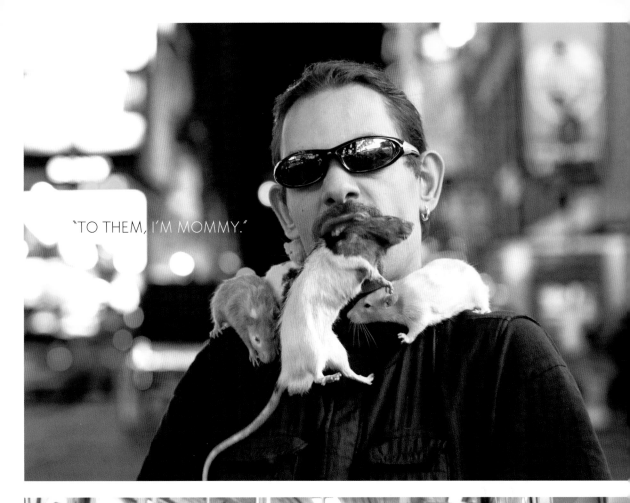

"TO THEM, I'M MOMMY."

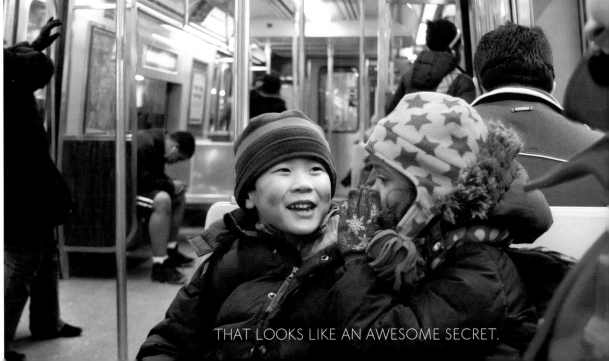

THAT LOOKS LIKE AN AWESOME SECRET.

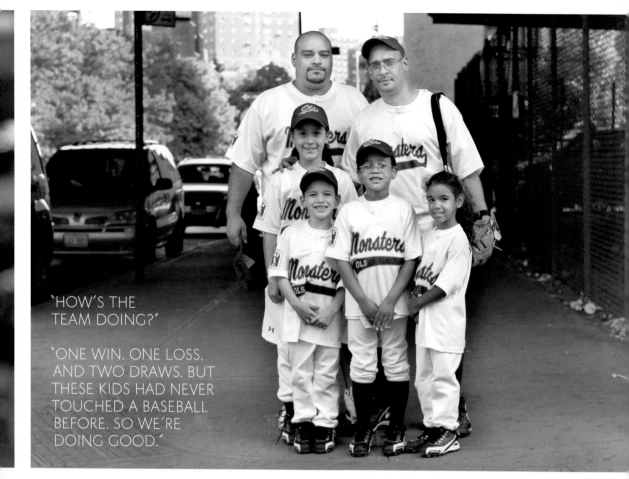

"HOW'S THE
TEAM DOING?"

"ONE WIN. ONE LOSS.
AND TWO DRAWS. BUT
THESE KIDS HAD NEVER
TOUCHED A BASEBALL
BEFORE. SO WE'RE
DOING GOOD."

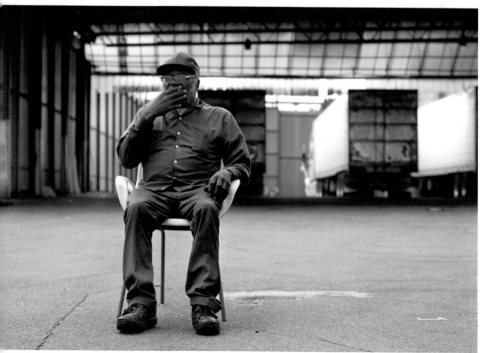

JUDGING BY
EVERYONE'S
EXCITEMENT,
THIS DAY WILL
ALWAYS BE
REMEMBERED
AT THE
LOADING
DOCK AS
THE DAY
"LARRY MADE
IT ON THE
INTERNET."

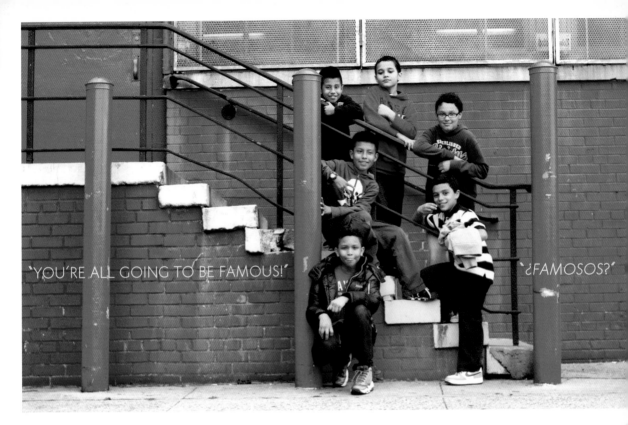

"YOU'RE ALL GOING TO BE FAMOUS!" "¿FAMOSOS?"

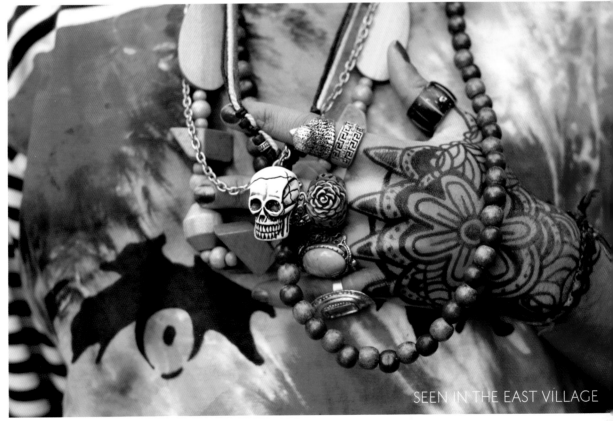

SEEN IN THE EAST VILLAGE

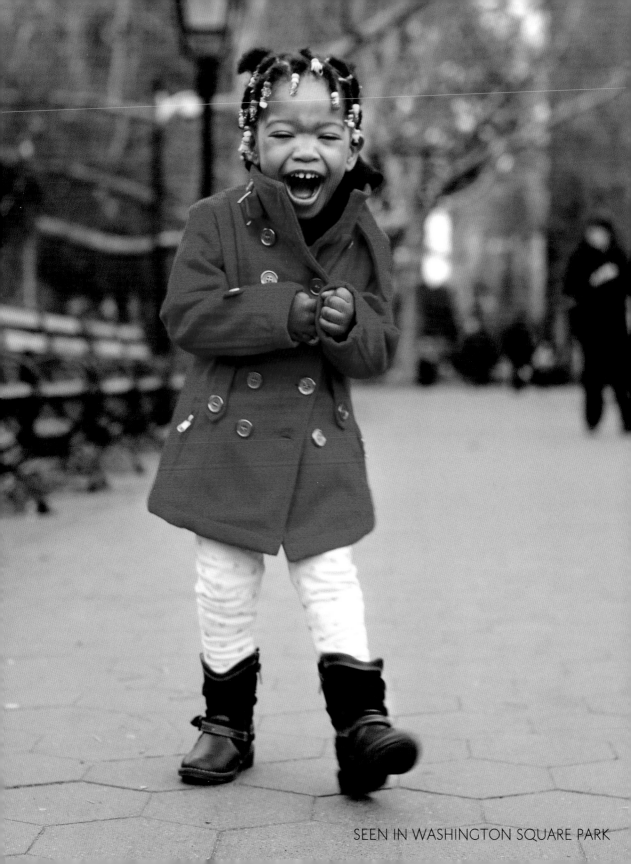

SEEN IN WASHINGTON SQUARE PARK

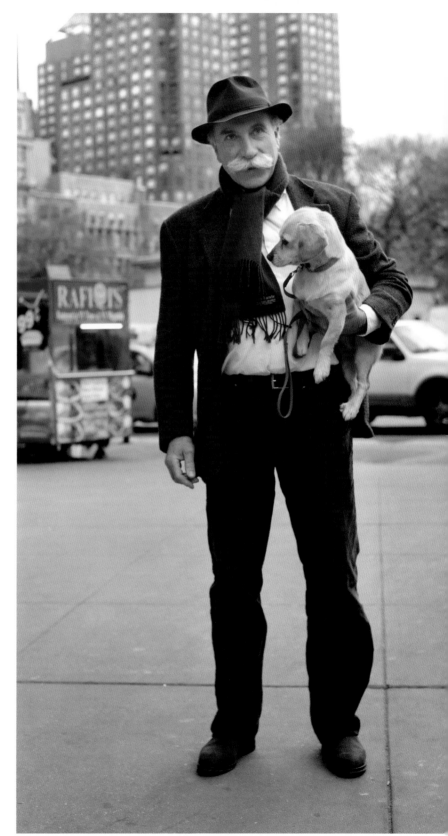

HYPERMASCULINE
MYSTERY MAN
COMPLEMENTS
EPIC MUSTACHE
WITH NEW PUPPY.

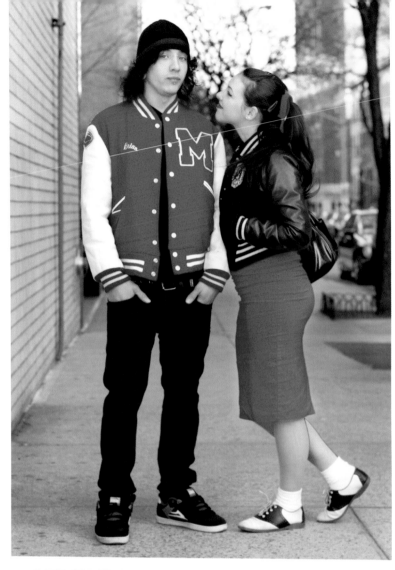

'WELL, I
ALWAYS
DRESS LIKE
THIS—THEN
I BOUGHT
HIM THE
JACKET AND
MADE HIM
WEAR IT.'

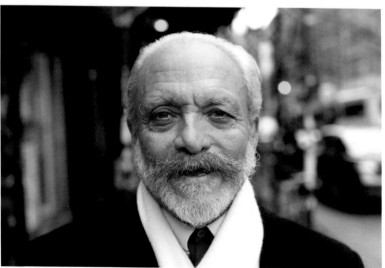

'IF YOU
COULD GIVE
ONE PIECE OF
ADVICE, WHAT
WOULD IT
BE?'

'PREPARE FOR
THE WORST.'

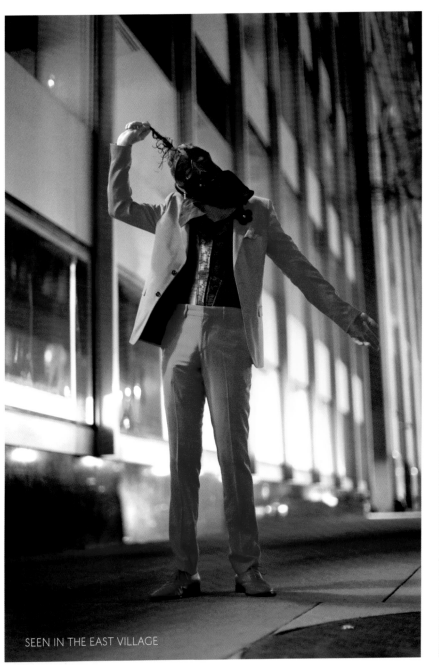

SEEN IN THE EAST VILLAGE

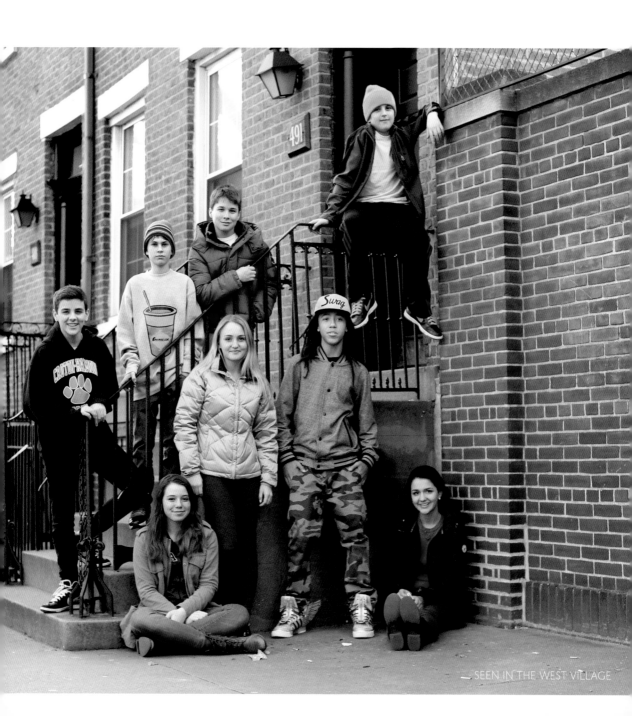

SOME DAYS I WORRY THAT I WON'T FIND
ANYONE TO PHOTOGRAPH. THEN I TURN THE
CORNER AND SEE A GIANT TREE MAN.

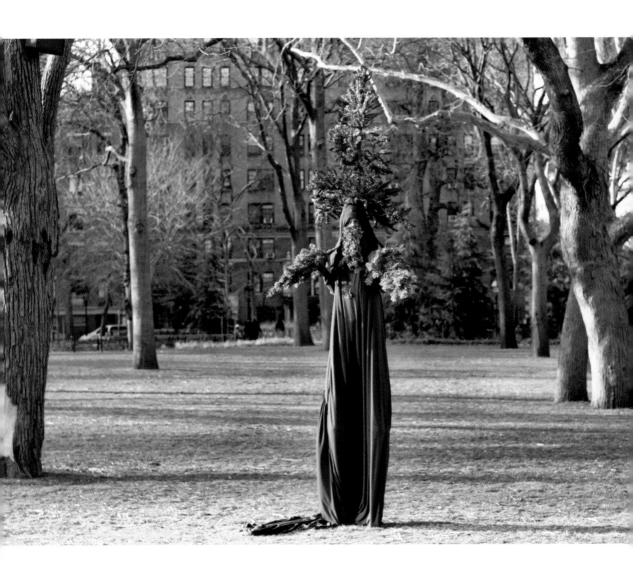

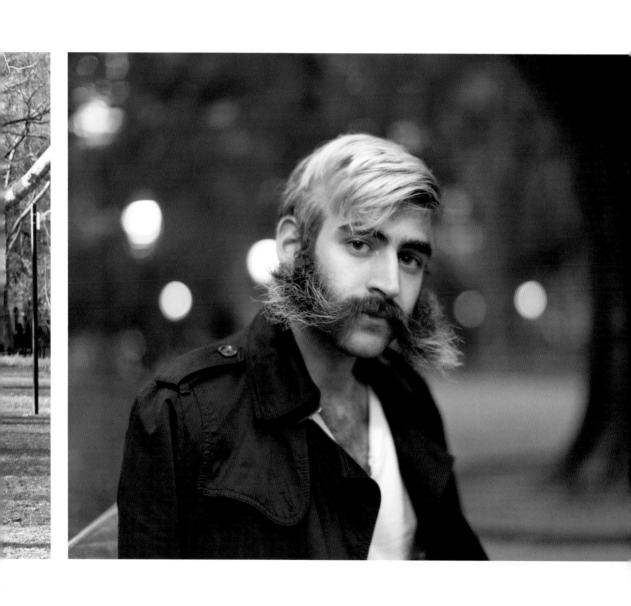

'I'M STUDYING TO GET A PH.D. IN NEUROSCIENCE, BUT IN MY FREE TIME I LIKE TO PERFORM IN BURLESQUE SHOWS.'

'EVERYONE ON
THE SUBWAY
IS ALWAYS
ABSORBED BY
THEIR PHONE
OR A BOOK.
I'M A SOCIAL
PERSON, SO THIS
IS MY WAY OF
INTERACTING
WITHOUT
BOTHERING
ANYONE.'

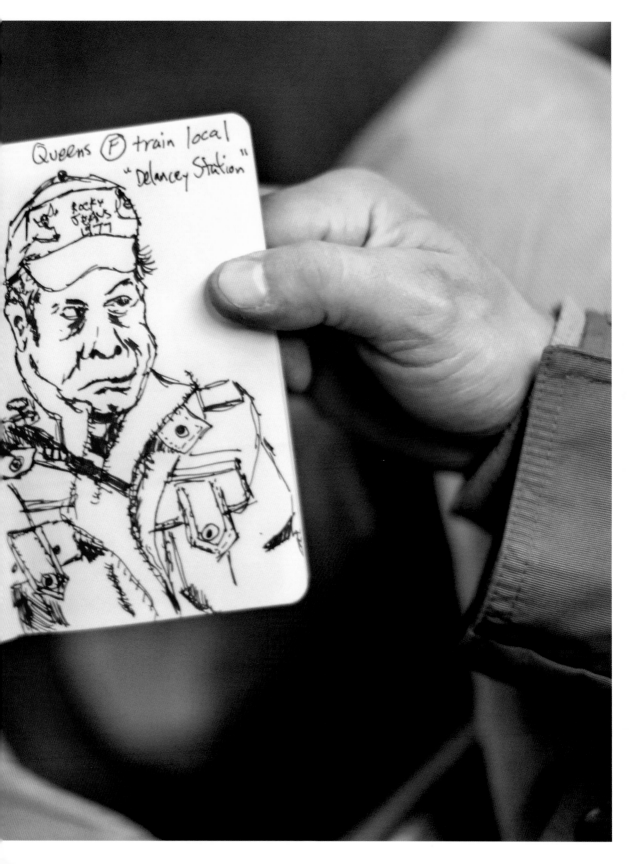

'WHAT'S YOUR STORY?'

'JUST RUNNING FOR PRESIDENT.'

HE THEN HANDED ME A PIECE OF LITERATURE THAT OUTLINED HIS PLATFORM. AMONG OTHER THINGS, HE PLANNED TO FIGHT FOR MANDATORY TOOTH-BRUSHING LAWS. HE ALSO HOPED TO PROVIDE 'A FREE PONY FOR EVERY AMERICAN.'

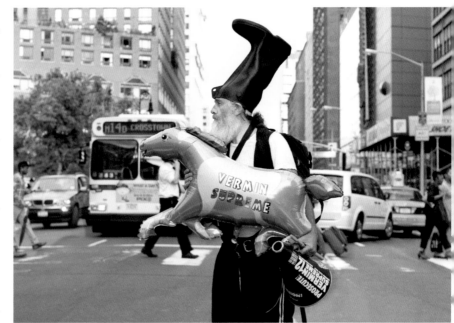

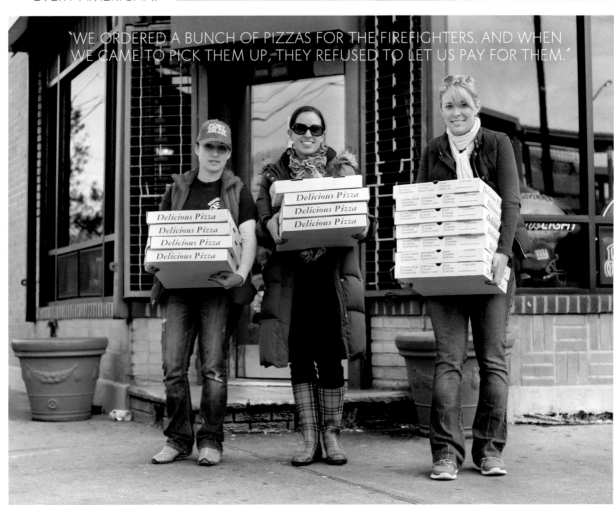

'WE ORDERED A BUNCH OF PIZZAS FOR THE FIREFIGHTERS. AND WHEN WE CAME TO PICK THEM UP, THEY REFUSED TO LET US PAY FOR THEM.'

A TRAFFIC CONE WAS KNOCKED OVER ON THE SIDEWALK DIRECTLY IN FRONT OF THESE MEN. I PICKED IT UP AND CASUALLY TOSSED IT ASIDE. THE MAN ON THE LEFT GOT REALLY STERN AND SAID: `I KNOW YOU DIDN'T JUST DO THAT TO MY CONE." I LOOKED AT HIM, WAITING FOR HIM TO LAUGH. A FEW SECONDS PASSED AND HIS FACE DIDN'T CHANGE. HE SEEMED GENUINELY UPSET. `I KNOW YOU DIDN'T JUST DO THAT," HE REPEATED.

THEN HE BURST OUT LAUGHING.

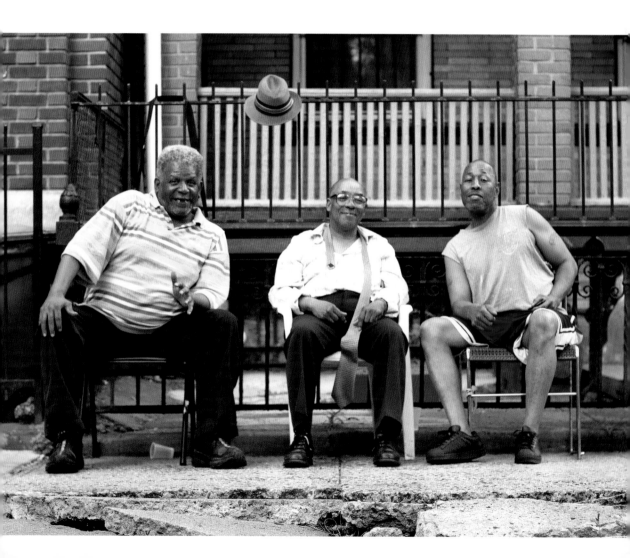

what day is it & in what month? these clocks never seemed alive
i can't keep up, & i can't back down, i've been losing so much time

"BLAH BLAH BLAH. You feel trapped in your life. what i'm hearing is this; hap
isn't worth any inconvenie

growing up isn't very helpful, when it comes down to it

when i was really little, i loved staring up at the night sky. it alw

fascinated me. the way the darker it got, the more stars would come

they'd almost always be there, every time i woke from a bad dr

& ran to the window, everytime *the daytime sunshine just wasn't enough,*

time i just *needed* reassurance that they hadn't gone anywhere

odd, but before the age of eight i don't have one a single memory

a cloudy night. */ *R seven years later, i'm still just a girl, looking.

for comfort, for sleep, for respect. for th

you. for someone to jump with, our arms outstretche

fingertips reaching to the heavens without the slightest idea who

out there. grasping for who-knows-what & our wishes have be

enveloped by balls of fire light years away, & yet there's the fee

that there is, there always will be, something more, something

bigger, something we want but are so so terrified to have. i

with the constant *feeling* of having something to say without

slightest idea what it is or who it's meant for. maybe that's

i started writing — in hopes that someday it'll finally come out,

a real epiphany feels like. *** standing there, head tilted up, taking it all in, in deep s

really. the only difference now is far more rainy nights.

((i just really want a chick-flick romance.))

every once in a while, you meet these people that make you t

that just maybe you've been doing something right after a

deserve them in your life

metaphors
that don't make
editors & red pens
cringe

[that was a time
before i'd quite
learned how to
lose myself in words
(leave myself to be
found) & so i tried
to let the little
pinpoints of light
be a replacement
for something i
had yet to
discover.] get the
i would
strangest feeling
that there was
something (inside
me, waiting
to give it
i knew
was how, &
somehow whispering
this to a twinkling
dark space made
me feel better.
just looking at them
gave me a sense of peace
sleeping right now
might be a good
idea... maybe...

this talking
kinda weirds
me out

yes, i do stupid th
make up words. i do
enough. i let my he
my brain. i keep
letters that i w
send in a mill

for life's not a paragraph
& death i think is no parentheses

something about you now ... i can't quite figure out... every
she does is beautiful ... & everything she does is right

REMEMBER TO TELL MILO: "well, a friend of mine has a "proud to be a david tennant fangirl" t-shirt... it's a pity i couldn't find one for you... "so you remember french boy?" "YES?!?!" "oh, well, nothing happened with him..."

useful phrases from "the book thief": smiles like salt. ruptured veins. waxy yellows. stood & played with the quietness. mistakes, mistakes — it's all i seem capable of at times. wooden teardrops. oaky smiles. DERP.

i don't even really know what to say; ~~putting~~ & i am fairly good at putting feelings on paper, so that's new. i dunno — i really dunno. i'm just putting syllables down on the page now with no real direction. & i haven't even really mentioned anything yet, no detail that would let ~~so~~ anyone other than myself to understand; *well that's just life i suppose* but that's just it, the "other than myself" bit. i can look at this tomorrow or next week or next month or possibly next year & most likely know what i'm talking about, & that in itself is worrying. you pick them up in the unlikeliest places

i love you insomnia is quite a beautiful thing, really — at least then i can control my dreams — I THINK I LOVE YOU. i'm yours, eternally. love, love, lovelovelove loveee...

what is there to tell you about brutality & beauty that you don't already know? the callouses on my right hand from playing amelia pond — the g... who w... the lines on my fingers from gripping the pen too...

if frodo can get the ring to Mordor, you can get out of bed. i shou...

sometimes i just stop & look back at the ~~last~~ fifteen ~~or~~ & a bit years th... up my life & think about all the things i wish i hadn't ~~done~~ done — & trust that's a pretty long list. people tell me that i'm too cautious, sometimes. & may... but i really can't help it; i just don't want you to turn into just another mistake, jus... more regret to add to my mental drama. maybe being careful is the way to happily after — i mean, if we want fairytale simplicity, it'd be pretty helpful ~~do~~ to create it our...

• •

maturity? *even*
you pick up ~~feelings~~ in the unlikeliest places. — | but i don't mean
desk drawers, the cracks in cobblestone paths, | kind of silly th
for example, or creaky desk drawers, or *la* | that you look ba
stuck in the knots of your shoelaces *la lie* | & laugh at, like
 | weird kid you ad...
listen, okay? i'm not perfect — i don't want | for a while or wast...
to be. i want to stay lost & awkward & | time worrying abou...
quirky & nerdy & me. but then there's the | the popular kids. i
matter of you... ~~it~~ it really shouldn't | think i mean real
be this hard of a choice. giving up ~~me~~ | regrets, although
you or giving up myself.... hmmmm. | perhaps i'm not mature
 | enough to know what
 | exactly that even means

"if i fuck it up, it's cool. that's art." ~ matt nathanson

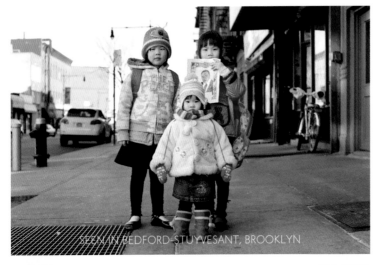

SEEN IN BEDFORD-STUYVESANT, BROOKLYN

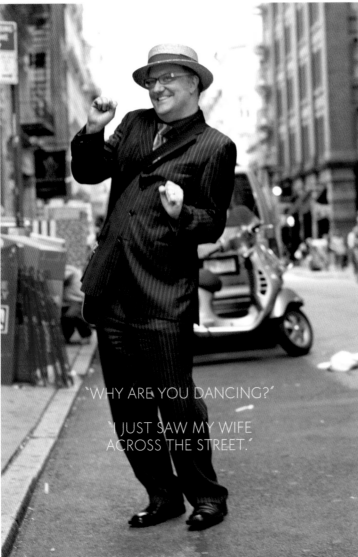

"WHY ARE YOU DANCING?"

"I JUST SAW MY WIFE
ACROSS THE STREET."

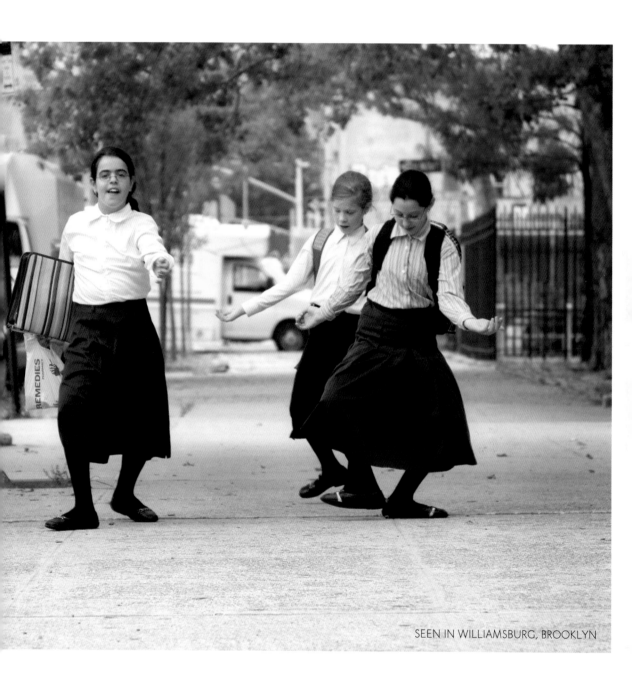

SEEN IN WILLIAMSBURG, BROOKLYN

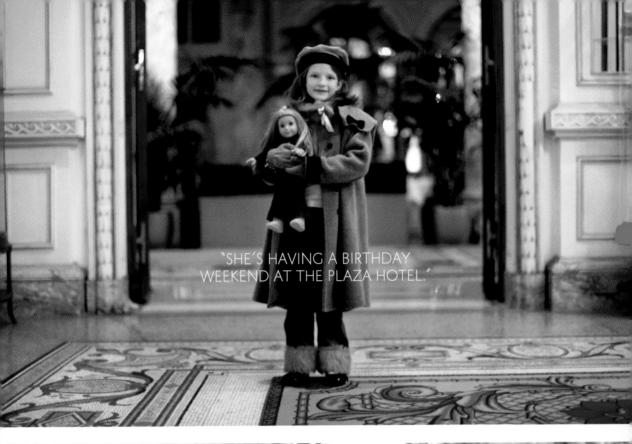

'SHE'S HAVING A BIRTHDAY
WEEKEND AT THE PLAZA HOTEL.'

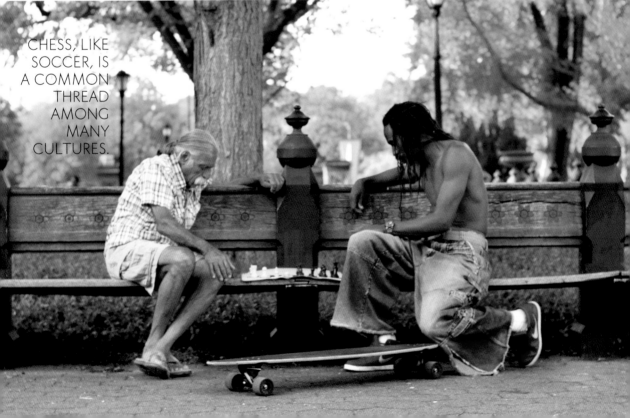

CHESS, LIKE
SOCCER, IS
A COMMON
THREAD
AMONG
MANY
CULTURES.

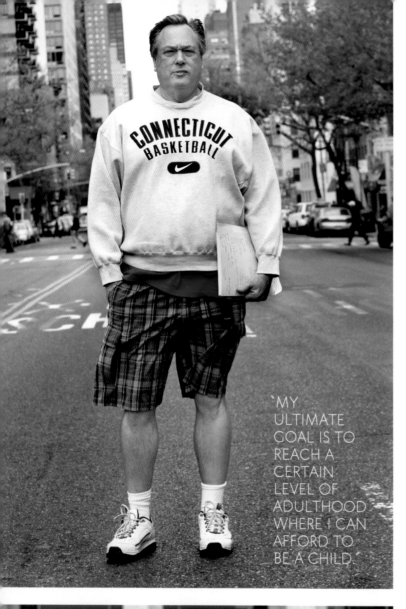

`MY
ULTIMATE
GOAL IS TO
REACH A
CERTAIN
LEVEL OF
ADULTHOOD
WHERE I CAN
AFFORD TO
BE A CHILD.`

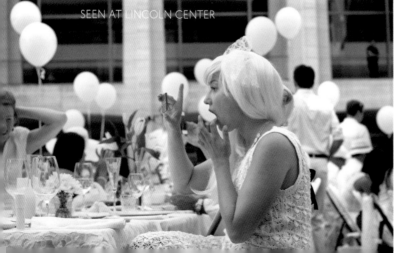

SEEN AT LINCOLN CENTER

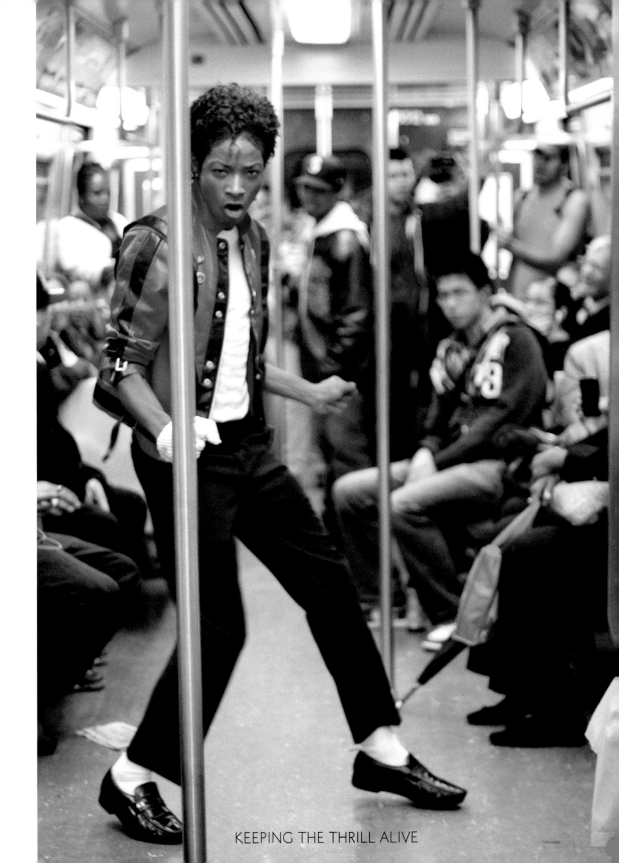

KEEPING THE THRILL ALIVE

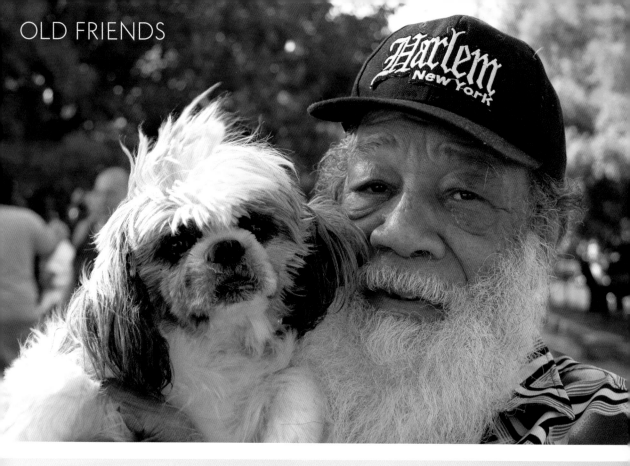

OLD FRIENDS

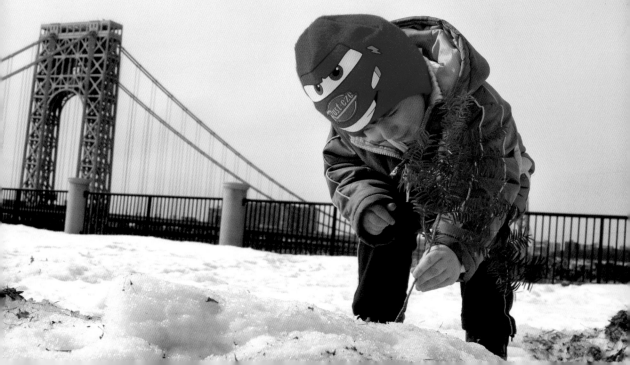

SOMETIMES SPRING NEEDS A KICK START.

'I'M GOING TO LET YOU TAKE MY PHOTO BECAUSE YOU SEEM LIKE A GENUINE PERSON. BUT JUST SO YOU KNOW—I DON'T NORMALLY LET PEOPLE STEAL MY SWAG.'

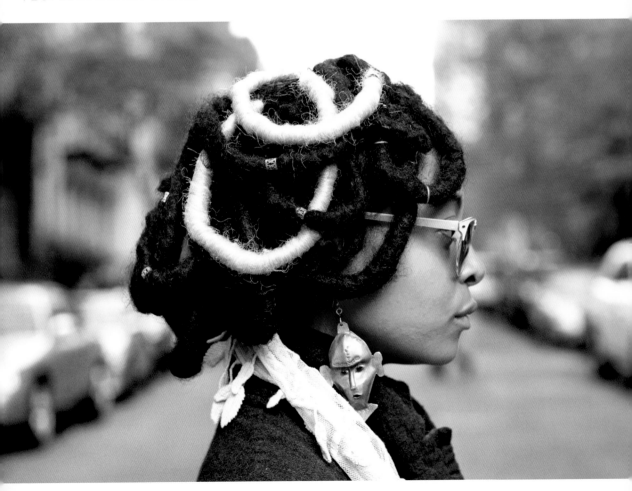

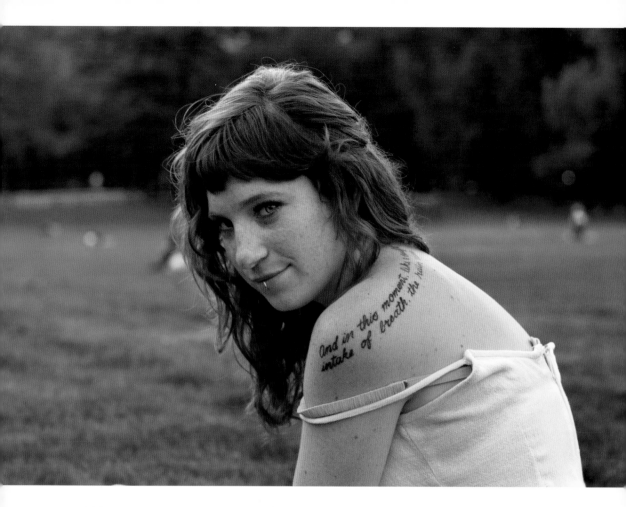

"MY FATHER HAS ASPERGER'S, SO IT'S ALWAYS BEEN VERY DIFFICULT TO CONNECT WITH HIM EMOTIONALLY. THEN, A FEW YEARS AGO, I WAS READING TRUMAN CAPOTE'S *OTHER VOICES, OTHER ROOMS*, AND THERE'S THIS SCENE WHERE THE MAIN CHARACTER PRAYS TO KNOW HIS FATHER. AND WHEN HE'S DONE PRAYING, THE CHAPTER ENDS: 'AND IN THIS MOMENT, LIKE A SWIFT INTAKE OF BREATH, THE RAIN CAME.' "

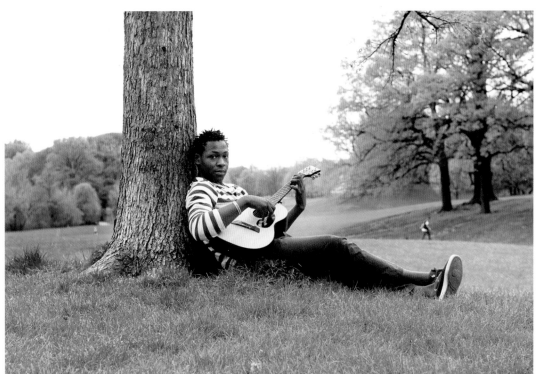

"I'M LEARNING A SONG."

"ARE YOU LEARNING IT
 FOR A GIRL?"

"... YEAH."

I ASKED HIS
SISTER TO
TELL ME
SOMETHING
ABOUT HER
BROTHER.
SHE SAID:

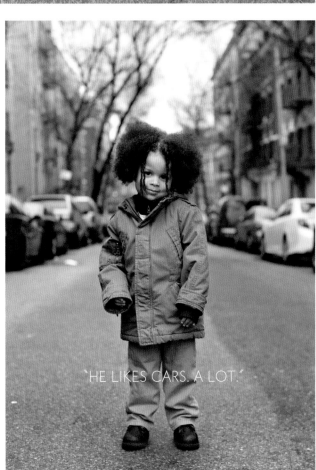

"HE LIKES CARS. A LOT."

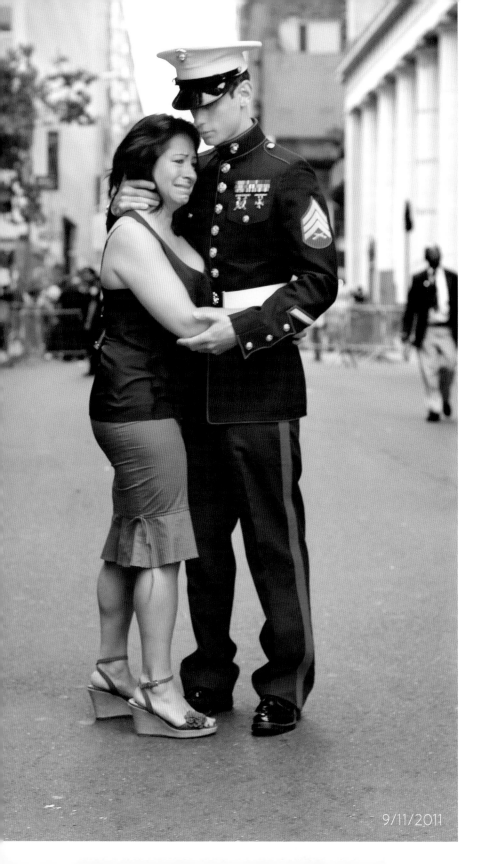

9/11/2011

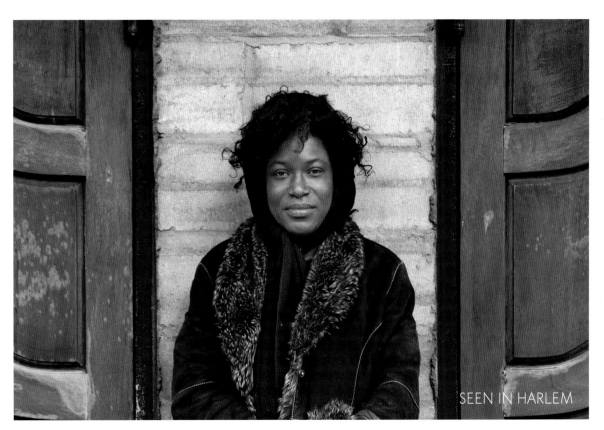

SEEN IN HARLEM

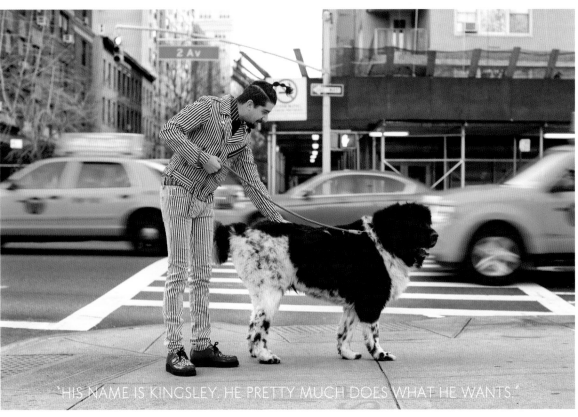

'HIS NAME IS KINGSLEY. HE PRETTY MUCH DOES WHAT HE WANTS.'

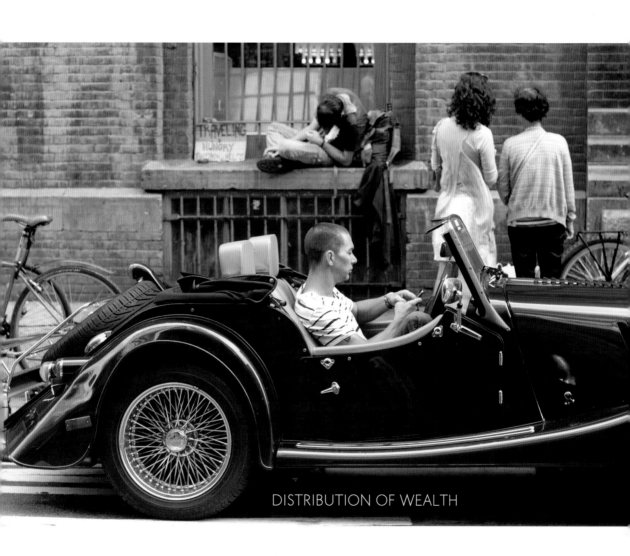

DISTRIBUTION OF WEALTH

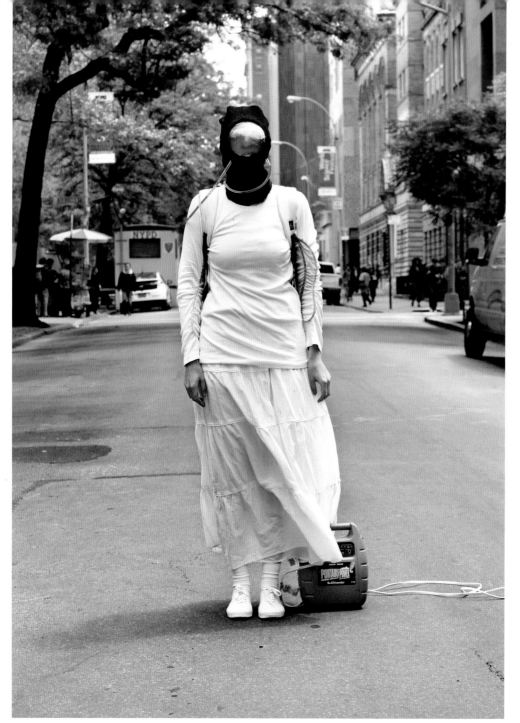

"WHEN YOUR PULSE DROPS BELOW SEVENTY-SIX, IT FUNNELS BLOOD OUT OF THE MASK AND YOUR VISION IS CLEARED. WHEN YOUR PULSE RISES ABOVE SEVENTY-SIX, THE BLOOD IS FUNNELED BACK INTO THE MASK AND YOUR VISION IS OBSCURED. IT'S DESIGNED TO TEACH THE USER TO BE SENSITIVE TO ENVIRONMENTAL STRESSORS, AND TO LEARN HOW THESE STRESSORS AFFECT THE BODY."

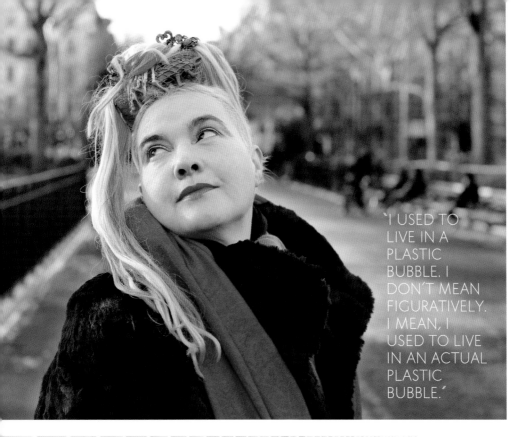

"I USED TO LIVE IN A PLASTIC BUBBLE. I DON'T MEAN FIGURATIVELY. I MEAN, I USED TO LIVE IN AN ACTUAL PLASTIC BUBBLE."

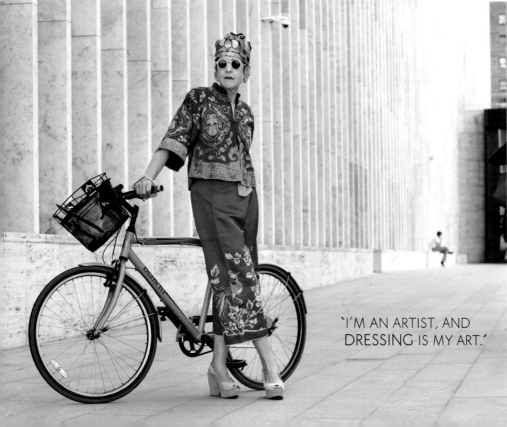

"I'M AN ARTIST, AND DRESSING IS MY ART."

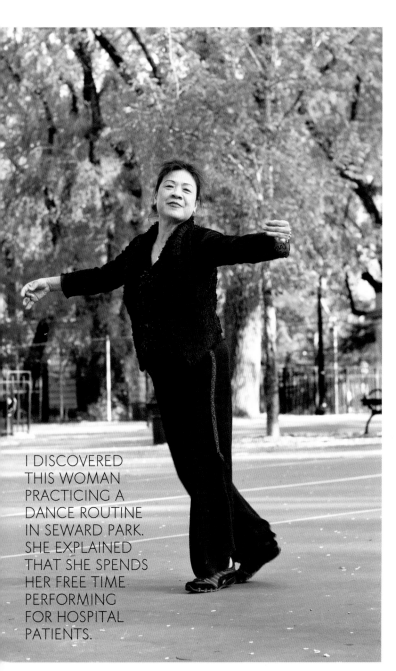

I DISCOVERED
THIS WOMAN
PRACTICING A
DANCE ROUTINE
IN SEWARD PARK.
SHE EXPLAINED
THAT SHE SPENDS
HER FREE TIME
PERFORMING
FOR HOSPITAL
PATIENTS.

THIS MAN WAS PERFORMING PUPPET SHOWS BASED ON THE SHORT STORIES OF FRANZ KAFKA. DURING PIVOTAL SCENES, HIS YOUNG ASSISTANT WOULD BLOW WILDLY INTO A SAXOPHONE.

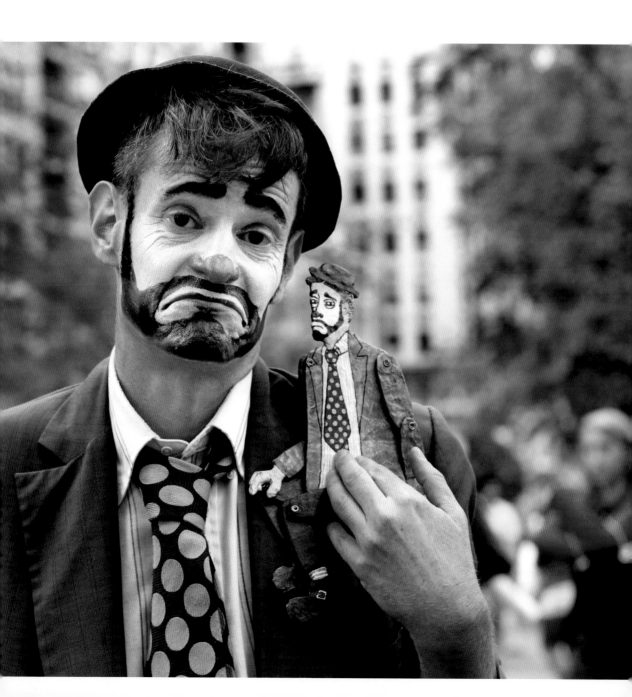

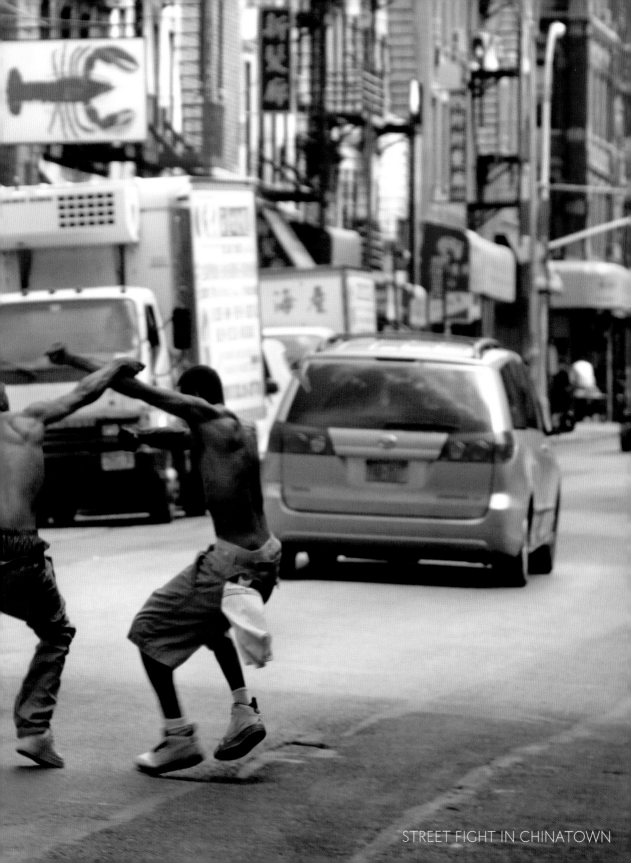

STREET FIGHT IN CHINATOWN

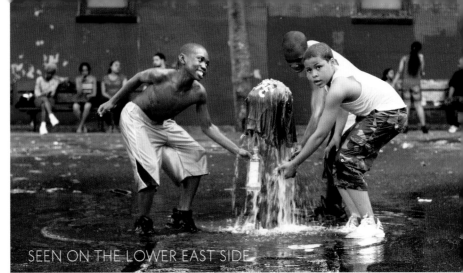

SEEN ON THE LOWER EAST SIDE

"I GREW UP IN SOUTH AFRICA, THEN I MOVED TO THAILAND FOR A FEW YEARS. NOW I'M HERE WORKING AS A PERSONAL CHEF. I SPECIALIZE IN FRENCH CUISINE, WITH A SOUTH AFRICAN AND ASIAN TWIST."

"YOU SHOULD NEVER SAY: 'I'M POOR.' INSTEAD YOU SHOULD ALWAYS SAY: 'I LIVE IN ABUNDANCE.' GIVE IT A TRY. I DID IT FOR A WHOLE MONTH ONCE. PEOPLE WERE BUYING ME LUNCHES, THEATER TICKETS—IT WAS GREAT."

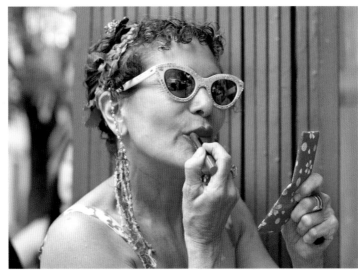

`JUST BECAUSE YOU'RE AN ADULT DOESN'T MEAN YOU'RE GROWN UP. GROWING UP MEANS BEING PATIENT, HOLDING YOUR TEMPER, CUTTING OUT THE SELF-PITY, AND QUITTING WITH THE RIGHTEOUS INDIGNATION.'

`WHY DO SO MANY PEOPLE SEEM TO LOVE RIGHTEOUS INDIGNATION?'

`BECAUSE IF YOU CAN PROVE YOU'RE A VICTIM, ALL RULES ARE OFF. YOU CAN LASH OUT AT PEOPLE. YOU DON'T HAVE TO BE ACCOUNTABLE FOR ANYTHING.'

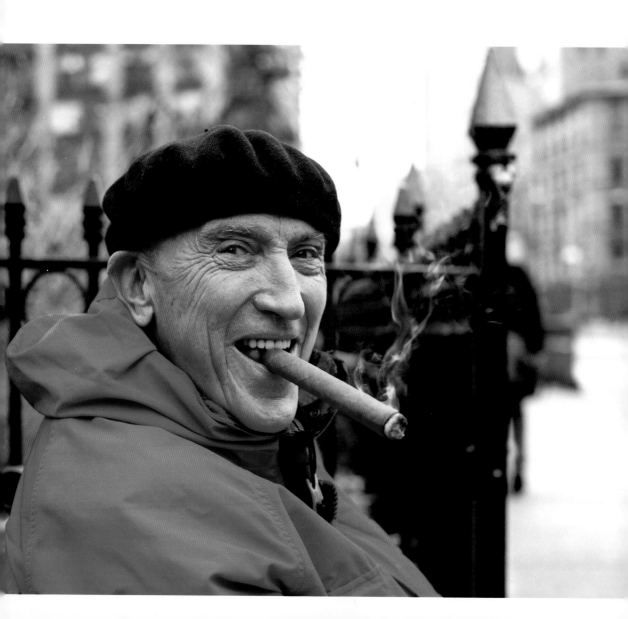

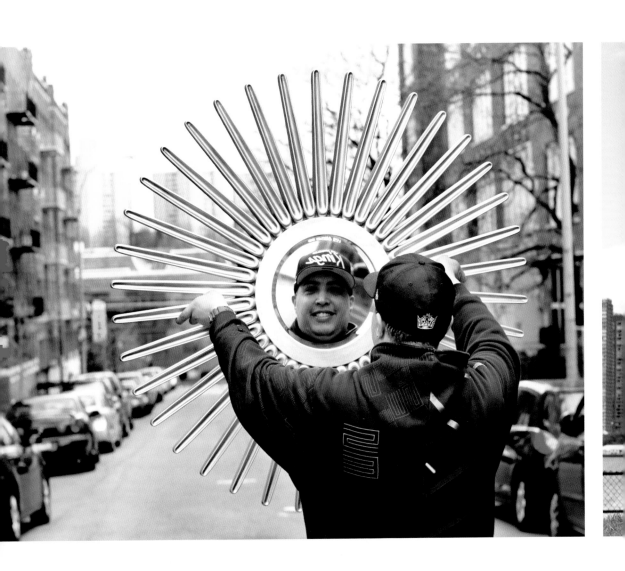

WHEN I EAT AT CAFÉS, I TRY TO GET A TABLE BY THE WINDOW.
JUST IN CASE SOMEONE WALKS BY WITH A GIANT SUN MIRROR.

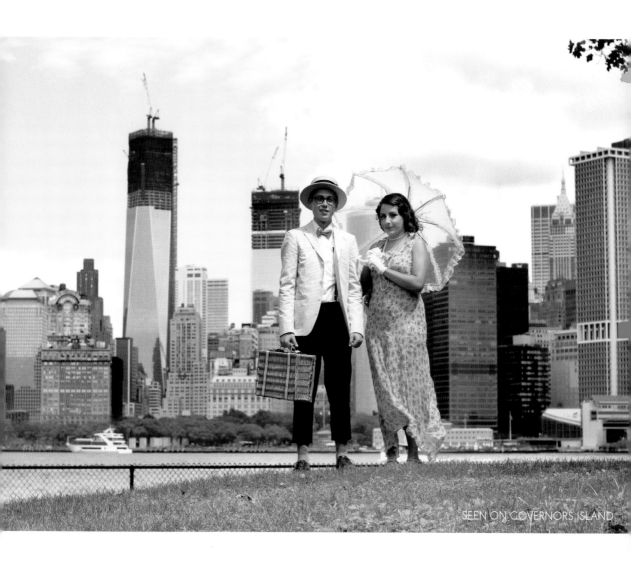

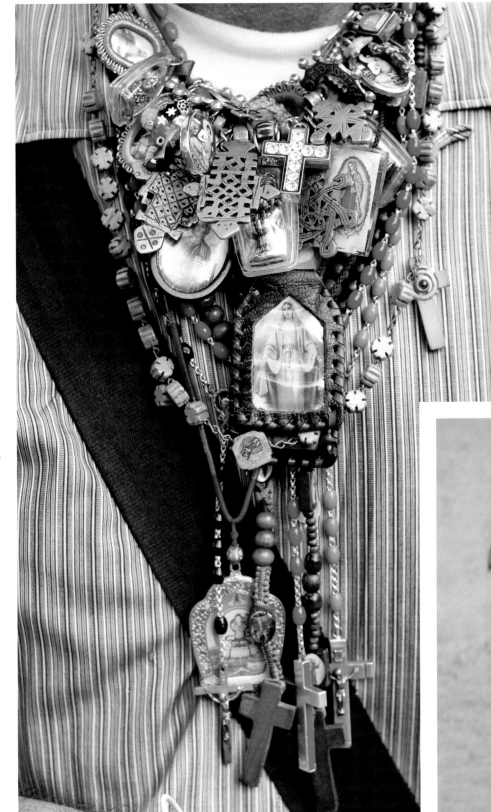

"I BELIEVE IN A LITTLE BIT OF EVERYTHING."

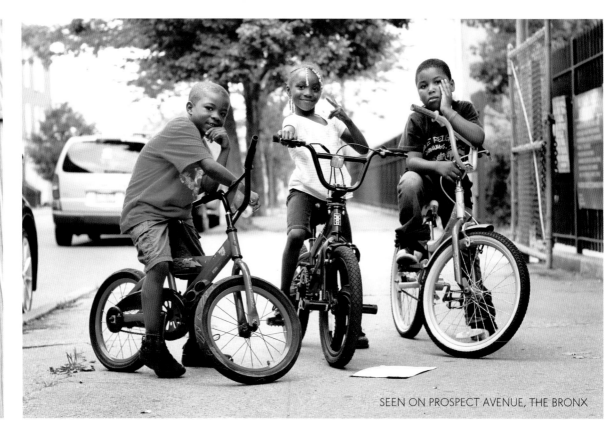

SEEN ON PROSPECT AVENUE, THE BRONX

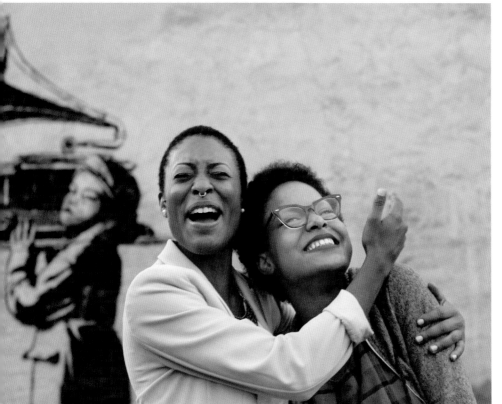

THIS MURAL WAS HOUSED IN A VACANT LOT SURROUNDED BY A HUGE CHAIN-LINK FENCE. I ASKED SEVERAL YOUNG MEN TO FOLLOW ME THROUGH A HOLE IN THE FENCE, BUT NOBODY WAS WILLING TO TAKE THE RISK. AFTER SEVERAL MINUTES, I FINALLY FOUND TWO PEOPLE WITH THE BALLS TO DO IT.

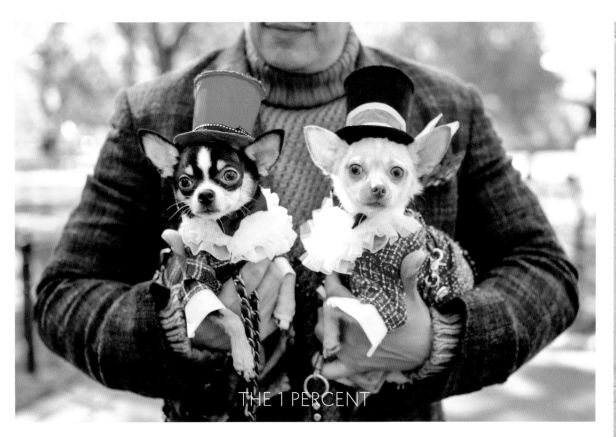

THE 1 PERCENT

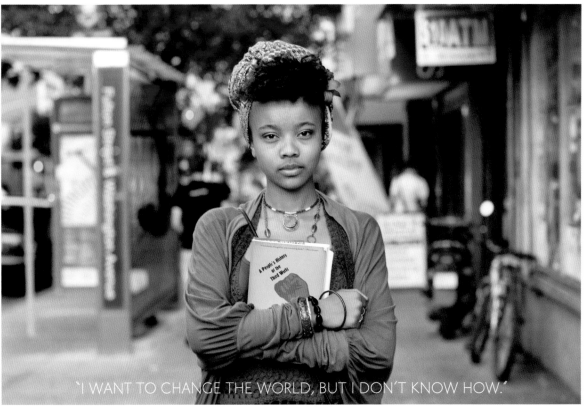

'I WANT TO CHANGE THE WORLD, BUT I DON'T KNOW HOW.'

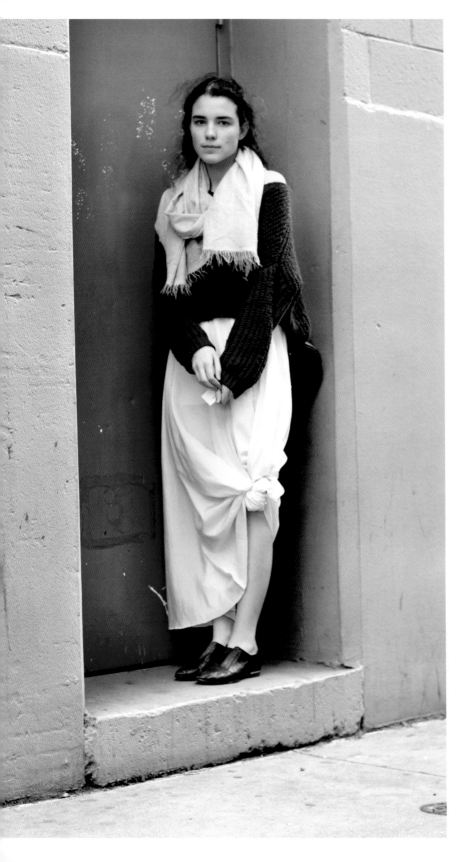

I DON'T THINK
SHE WAS FULLY
COMFORTABLE
WITH THE
PROCESS, BUT HER
APPREHENSIVENESS
CAME THROUGH
BEAUTIFULLY.

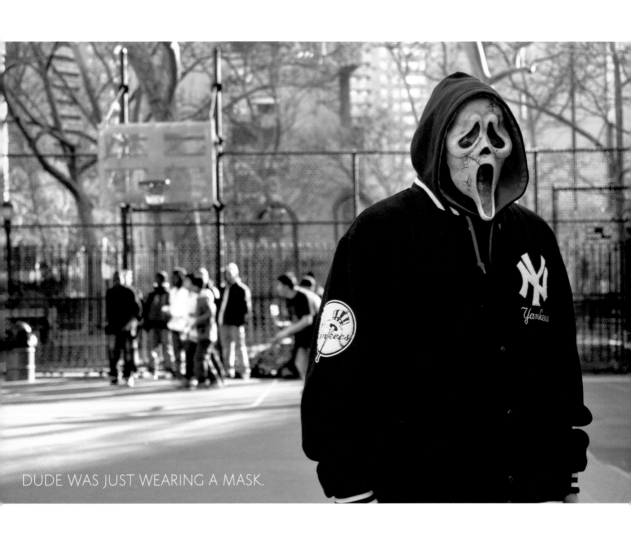

DUDE WAS JUST WEARING A MASK.

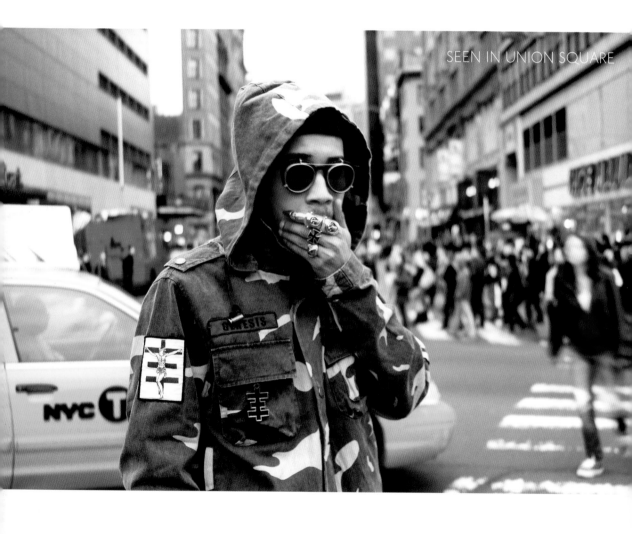

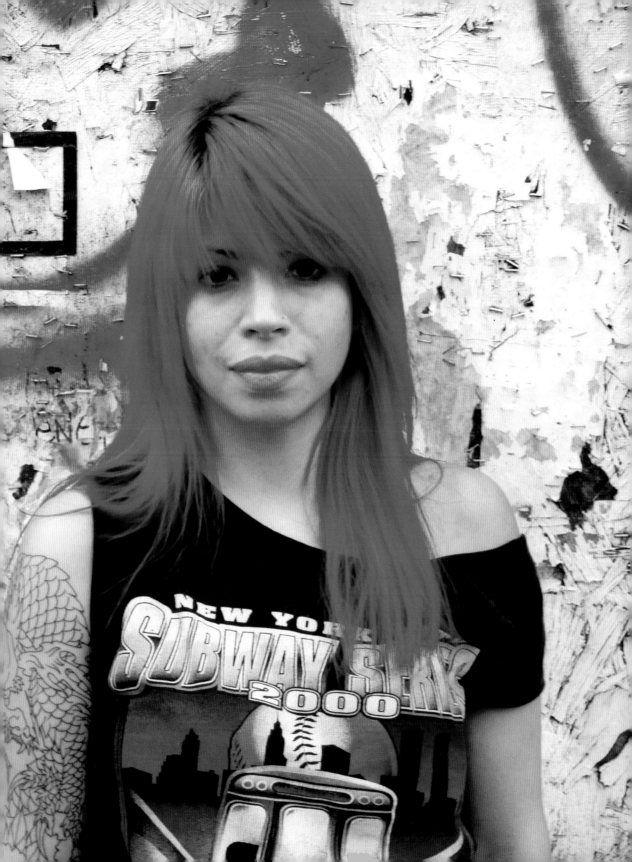

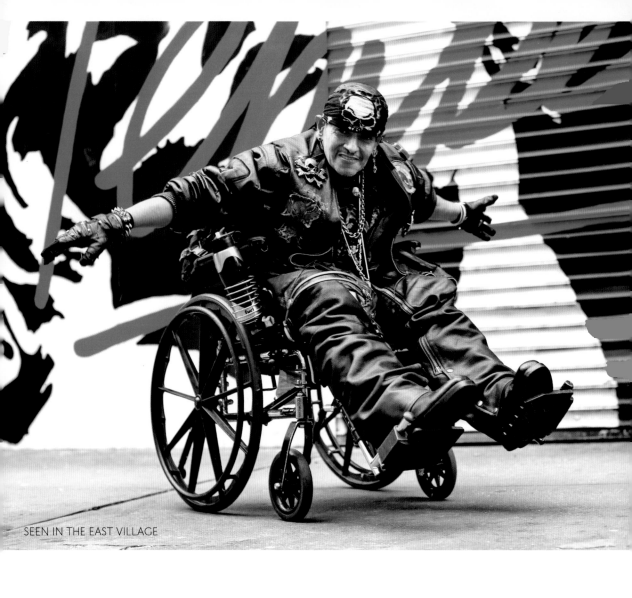

SEEN IN THE EAST VILLAGE

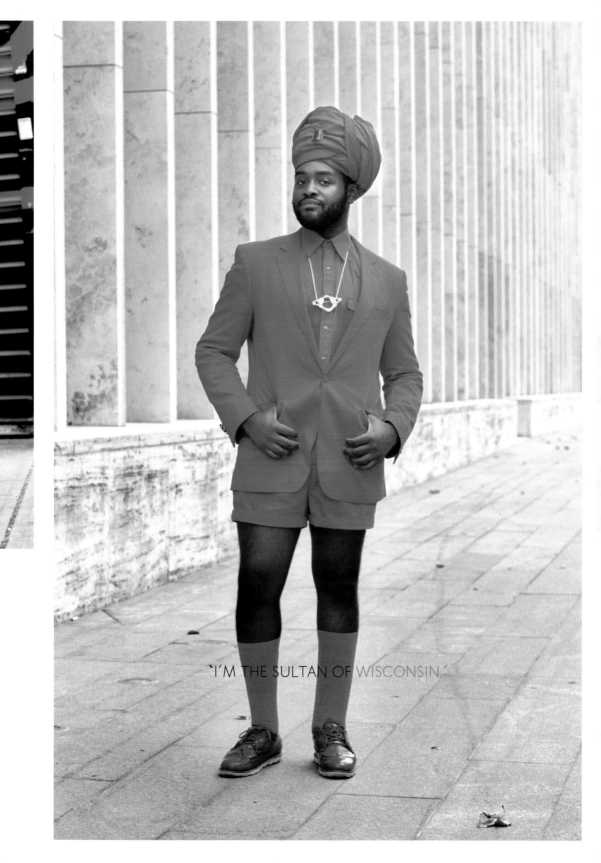

"I'M THE SULTAN OF WISCONSIN."

ACKNOWLEDGMENTS

These days I get tons of mail from people offering advice, help, and support. I appreciate all of it, of course. But I'd like to begin by thanking the people who provided these things back when HONY was just a crazy idea. Thanks to Sam Ward for telling me that I was going to be remembered for my "people pictures"—after my very first day of shooting. Thanks to Casey and Erin, Catherine, David, and everyone else who let me sleep on their couch during my first summer in New York. Thanks to Nathan Hicks for being the first true believer. Thanks to Eric Engdahl for all the counseling. Thanks to Jessie Canon for building an awesome Web site for some guy you didn't know, for free. Who does that!?!? You do. Because you're an awesome guy.

Thanks to Brian Lighthiser, Andy Anaszewicz, and Adam Schaefer. Emotional support is great—but you guys helped pay the rent. At some point, each of you dropped a ladder when I was absolutely convinced that I'd hit a wall. You made this possible. Thanks also to Steve Churchill, for being a dick. (You know I love you.) Thanks to my assistants, Olivia and Christina, for all the work you've taken off my back, for keeping me organized, and for taking my emo phone calls when I get hate mail. Thanks also to my roommate Dave for all the cynicism, skepticism, and

pessimism. It kept me grounded. Thanks to everyone at Tumblr for letting me hang out at the office and feel like a cool kid.

Thanks to my agent, Brian DeFiore. Late in the game, a lot of agents wanted to meet because of my audience. In the beginning, Brian wanted to meet because of my photos. Very grateful for his early and continued support. Brian—sorry about all the text messages on weekends. Thanks to everyone at St. Martin's Press for buying in to something new. Thanks to Yaniv Soha for all your helpful suggestions, and Jon Bennett for your mad skills.

Thanks to Tim Chia, Alex Rojas, and Keith Fiantago for teaching me how to trade bonds. You're three of the greatest guys I've ever known. You taught me that there were bighearted, honest people in every industry. You also taught me to take losses and keep swinging. And that I'll use forever. Thanks to Joe Coconate and Charles Okoye for being such great friends in Chicago.

Thanks to my parents for putting up with all the false starts and wild curves. Sorry about the scares. Thanks to Ryan for being a great brother. And lastly, thanks to my wonderful girlfriend, Erin—you have a heart of absolute gold and make me eat vegetables.

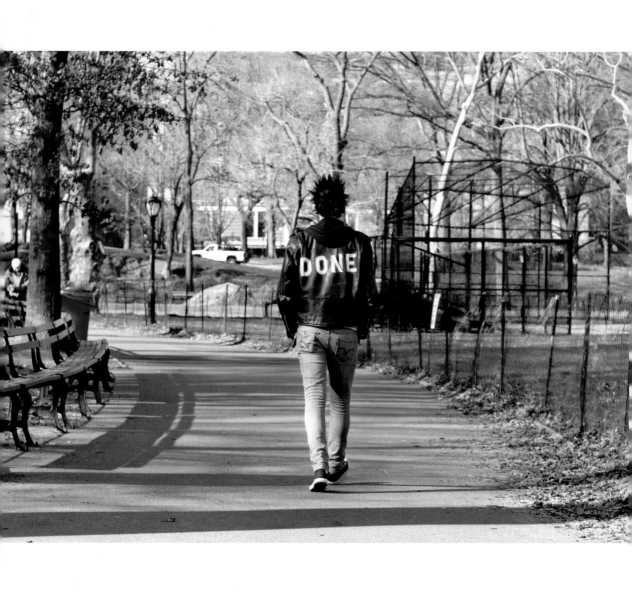